MEDIEVALISM

Garland Reference Library
of the Humanities
Volume 791

MEDIEVALISM

An Annotated Bibliography of Recent Research
in the Architecture and Art of Britain and North America

Edward Kaufman

Sharon Irish

GARLAND PUBLISHING, INC. • NEW YORK & LONDON
1988

Library of Congress Cataloging-in-Publication Data

Kaufman, Edward, 1952–
 Medievalism: an annotated bibliography of recent research in the
architecture and art of Britain and North America / Edward Kaufman,
Sharon Irish.
 p. cm. — (Garland reference library of the humanities; v.
791)
 Includes Index.
 ISBN 0-8240-7896-9 (alk. paper)
 1. Art, British—Bibliography. 2. Art, American—Bibliography.
3. Art, Canadian—Bibliography. 4. Medievalism in art—
Bibliography. I. Irish, Sharon, 1952– . II. Title.
III. Series
Z5961.G1K38 1988
[N9491]
016.7'0941—dc19 88–11072
 CIP

Printed on acid-free, 250-year-life paper
Manufactured in the United States of America

CONTENTS

PREFACE

The compilers of a bibliography on medievalism in art
and architecture run the risk of displeasing nearly
everyone: those who do not believe in bibliographies;
those whose works have been inadvertently left out or
inadequately described; those who find fault with our
categories, or with our self-imposed limitations; and
those who object that the entire subject is too narrow,
or too broad, or even non-existent. We should like,
therefore, to say a few words about the subject and about
our intentions.

First of all, the reader will notice that the pictorial
arts play a secondary role to architecture in this
compilation, and that for two reasons. First, we are
both architectural historians. Second, the phenomenon of
medievalism--a sustained probing, and creative interest
in the arts and manners of the middle ages--is most
particularly an architectural one. Not that medievalism
has played no role in the history of painting. On the
contrary, one might instance the illustration of medieval
subjects by Edwin Austin Abbey or F.L. Griggs, the
adoption of medieval stylistic traits by John LaFarge or
of medieval techniques by Thomas Gambier-Parry, the
collecting of medieval art by James Jackson Jarves, or
the imitation of medieval ideals of artistic production
by the Pre-Raphaelites. But these strands never
coalesced as they did in architecture to form a broad,
successful, and durable movement. The situation with
architecture is indeed very different: for several
generations, architects were conscious of engaging in a
Gothic Revival; they called it that; and later
generations of scholars, beginning with Eastlake in 1872,
have continued to call it that. So there is in
architectural history a long-established field known as
the Gothic Revival which has no precise counterpart in

the pictorial arts. This situation is reflected in our
bibliography.

Still, in titling this work, we elected to avoid the
term "Gothic Revival" and to use instead the less
colorful "Medievalism." That is again for two reasons.
First, the phenomenon of medievalism in modern culture
has not been limited to the Gothic; eighteenth century
antiquarians, for example, were hardly equipped to make
the sort of historical distinctions between Gothic and
Romanesque, or even between Gothic and Elizabethan, that
we now take for granted. (Though even now period and
style terms can still excite controversy: see, e.g., Jan
Bialostocki, "Late Gothic: Disagreements About the
Concept," **Journal of the British Archaeological
Association.** s.3, 29 [1966]: 76-105.) Second, although
the advocacy of medieval forms was sometimes accompanied
by the sort of missionary zeal that properly deserves the
term "revival," this was not always so. The term
"medievalism" therefore seems at once more accurate, more
comprehensive, and less value-laden than "Gothic
Revival."

When did medievalism begin? It has been around, in
varying strengths and proportions, for practically as
long as the middle ages have not, perhaps from the late
sixteenth, certainly from the early eighteenth century,
in England and from the end of the eighteenth in America.
Our bibliography reflects this broad historical
background. As to when medievalism ends, that is a more
difficult question. It blazed up fiercely, and to all
appearances finally, in the first quarter of the
twentieth century, at the Cathedrals of Liverpool, New
York and Washington, D.C., at Cass Gilbert's Woolworth
Building, Raymond Hood's Chicago Tribune Tower, Charles
Z. Klauder's University of Pittsburgh, and Sir George
Oatley's University of Bristol. Yet it did not die with
this great effulgence but hung on tenuously behind the
shadow of International Modernism: John Sebastian Comper,
son of the more famous Sir Ninian, designed the very
competent Gothic church of St. Augustine, High Wycombe
(Bucks.) in 1955. Traveling through England and America,
one comes across other forgotten epigoni of the Gothic
Revival, some no more than thirty or forty years old.
And, of course, the taste for medieval art and
architecture has continued quite unabated among tourists,
scholars, and connoisseurs, even though the impulse to

imitate may have flickered away.

But has it indeed flickered quite away? Ten years ago, one might have been forgiven for thinking that it had (though even then, one would have been forgetting the tracery Gothicism of Edward Durrell Stone or Minoru Yamasaki). But now, it is by no means so clear. Think of Philip Johnson's pinnacled Pittsburgh Plate Glass complex (the tower based not on a Gothic but on a Gothic **Revival** model, the Houses of Parliament); or of the quatrefoil Gothic pillars of Kohn Pedersen and Fox's new Procter and Gamble headquarters in Cincinnati. Such medieval touches may appear to be "sports" amidst the predominantly classical coloration of Post-Modern historicism. But they may also be the harbingers of a new medievalism. If that turns out to be so, the hiatus between the last outposts of Victorian Gothicism and the pioneers of Post-Modern Gothicism will not appear so very great to posterity--no greater perhaps than the gap between the last Gothic mason and his first halting imitator.

This bibliography, however, does not attempt to cover these latest signs of resurgence. It trickles out somewhere in the mid-twentieth century (which in practice, given the paucity of scholarship on twentieth century eclecticism, means about 1900). This has the convenient side effect of ensuring that everything in our bibliography (with the exception of a few reprints) will be secondary sources. In other ways, however, the boundaries of this work did not establish themselves so neatly, and a few words on our editorial procedures will be in order.

The decision to fix 1960 and 1984 as chronological limits reflects the unpredictability of access to literature published more recently, coupled with the symbolic tidiness of a quarter-century span. More important, it reflects our intention to set down a record which might serve as a description of the current state of the field. We are no longer part of the era that produced the pioneering research and interpretations of Kenneth Clark, Basil F.L. Clarke, or H.S. Goodhart-Rendel. It seemed to us that we were no longer part even of the era that produced the great surveys of Paul Frankl, Henry-Russell Hitchcock, Sir John Summerson, or Sir Nikolaus Pevsner. We still rely on these works, but we feel somewhat detached from them: their problems are

not exactly ours. To define precisely when our own set
of problems arose is more difficult, but on balance, and
granting the practical necessity for a terminus, 1960
seemed a reasonable choice.

All the same, given the nature and history of the
subject, the bibliography would have suffered through too
strict adherence to this rule. Though we have not
annotated any works from before 1960, we have felt free
to make reference to earlier studies, both within the
bibliography and the accompanying textual material,
wherever they contributed significantly to the shaping of
an issue or the documentation of a problem. We hope that
these references will increase both the utility of this
bibliography as a reference guide and its accuracy as a
historiographical portrait of the field.

Within the bibliography, three levels of organization
have been adopted. First of all, the figural arts have
been separated from architecture and treated, as already
indicated, somewhat in the way of a supplement. There
are, however, a few ambiguities: while sculpture and book
design have been classified under art, stained glass,
furniture, and other decorative arts have been grouped
with architecture as allied arts. Second, within the
architecture and art sections, the material has been
divided geographically, Great Britain and Ireland forming
one group, the United States and Canada a second. Edward
Kaufman was responsible throughout for the former, Sharon
Irish for the latter. Third, within the British section,
the material has been divided chronologically into two
categories, pre- and post-1840: the lack of a similar
division within the American material reflects our
assessment of the differing historical situations, as
well as the different shape of the scholarly literature.

Within these broad categories, certain problems of
access are inevitable. These occur not only when the
focus of a book or article is ambiguous but also when a
building's attribution is contested or when primary
responsibility cannot be clearly assigned, as is often
the case with buildings designed in stages. Suffice it
to say that we have considered as monographs all studies
which focus primarily on the works (or on a single work)
of an individual, whether architect, painter, patron, or
critic. Studies which cannot be so defined have been
treated as general works, with the exception of those
that pertain to particular places or buildings (whether

anonymous or of multiple authorship): these last have
been arranged topographically. Though each item in the
bibliography carries a unique number, we have relied on
cross-references, together with the index, to eliminate
any remaining uncertainties.
The interdisciplinary nature of medievalism poses its
own bibliographical challenges. A work such as the
present one which omitted Blake, Ruskin, Rossetti, or
Morris, would be flawed indeed, yet to provide a complete
bibliography on any one of these figures would swell the
work to unmanageable proportions. We have not attempted
to do so. In dealing with polymaths like these (as well
as other much studied artists like Turner and Constable),
we have followed these guidelines: to include studies
specifically on medievalism in art and architecture, or
containing significant discussions of the subject; to
include general works of particular importance or
relevance (a highly subjective judgment); to exclude all
other general works as well as all studies on themes
unrelated to the subject of this bibliography. As a
rule, polymaths have been listed as artists or architects
according to the dominant area of their production, with
cross-references wherever necessary: the only exceptions
are Ruskin and Morris, whose historiographical stature
demanded separate treatment.
It should finally be noted that we have omitted
unpublished dissertations, book reviews, guidebooks
available only, or principally, at the site, and
reprints, unless they contain significant new material.
The reader can be assured that we have seen every item
described unless specifically noted.
We would like to thank Gail Fenske, Sarah Bradford
Landau, Katherine Manthorne, David Van Zanten, and John
Zukowsky for suggestions. The staffs of the Avery
Library at Columbia University, the Burnham Library at
the Art Institute of Chicago, the Ricker Art and
Architecture Library and the Interlibrary Loan Office at
the University of Illinois at Urbana-Champaign have been
unfailingly helpful. Many thanks to Elline Long of
Decatur, Illinois, for her computer skills, patience and
friendly cooperation.

INTRODUCTION

A. Medievalism in Great Britain and Ireland

England in the middle of the sixteenth century was
still an essentially Gothic country, and the new
classical style of the Renaissance, which had been
introduced in Italy in the early fifteenth century, did
not make serious inroads in England until the second half
of the sixteenth century. Even then, it began as a
courtly, or at least aristocratic, fashion, and the old
Gothic way of building continued essentially unaltered in
many parts of the country, surviving until as late as the
mid-eighteenth century. This survival constitutes one of
the essential features of the after-life of Gothic in
post-medieval England, and attempts to distinguish it
from revival (particularly in the important Gothic work
carried out at both Cambridge and Oxford during the
seventeenth century) have been hotly debated (see, e.g.,
S. Lang, no. 16). For the continuance of traditions, the
classic article is Howard Colvin's "Gothic Survival and
Gothick Revival," **Architectural Review** 103 (1948): 91-98.
Mark Girouard, by contrast, has shown the importance of
conscious Gothicism in the very early seventeenth century
at Bolsover Castle and elsewhere (nos. 10, 48, 148).
Other contributions to the controversy, in addition to
nos. 8, 39, 57, 60, 66, include Sir Alfred Clapham, "The
Survival of Gothic in Seventeenth-Century England,"
Archaeological Journal, 106 for 1949 [1952]: 4-9; Basil
F.L. Clarke and H.M. Colvin, "The Rebuilding and Repair
of Berkshire Churches During the Seventeenth, Eighteenth,
and Early Nineteenth Centuries," **Berkshire Archaeological
Journal** 53 (1952-53): 65-96; 54 (1954-55): 58-118; 55
(1956-57): 73-79; Louis Osman, "Staunton Harold,
Leicestershire and Foremark, Derbyshire—Two Laudian
Gothic Churches Now Under Restoration," **Transactions**

of the Ancient Monuments Society, NS. 4 (1956): 66–78; and J. Simmons and H.M. Colvin, "Staunton Harold Chapel," **Archaeological Journal** 112 (1955): 173–76.

It was, in any case, the early eighteenth century which saw the dramatic expansion of medievalist experiments at a high level of artistic awareness. Both Hawksmoor and Vanbrugh built powerfully in the medieval style (nos. 46, 111, 152); Vanbrugh even built himself a castellated house. Gothic soon proliferated. Mowl and Earnshaw maintain (no. 197) that the first significant Georgian castellated building was Shirburn Castle, begun in 1716 and just antedating Vanbrugh Castle; it was followed in the early 1730s by Kent's work at Esher Place and Hampton Court; by the curious Gothic tower at Whitton Place of the same decade, built by Roger Morris though perhaps designed by Gibbs; by Clearwell Castle, of about 1735; by Gibbs's famous Gothic temple at Stowe, about 1741; by Langley's much maligned though influential pattern book, **Ancient Architecture Restored**, published in 1742; by William Halfpenny's Stouts Hill of 1743, Sanderson Miller's Radway Grange begun in 1744, Morris's Inverary Castle of 1745; by the gothicization of Arbury Hall, begun in 1748 and involving Keene, Miller, and Couchman; by that of Raby Castle, begun in 1748 and involving an even larger cast of characters; and finally, by that of Horace Walpole's Strawberry Hill, begun in 1749. By the 1740s, medievalism had become an aristocratic fashion and Gothic a favored style for country houses and landscape parks; it would remain so throughout the Georgian period. (Fundamental to the study of Georgian Gothic country houses is Christopher Hussey's three volume study, **English Country Houses. Early Georgian 1715–1760, Mid Georgian 1760–1800,** and **Late Georgian 1800–1840,** London, 1955, 1956, 1958. Included are short monographic studies of such important examples as Strawberry Hill, Lacock Abbey, Arbury Hall, Downton Castle, Luscombe Castle, Belvoir Castle, Tregothnan, Toddington Manor, Penrhyn Castle, Mamhead, and Scotney Castle.)

The development of the landscape garden in early eighteenth century England was indeed a contributory factor in the rising popularity of the Gothic. (From a wide literature on garden design, the following might be singled out as particularly helpful: H.F. Clark, **The English Landscape Garden**, 2nd. ed., Gloucester, 1980; Ray Desmond, **Bibliography of British Gardens**, Winchester,

Introduction

1984; John Dixon Hunt and Peter Willis, **The Genius of the Place.** **The English Landscape Garden 1620-1820**, New York, 1975; Christopher Hussey, **English Gardens and Landscapes 1700-1750**, London, 1967; David Jacques, **Georgian Gardens: The Reign of Nature**, London, 1983; Edward Malins, **English Landscaping and Literature, 1660-1840**, London, New York, 1966; Ronald Paulson, **Emblem and Expression: Meaning in English Art of the Eighteenth Century**, Cambridge [Mass.], 1975; Nikolaus Pevsner, "The Genesis of the Picturesque," **Architectural Review**, 1944, reprinted in no. 22, v. 1; A.A. Tait, **The Landscape Garden in Scotland, 1735-1835**, Edinburgh, 1980; Peter Willis, **Charles Bridgeman and the English Landscape Garden**, London, 1977; Rudolf Wittkower, "English Neo-Palladianism, the Landscape Garden, China and the Enlightenment," in **Palladio and Palladianism**, New York, 1974; Kenneth Woodbridge, **Landscape and Antiquity: Aspects of English Culture at Stourhead, 1718-1838**, London, 1970; and see also nos. 58, 68, 106, 121, 144-45, 177, 191.) The landscape garden required structures-- tempietti, pergolas, prospect towers, screens, summer houses, follies--whose main function was to be seen, or to provide a point from which to see. Such buildings could be somewhat lighthearted and experimental, as long as they were full of savor and not merely ordinary. At the same time, the development of complex literary and political programs within the landscape garden encouraged the conscious exploitation of various styles, including the Gothic, for these small buildings. Gibbs's Gothic temple at Stowe was one of the earliest important essays in this vein; it was followed, especially after the middle of the century, by a great many sham ruins and castellated pavilions (nos. 35, 53, 57, 118, 144, 160-62), all capitalizing on the growing vogue for the middle ages.

The Gothicism of the early eighteenth century, whether of the landscape garden or the country house, has not fared particularly well among scholars. Favoring frankly decorative effects, drawing upon elusive associations, lacking the apparatus either of a strongly combative polemic or of a well developed scholarly tradition, it has seemed, quite wrongly, to lack historical seriousness. The result is that, while a few general works have touched illuminatingly on the period and a great many short articles have set forth the histories of individual houses, the question of how medievalism

relates to the larger picture of architectural production
in the early eighteenth century remains somewhat unclear.
What is quite clear is that Sir Horace Walpole's famous
Gothic villa, Strawberry Hill, was not the pathbreaking
building that it has often been claimed to be. Yet
Walpole's importance should not be underestimated. First
of all, he was so prominent, and his villa so close to
the fashionable West End of London, that what he did
there could hardly be ignored. Then, too, Strawberry
Hill's medieval decor was remarkably sumptuous, and it
was buttressed by an equally sumptuous structure of
literary and historical associations. Walpole himself
was a noted collector and antiquarian, and one of the
early scholars of Gothic architecture. He was also a
Gothic novelist: indeed, his **Castle of Otranto** (published
in 1765), was the first of those melodramatic romances of
haunted castles and fanatical monks which would become so
popular in the late eighteenth century. Finally, to
complement his own varied activities, Walpole assembled a
coterie of amateur medievalists around him, including
Richard Bentley, who was also responsible for the Gothic
illustration to Gray's "Elegy in a Country Churchyard,"
and probably for the marvelous Rococo Gothic church at
Shobden. So Walpole's Strawberry Hill represents a
crystallization of medievalism on several levels, and it
may serve as a convenient symbol of the new level of
complexity and sophistication achieved by about 1750.

After the middle of the eighteenth century, the status
of the neo-Gothic changes rapidly. By this time, the
belief in a single standard of architectural beauty had
largely broken down, opening the way to an eclecticism
which ranged freely over the Roman, Greek, Renaissance,
Gothic, Hindu, Chinese, and Saracenic styles. (For the
development of the idea of style and of the Gothic style
in particular, see Esmond Samuel de Beer, "Gothic: Origin
and Diffusion of the Term; the Idea of Style in
Architecture," **Warb** 11 (1948): 143-62; see also nos. 8
and 9, both with extensive bibliographies). Other
developments in aesthetic theory aided this proliferation
of styles, and hence indirectly the growth of
medievalism. One was the theory of association--the
theory, that is, that buildings or works of art were
valid not for their intrinsic beauty but for the trains
of thought or reminiscence which they provoked: for
association in architecture, see in addition to nos. 3,

123, 234, John Archer, "The Beginnings of Architectural
Associationism in Eighteenth Century Architecture,"
Eighteenth Century Studies 16 (1978-79): 241-64; Walter
Jackson Bate, **From Classic to Romantic. Premises of
Taste in Eighteenth Century England**, N.Y., 1946; H.F.
Clark, "Eighteenth Century Elysiums. The Role of
'Association' in the Landscape Movement," **Warb** 6 (1943):
165-89; and Walter Hipple, **The Beautiful, the Sublime,
and the Picturesque in Eighteenth Century British
Aesthetic Theory**, Carbondale, 1957.

One specific case of association ought to be mentioned:
the melancholy reverie over the passage of time and
human greatness induced by ruins. The classic ruins of
ancient Rome were of course ideal for this purpose, but
so were the ruined abbeys of England, and as the vogue
for picturesque travel and for native sites began to
achieve parity with the traditional Grand Tour, the
popularity of medieval ruins increased: for the enjoyment
of ruins, Rose Macaulay's **Pleasure of Ruins** (1953,
reprinted 1964) is still valuable.

The mention of picturesque travel brings up another
point: the proliferation of aesthetic categories--the
beautiful, the sublime, and the picturesque--also helped
to buttress the revival of Gothic forms, which were
increasingly demanded for their specifically picturesque
(and sometimes sublime) qualities. David Watkin has
recently written a history of the picturesque tradition
(**The English Vision. The Picturesque in Architecture,
Landscape and Garden Design**, London, 1982), but the
standard works by Christopher Hussey (**The Picturesque**,
London, 1927), Samuel Monk (**The Sublime**, New York, 1935),
and Walter Hipple (**The Beautiful, The Sublime, and The
Picturesque in Eighteenth Century British Aesthetic
Theory**, Carbondale, 1957) remain more analytical; Carl
Barbier's biography of William Gilpin (**William Gilpin and
His Theory of the Picturesque**, Oxford, 1963) should also
be consulted.

One last category of aesthetic thought which
contributed to the growth of medievalism was historical
scholarship. The antiquarian encounter with the past had
begun as early as the sixteenth century and was
connected--as it would continue to be--with the
developing passion for topography, for travel, for the
exploration and explication of the native countryside.
(Here Esther Moir's **The Discovery of Britain. The**

English Tourists, London, 1964, is particularly helpful.)
During the seventeenth century, critical awareness of
medieval architecture deepened, as articles on Evelyn and
Aubrey (nos. 79, 104) and the publication of North's
commentary (no. 135) show. But it was in the period from
about 1760 to 1830 that the pace of research accelerated
most dramatically and that this research had its most
profound impact on architecture. In 1760, after all, the
forms and chronology of Gothic architecture were still
murky, and what little knowledge there was still belonged
to a very restricted circle. But by the 1830s, thanks to
the research and publications of A.C. Pugin, E.J.
Willson, John Britton, Thomas Rickman, and others, any
architect with the money to assemble a library could
master the subject. In the fields of costume, arms and
armor, and furnishings, the situation was precisely
parallel, thanks to the work of Joseph Strutt, Francis
Grose, J.W. Planché, Alfred Stothard, Sir Samuel Rush
Meyrick and Henry Shaw. The works of the medievalists,
artists, architects and theatrical producers alike mirror
this changing situation.

The history of scholarship has never been a popular
subject among Anglo-Saxon art historians, and in this
case at least, that is unfortunate. A few scholars,
including Stuart Piggott and J.M. Frew, have written on
the subject of medievalist scholarship (nos. 47, 55, 61,
79, 82, 88, 94); see also no. 8, 21, 30 and Joan Evans, **A
History of the Society of Antiquaries,** London, 1956;
Stuart Piggott, **William Stukeley: An Eighteenth Century
Antiquarian,** Oxford, 1950; and Paul Yvon, "La renaissance
gothique en Angleterre dans ses rapports avec la
Normandie," **Bulletin de la Société des Antiquaires de
Normandie** 38 [1929]; for the impact of antiquarian
studies on art, see nos. 505, 510, 539, 543, 573, 579;
the literature on topographical painting, and on Sir
Walter Scott's impact on the visual arts (both discussed
below) is also helpful at times. But the scholarship of
medieval architecture contains numerous promising avenues
of research which have not even begun to be explored.

Spurred by an intellectual climate of eclecticism,
association, history, and picturesque travel, the Gothic
changed character rapidly during the late Georgian
period, becoming an accepted mode for all kinds of
architecture. Most of the leading architects now
designed with facility in both Gothic and classic.

Introduction

Certainly Robert Adam did: Adam, whose delicate and
recondite classical works have elicited so much
admiration, also designed great houses in the castle
style, whose importance a series of recent articles
underlines (nos. 69-73); see also no. 57. James Wyatt,
whose classical work owes so much to Adam, was also a
medievalist of the first importance: in his early country
house, Lee Priory, he was seen to have inherited the
mantle of Walpole and Strawberry Hill; later, he built
perhaps the most spectacular Gothic house of all,
Fonthill Abbey, for a rich, eccentric collector-author
rather like Walpole (nos. 169, 171, 174-75); finally,
Wyatt became notorious as one of the most prolific
restorers of Gothic cathedrals. Nash, Wilkins,
Wyatville, Soane--all of the great public architects of
the early nineteenth century designed in Gothic as well
as classic. Their works are known in far greater detail
than those of the early Georgian pioneers of medievalism;
indeed, so extensive are the bibliographies on Adam and
Soane that we have included only the items most useful
from a medievalist point of view.

During the early nineteenth century, the Gothic came to
be thought of as a style particularly suited to religious
buildings. But in the eighteenth century, this was not
yet the case. Though there are a few splendid
exceptions, church building played little role in the
development of eighteenth century medievalism; indeed it
played but a minor role in English architecture
generally. (The standard treatment of the subject is
Marcus Whiffen's **Stuart and Georgian Churches. The
Architecture of the Church of England Outside London
1603-1837**, London, 1947; see especially Chapter Five, on
the Gothic Revival. See also, in addition to nos. 17,
23, 31, 44, 57, 116, 420, the valuable work by B.F.L.
Clarke and H.M. Colvin, noted above on p. xi, and John
Stanley Purvis, **The Condition of Yorkshire Church Fabrics
1300-1800**, London 1958.) The great event in the revival
of churchbuilding was the Church Building Act which was
passed by Parliament in 1818. This established a fund to
provide places of worship for the increasingly large
unchurched population. The churches were mostly cheap--
that was the intent of the Act--and somewhat barren, and
indeed the Gothic ones became within a generation the
objects of blistering scorn. Yet the Commissioners'
Churches, as they were generally called, formed the first

xix

extensive corpus of medievalist church architecture, and
were therefore of the greatest importance. M.H. Port's
book (no. 62) remains the standard study, (and see also
nos. 56, 150), and it is both fair and thorough, yet
these much ridiculed buildings stand in need of a
sympathetic reevaluation.

It was during the late Georgian period also that
medievalism became a substantial force in the pictorial
arts. At first, this was primarily through the
illustration of Gothic subjects drawn from medieval
literature and history and artistically adapted to fit
accepted canons of neo-classical painting. History
painters added the deeds of national kings and heroes to
their stock of classical subjects (nos. 121, 510), while
artists like Flaxman, Fuseli, and Blake began to explore
the writings of Dante and Chaucer (nos. 121, 510, 518,
559). The revival of Milton and Shakespeare also had
tangential connections to medievalism, the latter not
only through the eighteenth century cult of native (and
unclassical) genius that developed but also through the
support it gave to research in medieval costume--research
that would culminate in the historicist productions of
Kean and Kemble at the end of the Georgian period. (See
Ronald Paulson, **Book and Painting. Shakespeare, Milton
and the Bible: Literary Texts and the Emergence of
English Painting**, Knoxville, 1982; M. Pointon, **Milton in
English Art**, Manchester, 1970; W.M. Merchant, **Shakespeare
and the Artist**, Oxford, 1959, and Sybil Rosenfeld,
Georgian Scene Painters and Scene Painting, Cambridge,
1981, esp. Chaps. 4 and 11.) Most remarkable of all
though was the vogue for Ossian, the national bard of the
Celtic North, who turned out to have been the imposture
of a Scotsman named Macpherson (nos. 587, 596-98). And
in the nineteenth century, the novels of Sir Walter
Scott, which were so important in popularizing the study
of the national past, achieved a tremendous vogue among
painters and illustrators, not only in England but also
in France (nos. 589-92, 599-601).

Medieval architecture also provided an important
subject for painters. The cult of ruins, which we have
already mentioned in connection with the eighteenth
century landscape garden, produced a harvest of romantic
pictures from landscape painters like Loutherbourg,
Turner, and even Constable (nos. 494, 505, 539, 541-42,
567). Of even greater interest, however, are the works

of the topographers. From Francis Place in the early
eighteenth century (no. 573), through A.C. Pugin and
Cotman in the early nineteenth (nos. 354, 543-48), the
topographers of medieval churches and castles played an
important, though still largely unexplored, role in
antiquarian scholarship and in popular medievalism.
After the Napoleonic wars, a new crop of artists,
including Prout, Boys, Bonington, and Roberts, catered to
a widespread taste for the picturesque architecture and
streetscapes of foreign lands (nos. 524-27, 577-78).
(For an introduction to topographical art, J.R. Abbey's
massive catalogues are essential: **Scenery of Great
Britain and Ireland in Aquatint and Lithography, 1770-
1860**, London, 1952; and **Travel in Aquatint and
Lithography, 1770-1860**, 2 vols., London, 1956-57.
Serious researchers will also find no. 515 and M.W.
Barley's **A Guide to British Topographical Collections**,
Council for British Archaeology, 1974, invaluable. The
standard works on landscape painting and water-color are
also useful, though hardly sufficient: see e.g., Martin
Hardie, **Water-colour Painting in Britain** [edited by
Dudley Snelgrove with Jonathan Mayne and Basil Taylor],
London, 3 vols., 1966-68; Luke Herrmann, **British
Landscape Painting of the Eighteenth Century**, London,
1973; Michael Twyman, **Lithography 1800-1850**, London, 1970
[especially Part 3, "Topographical Lithography in England
and France"]). Much later in the nineteenth century, in
the work of Axel Haig (no. 558), and even later in that
of F.L. Griggs (no. 557), the depiction of medieval
architecture broke free of topographical or illustrative
constraints and became a quasi-independent branch of
print-making.

By the 1830s, knowledge of medieval architecture was
substantial and widely diffused, and its acceptance
secure. Its status was recognized in the competition for
the new Houses of Parliament, held in 1836, whose rules
stipulated a design in either the Gothic or Elizabethan
style. It is at this time that the true "revival" of
Gothic architecture begins. With the publication of
**Contrasts, or a Parallel between the Architecture of the
Fourteenth and Fifteenth Centuries and Similar Buildings
of the Present Day** in 1836, the fiery young A.W.N. Pugin
launched a campaign for the adoption and further
development of Gothic architecture which he would
continue to wage on aesthetic, theoretical, and religious

xxi

fronts until his untimely death in 1852. At the same
time, groups of young men at Oxford and Cambridge were
rediscovering the charms of religious enthusiasm and were
either drifting towards Roman Catholicism (a shift which
Pugin made about 1835) or pushing their own church, the
Anglican church, in the direction of a Romanized liturgy.
At Cambridge, through the foundation of the
Ecclesiological Society, this movement had a profound
impact on the study and revival of Gothic. The
Ecclesiological Society maintained not only that Gothic
was the only proper style for genuine Christian worship,
but that there was a rigid standard of correctness and
devotion by which revived Gothic architecture could be
judged--and to which they alone held the key. A great
many architects fell under the combined sway of Pugin and
the Ecclesiologists, particularly from the early 1840s:
Butterfield, Carpenter, Pearson, Street, Bodley, Scott,
Ferrey, Cundy, and others too numerous to mention. Of
course, what also needs to be said is that a great many
wealthy Victorians also fell under their influence,
helping through their patronage to create an astonishing
upswing in the building and rebuilding of churches. (For
Ecclesiology, the standard works remain nos. 201 and 266.
For Victorian church building in general, Basil F.L.
Clarke's **Church Builders of the Nineteenth Century**,
London, 1938, reprinted 1969, remains a valuable source.
See also the same author's **Anglican Cathedrals Outside
the British Isles**, London, 1958; and G.W.O. Addleshaw and
Frederick Etchells, **The Architectural Setting of Anglican
Worship**, London, 1948.)

The mention of church architecture calls to mind one of
the most complex and least understood issues in the
history of medievalism: the preservation and restoration
of medieval architecture. Until the late eighteenth
century, little value was placed in Gothic churches, and
repairs or restorations--which were generally carried out
either to stabilize or to modernize--did not necessarily
respect the original style. (The most detailed studies
of the treatment of churches during this period are those
of Clarke and Colvin, and Purvis, cited above on p. xi
and p. xvii; see also nos. 2, 66). The situation changed
rapidly in the late eighteenth century, and although
structural stabilization remained a major motive in most
restorations, admiration of the original became an
important factor too. Architects and clerics wanted to

improve upon original beauties, and so in the end, through radical removal of later elements, conjectural restitution of earlier ones, reworking of surfaces, and other procedures, they did as much damage as their less appreciative predecessors. Not that the theory of restoration condoned such damage: a generation or more before Morris's Society for the Protection of Ancient Buildings set forth its preservationist tenets, Ruskin and Scott had already been saying essentially the same things. It was simply that architects, confronted with the constraints and opportunities of practice, did not follow theory, and this remained as true in 1880 (or indeed in 1980) as it had been in 1780.

The first attempt at a history of restoration theory and practice was probably M.S. Briggs's **Goths and Vandals**, published in 1952. There have been a few subsequent studies (nos. 2, 7, 18, 20, 212-13, 223, 228) but no systematic attempt to balance the analysis of theory with close, empirical observation of practice. Recent studies of individual cathedral restorations, most particularly by James Wyatt and Sir George Gilbert Scott (nos. 100-102, 143, 163-67, 255, 365-68, 374), however, have gone far towards a more subtle understanding of the issue and have helped to lay the foundations for a more general treatment.

During the period following Pugin, the leading spokesman of the medievalist position was undoubtedly John Ruskin, and there is no question that Ruskin learned a great deal from Pugin--though precisely what and how much is still being debated (see nos. 432, 436-37, 454). Ruskin was no Catholic, nor yet a High-church Anglican, but he was, with the publication of the **Seven Lamps of Architecture** in 1849 and the **Stones of Venice** beginning in 1851, the leading spokesman for a Gothicism which resembled Pugin's in its combination of a rigorous structural rationalism with a richly developed symbolism and a sweeping program of social reform. Ruskin was also, quite simply, one of the greatest architectural writers of all time, and his urgently phrased insights cannot but have had a profound impact upon those who first heard and read him--though again, the nature and extent of that impact is still a subject of speculation (see nos. 432, 436, 454).

One who had much to learn from Ruskin was William Morris. An Oxford undergraduate, then an articled

assistant in the office of George Edmund Street, Morris
imbibed (and ultimately carried much further) Ruskin's
ethical concern with labor and with the economics of
modern society as well as Pugin's concern for beautiful
decoration. In 1861, he founded the firm of Morris,
Marshall, Faulkner and Co., which quickly became one of
the leading purveyors of high-style medievalist
furnishings. Morris himself was an inspired designer of
textiles, wallpaper, and books; by association with
designers like Webb, Rossetti, Ford Madox Brown, and
Burne-Jones, he also had a profound impact on the
development of medievalist stained glass, furniture, and
other crafts (for literature on the Pre-Raphaelites, see
the section on the visual arts below). Ultimately, his
designs--which departed increasingly from their
medievalist origins--and his social vision were to help
shape the Arts and Crafts movement.

The quarter century or so which began with the rise of
Pugin and the Ecclesiological Society was one of the high
points not merely of medievalism but of British
architecture. In an article published in 1957, Henry-
Russell Hitchcock called it "High Victorian Gothic"
(**Victorian Studies** 1: 47-71), and the label has stuck, as
more recent studies by Hersey and Muthesius show (nos.
234, 247). Quite apart from the work of Ruskin and
Morris, "High Victorian" architects like Butterfield,
Street, Pearson, and Bodley developed a medievalist
architecture marked equally by scholarly insight and by
formal power and originality. Theirs was a totally
"modern" architecture, dedicated to the present, and
indeed the future, despite its roots in the past. These
architects also helped, with Morris, to direct a
phenomenal development of architectural crafts such as
stone- and woodcarving, encaustic tiles, stained glass,
decorative painting, and ironwork, and of related
decorative arts such as furniture, wallpaper, and work in
precious metals. It is fitting therefore that this
period has received so much scholarly attention. We have
had monographic articles, and even a few books, on a
number of the major figures (and some minor ones too).
We have had a veritable flood of scholarship on Ruskin
and Morris. And we have had substantial studies on the
Ecclesiological Society, on church furnishings and other
decorative arts, and on "High Victorian Gothic". Not
that the subject is exhausted: we are still waiting for

full-scale monographs on Pugin, Street, and Bodley (to
name only the most obvious gaps), the Ecclesiological
Society is due for reappraisal, and there are as yet no
general studies of restoration and preservation or of the
architectural crafts. But the field has at least been
well plowed.

One aspect of this scholarly interest in the High
Victorian Gothic deserves separate notice, for it helps
to explain the entire phenomenon. Ever since the 1930s,
scholars had been busy creating historical pedigrees for
the theory of functionalism that seemed to underly much
of twentieth century architecture. Edward Robert de
Zurko's **Origins of Functionalist Theory** (New York, 1957),
traced the subject from the ancient Greeks and found that
Victorians like Pugin and Ruskin played an essential role
in its development. But Phoebe Stanton had already cast
Pugin in this light, as a seeker after design principles
and an enemy of mere revivalism, in an article of 1954
("Pugin: Principles of Design versus Revivalism," JSAH
13: 20-25), and so he and his High Victorian successors
are still often presented. Certainly the formal vigour
and toughness of these architects, combined with their
brash and forthright use of factory-made brick and their
inventive transformation of received forms, encouraged
this reading. But the field is now open for more
flexible and nuanced interpretations that might address
the Victorians' genuine and deep fascination with
history, as well as their anxieties over religion,
politics, and the expressive capabilities of architecture
itself. (Nos. 208, 234, 237 and 283 represent attempts
in this direction.)

If there is a serious deficiency in the scholarship on
this period, however, it lies outside of this "High
Victorian" ambit. We still know very little about
architecture and design outside the immediate circle of
Pugin, Ruskin, Morris, the Ecclesiological Society, and
the high Victorian Gothicists--who after all represented
a relatively restricted part of the Victorian building
world. To give two obvious examples: the secular
architecture of the period is still hardly known (though
see nos. 218, 222, 231, 247, 278, 297, 407); while low-
church, Evangelical, dissenting, and even Catholic
architecture (beyond Pugin and his immediate followers)
remains almost entirely unknown (see, however, Andrew
Landale Drummond, **The Church Architecture of**

Protestantism, Edinburgh, 1934, and no. 17). Until light
is shed on these murky domains, our picture of the period
will remain seriously flawed.

There are gaps too in our knowledge of the pictorial
arts of this period, which was an extremely important one
for the development of medievalism. The artists who had
depicted medieval architecture or literary subjects at
the beginning of the century had had no wish to make
their pictures look medieval; by the middle of the
century, they were emulating both the aesthetics and the
techniques of medieval art. As early as 1800, indeed,
certain artists began to appreciate the purely artistic
merits of medieval art. Flaxman and Blake, in their
search for a highly stylized, abstracted linearism,
looked to both Greek and Gothic art (nos. 508, 518, 520,
553). Nor was this equation between two inspired yet
academically imperfect styles idiosyncratic: as late as
the middle of the nineteenth century, analogies were
drawn between early Gothic and early or pre-classic art.

By this time, aesthetic had been supplemented by
technical admiration, at least in the case of fresco
painting. Here, architecture played a key role, for the
great task of decorating Barry and Pugin's new Houses of
Parliament provided a spur to the revival of fresco
painting (see, in addition to nos. 344, 418, 554, 568-69,
T.S.R. Boase, "The Decoration of the new Palace of
Westminster," **Warb** 17 (1954): 319-58; the technique of
tempera painting was revived later: see no. 588). But by
this time, a taste for Italian fourteenth and fifteenth
century painting was becoming widely diffused. George
Darley and Anna Jameson had been writing about it (nos.
444, 549, 564); the Arundel Society, assisted by Ruskin,
was popularizing it (no. 487); Thomas Gambier-Parry, a
leading proponent of the fresco revival, was beginning to
collect it (nos. 418, 554-55). (For the revival of
interest in early Italian Renaissance painting, see also
nos. 431, 443, 488, 493, 503, 508, 512, 552-53, 566,
574). Nor was this the only branch of medieval art to be
avidly collected. Ruskin and Morris were avid collectors
of miniatures, as were architects like Street and Burges
(nos. 439, 504, 507). Ivories and enamels also came to
be highly prized (no. 482). In fact, widespread
appreciation of medieval art began in the mid-nineteenth
century and has really never abated.

Introduction

There is hardly a topic in the history of medievalism in the visual arts which does not deserve further research. But there is one subject which has received an immense amount of study, and that is Pre-Raphaelitism. The Pre-Raphaelite Brotherhood, formed in 1848 by the young painters William Holman Hunt, John Everett Millais, and Dante Gabriel Rossetti, was an alliance based on a synthesis of naturalism and medievalism (the latter filtered through the Nazarenes). Other artists were more loosely affiliated. The medievalism of the Pre-Raphaelites was more wholehearted and complex than that of any earlier artists, encompassing style, technique, subject matter and, if not religion, a certain ethos. They were dedicated to the cause of the crafts and worked closely with Morris on the production of furniture and stained glass (nos. 277, 476, 480, 514); Rossetti designed his own picture frames (no. 582); Burne-Jones designed stained glass for Ruskin and mosaics for George Edmund Street (nos. 393, 536-37). The links between High Victorian Gothic architecture and Pre-Raphaelitism were indeed strong. But like Ruskin and Morris, the Pre-Raphaelites really stretch the boundaries of medievalism, as their bibliography stretches the bounds of this work. It is only fair to remind the reader that what is included here is but a sampling of scholarship on the subject.

For the Gothicist of the 1850s and 60s, whether architect, painter, or polemicist, it was possible to believe that the Revival was really working. The battle for Gothic churches had been won; that for Gothic secular buildings was being bravely fought. Originality, significance, and power seemed readily achievable. But soon, doubt began to overtake optimism. In architecture, a younger generation was turning away from Gothic orthodoxy to a freer form of eclecticism, often known as the Queen Anne style, or to various forms of aestheticism. As early as the 1860s, Morris and his associates had been turning to non-Gothic precedents for inspiration, and the detachment of medievalist ideology from Gothic form became more and more pronounced towards the end of the century.

The clearest example of this lies, of course, in the Arts and Crafts movement which began to blossom in the second half of the 1880s with the formation of numerous guilds and societies for the production and exhibition of

decorative arts. Leading Arts and Crafts designers and organizers like Mackmurdo, Ashbee, and Gimson owed an enormous debt to William Morris, both to his social campaign and to his design work (behind both of which, as we have seen, stood the figures of Ruskin and Pugin). Many leading practitioners, moreover, began their careers either as hard-line Gothicists or as pupils of hard-line Gothicists. In the proliferation of guilds, the Arts and Crafts movement was indeed more daringly medieval than its predecessors, who relied on more standard methods of production for their medievalist designs. Yet the furniture of Mackmurdo, Gimson, or the Barnsleys, the architecture of Ashbee, Voysey, Lethaby, or Prior does not look nearly so Gothic as the work of the preceding generation. The inspiration is still there, but so transformed that in many of its most characteristic productions, the Arts and Crafts almost ceased to belong to the phenomenon of medievalism.

One reason why the Arts and Crafts appears in this light is quite simply because, by the end of the nineteenth century, a less theoretically articulate but more archaeologically correct approach had emerged in contrast to the formally free yet ideologically stringent work of the Arts and Crafts. And this strand of Gothicism--again in contrast to the Arts and Crafts, which have been extensively studied--has hardly even begun to be explored. We need substantial studies of Bentley, Bodley, Caröe, Comper, Sir Giles Gilbert Scott; of the competitions for the Anglican cathedrals of Manchester and Liverpool, and for the Catholic cathedral of Westminster; of the vast brick Gothic churches which went up all over the developing outskirts of late nineteenth century London (and presumably of other cities); and of the Tudor architecture of the suburbs (see nos. 261, 320, 322, 379, 402, and 661). Until we have these, the contours of this last great outpouring of Gothic architecture, as well as its relationship to the larger history of medievalism, will remain somewhat conjectural.

Just as the rise of medievalism had begun before the last traces of the middle ages had faded away, so the study of medievalism began before this last outburst was quite exhausted. The first great monument of medievalist historiography appeared indeed at the very peak of the Gothic revival. This was Charles Locke Eastlake's

A History of the Gothic Revival, published in London in
1872. Here, Eastlake attempted for the first time to
present the entire sweep of medievalism in English
architecture, leading from the antiquarians of the
sixteenth century to the architects of his own day,
Butterfield, Street, and others. But there was little
interest in following up his investigations, so that the
next great historiographical contribution, Kenneth
Clark's **The Gothic Revival,** was not made until 1928, when
medievalism really was in decline, and scholars were
feeling increasingly detached from their subject.

Clark's treatment of the Gothic Revival differed
significantly from Eastlake's in two ways. First, it
gave much greater recognition to the literary component
of the subject, especially to the poets of the eighteenth
century. (For this, see also R. Haferkorn, **Gotik und
Ruine in der englischen Dichtung des achtzehnten
Jahrhunderts,** Leipzig, 1924; and for more recent
treatments of early literary gothicism from a political
perspective, J. Colton, "Kent's Hermitage for Queen
Caroline at Richmond," **Architectura** 2/1974: 181-91; S.
Kliger, **The Goths in England,** Cambridge [Mass.], 1952,
and no. 106.) Secondly, it no longer led triumphantly to
the present--Clark's or Eastlake's. Instead, an
ambivalence about the value of the achievements which he
chronicled could be perceived throughout the book. In
this, Clark set the tone for the next decade, indeed for
the next three decades.

Even before Clark, that genial yet incisive critic,
H.S. Goodhart-Rendel, had already begun to turn his
attention to Victorian Gothic (vide his "English Gothic
Architecture of the Nineteenth Century," **R.I.B.A. Journal**
31 [1924]: 321-30. Goodhart-Rendel's most influential
later works are "Rogue Architects of the Victorian Era,"
R.I.B.A. Journal 56 [1949]: 251-59, and **English
Architecture Since the Regency. An Interpretation,**
London, 1953). During the 1930s, he and John Betjeman
would help to create a taste for Victorian Gothicism.
The 1930s also saw the foundations of the scholarly study
of the subject. Trappes-Lomax's important biography of
Pugin was written in 1932 and W.S. Lewis's seminal
article on Strawberry Hill in 1934. Paul Yvon's more
general study, **Le gothique et la renaissance gothique en
Angleterre (1750-1880)** was published in 1931, Ronald
Bradbury's **The Romantic Theories of Architecture of the**

Nineteenth Century in 1934, Agnes Addison Gilchrist's
Romanticism and the Gothic Revival in 1938, Basil F.L.
Clarke's **Church Builders of the Nineteenth Century** in the
same year. By the end of the 1930s, in short, a good
deal of specialized research had been done, theories and
evaluations had been advanced, and an interpretive
structure was beginning to emerge. This last was
forwarded with particular efficacy by a book which
appeared in 1936 and has been in print almost
continuously since then: Nikolaus Pevsner's **Pioneers of
the Modern Movement.** In this small book, Pevsner traced
the roots of international modernism back through Morris
and the Arts and Crafts to the Victorian Gothicists: the
thesis has been enormously influential and has subtly
influenced almost all evaluations of medievalist
architecture until very recent years.

During the 1940s, the stream of historical research
broadened, especially in England. In 1945, the
Architectural Review published an entire issue devoted to
the Gothic Revival, including articles on Strawberry
Hill, Goethe, Rickman, Butterfield, Cardinal Newman, and
Pusey. Of these articles, Sir John Summerson's on
Butterfield, provocatively titled "William Butterfield,
or the Glory of Ugliness," stands out for both insight
and durability: it was still provoking scholarly
rejoinders in the 1970s, and is still in print, and much
read, in the 1980s. Howard Colvin's pathbreaking article
on "Gothic Survival and Gothic Revival" appeared in 1949,
and in 1950, Nikolaus Pevsner's article on "Good King
James's Gothic." In the same year, Pevsner finished
directing a most important dissertation—Phoebe Stanton's
on Pugin, which led to an article, "Pugin: Principles of
Design versus Revivalism," in 1954, and to a small book
in 1972. But in the meantime, the first biography of a
mid-Victorian Goth not written by a disciple or
descendant had been published: this was Dudley Harbron's
The Conscious Stone. The Life of Edward William Godwin,
published in 1949 and reprinted in 1971.

The decade of the 1950s was one of consolidation, of
large projects and big pictures. In 1951, the first
volume of Pevsner's **The Buildings of England** was
published: this monumental series of architectural
guidebooks is still being expanded and revised and is
still invaluable to scholars. In 1953, Sir John
Summerson's contribution to the Pelican History of Art

series, **Architecture in Britain 1530 to 1830,** appeared
with several chapters sensitively placing medievalist
trends within the overall framework of the period. The
next year saw Henry-Russell Hitchcock's massive **Early
Victorian Architecture,** with important chapters on Pugin
and church architecture; and in 1958 appeared his own
contribution to the Pelican History of Art, **Architecture:
Nineteenth and Twentieth Centuries.** Finally, the decade
closed, in 1960, with Paul Frankl's magisterial tome, **The
Gothic,** a survey of the entire historical sweep of
attitudes to Gothic architecture.

With 1960, the historiography of medievalism enters the
realm chronicled by our bibliography, and it is perhaps
not necessary to say much more about the next twenty-five
years, except to remark that the volume of work dedicated
to the subject has climbed rapidly, that (at least in
architecture and the decorative arts) the discourse has
been determinedly professionalized, and that the
consensus of taste has shifted gradually, but in the end
drastically, from the ambivalence manifested by Kenneth
Clark in 1928. Authors as late as the 1950s had to mask
serious appreciation of their subject beneath a pose of
witty nonchalance. A few critics still maintain this
posture (though with wit and wisdom decreasing in equal
measure), but it is no longer necessary: for better or
for worse, medievalism has achieved academic
respectability.

B. Medievalism in North America

Medievalism in the "colonies"--that is, in Canada and
the United States--has had little continuity and even
less coherence than that in Britain. The land is too big
and the people too diverse to allow for any synchronized
development. While one can isolate two "waves" of
medievalism, one in the mid-nineteenth century (1840-70)
and one at the century's turn, different regions
experienced the inundations at various times, blurring
any distinct chronology. (Regional influences also
modified forms. See, for example, Margaret Carter, **Early
Canadian Courthouses** [Quebec: National Historic Sites and
Parks Branch, Environment Canada, 1983].) We will
consider medieval revivals in Canada and the United

States without chronological punctuation. Still, despite
the discontinuity, one can recognize British influences
as paramount until 1870. Following the Civil War,
theorists and artifacts from other European nations began
to affect the currents of North American medievalism.

In reviving medieval forms, North Americans had no
originals to study except the seventeenth century frame
houses built using essentially medieval techniques.
These techniques included half-timbering (Fachwerk or
colombage pierroté) and pièce-sur-pièce (nos. 648, 695,
704, 718, 720-21, 723, 728, 731, and 736).

Often these techniques that survived from at least the
Middle Ages in Europe were imitated in later centuries
due to the associations they imparted. Medievalism here
was practically all romance and the imagination. It had
little of the moral force that attended the Gothic
Revival in Britain. For that reason, Romanticism is a
better word to describe the motivations of artists on
this continent, but that term leads us into a
terminological morass. Some, like Walter Kidney (no.
647), would rather label Romanticism Eclecticism; others
prefer Historicism. Whatever the label, Romantics did
look to the past for renewal, recreation and relief, and
that past included the Middle Ages. Medievalism, viewed
as a category within Romanticism, usefully narrows the
stylistic considerations.

Some North American artists were frustrated by the
provincial nature of the arts here; a few even removed
themselves to Europe permanently (Benjamin West, for
example). Others adapted elaborate medieval forms to
simple materials (Andrew Jackson Downing, Richard Upjohn)
or developed regional variations on a medieval theme
(Edward Medley). A third group of artists, at the end of
the nineteenth century and the beginning of our own
century, teamed up with imported artisans or compatriots
trained abroad to create masterpieces in medieval revival
styles (H.H. Richardson, Ralph Adams Cram). Useful
general references on architects and artists in the
United States include: George C. Groce, and David H.
Wallace, **The New-York Historical Society's Dictionary of
Artists in America, 1564-1860** (New Haven: Yale Univ.
Press, 1957) and Henry F. and Elsie Rathburn Withey,
Biographical Dictionary of American Artists (Deceased)
(Los Angeles: New Age Publishing, 1956).

The first American to revive medieval forms consciously was the painter Benjamin West. (Another American painter, J.S. Copley, pioneered with a Spenserian theme in his "The Red Cross Knight" of 1793, but this was an isolated instance in his career.) West had emigrated from Pennsylvania to London in the 1760s and transformed history painting by illustrating events from many different centuries rather than limiting himself to antique subjects. As an expatriate, West mined the medieval past of his adopted country. The eight paintings that West did for Windsor Castle in the 1780s of the life of the fourteenth century King Edward III confirmed the painter's international reputation.

Not surprisingly, an English expatriate, the architect Benjamin Latrobe, imported the Gothic Revival to America for the first time. Trained in England and Germany, Latrobe proposed Gothic features on several of his buildings and projects: a private house in Philadelphia, Sedgley (William Crammond House, 1799); the Baltimore Cathedral (1804); and the Bank of Philadelphia (1805). (On Latrobe, see Talbot Hamlin, **Benjamin Henry Latrobe** [New York: Oxford, 1955].) The earliest known criticism on Gothic Revival buildings in America appeared in 1811 and concerned the works of two of Latrobe's students, William Strickland and Robert Mills. Strickland's crenellated Masonic Hall in Philadelphia was the subject of "On Gothic Architecture," in **The Free Mason's Magazine and General Miscellany** (2, no. 1 [October 1811]: 63-64). A house on which Mills supposedly worked was the focus of "Dorsey's Gothic Mansion," in **Port Folio** (5, no. 2 [February 1811]: 125-26). (See no. 644, pp. 146-47). Latrobe lamented ever introducing the Gothic mode to an America that he felt was incapable of understanding it. To his regret, the revival of Gothic forms which he had fostered continued to be independent of careful translations. Romance held sway and during the years that Latrobe himself experimented with the Gothic Revival, Charles Brockden Brown published America's first "Gothic" novels. (On Brown, see no. 644, pp. 148-49.)

Latrobe's Gothicism was not widely copied, even by his students whom he felt so misunderstood it. Medieval revival works by other architects were few: Maximilian Godefroy built St. Mary's Chapel in Baltimore in 1803; Charles Bulfinch designed a Congregationalist church in Boston in 1809. Both of these Gothic Revival churches

remained the exception rather than the rule for several
decades. The engineer, James Renwick, Sr., proposed a
prescient Gothic design for Columbia College, New York,
in 1813. (See Adolf Placzek, "Design for Columbia
College," **JSAH** 11 [May 1952]: 22-23.) During this same
decade, the Roman Catholic Bishop of Quebec, J.-O.
Plessis, was enthusiastic about the emergent Gothic
Revival to the south, at New York City's Old St.
Patrick's Cathedral (Joseph Mangin, 1809-15.) Bishop
Plessis's journals make his appreciation of the Gothic
evident and he was, apparently, a key figure in fostering
acceptance of the Gothic in Canada. See J. Philip
McAleer, "St. Mary's [1820-1830], Halifax: An Early
Example of the Use of Gothic Revival Forms in Canada,"
JSAH 45 [June 1986]: 134-47.)

Generally, medievalism flourished in the literary
rather than the building arts. Washington Irving and
James Fenimore Cooper are perhaps the best known authors
who employed medieval themes, to different effects, in
their writings. Painters, often in the circle of
Benjamin West, periodically chose a medieval subject from
literature. Washington Allston depicted "The Flight of
Florimell" (from Spenser's **The Faerie Queene**) in 1819,
for example.

Those interested in the building arts saw Gothic forms
as "agreeable in some instances," in the words of Dr.
Jacob Bigelow, a physician, botanist and arts enthusiast.
His **Elements of Technology, Taken Chiefly from a Course
of Lectures Delivered at Cambridge, on the Application of
the Sciences to the Useful Arts** was published in 1828 in
Boston and, while not entirely devoted to medieval
architecture, Bigelow's essay drew heavily on writings by
A.W.N. Pugin and John Britton to tentatively praise
Gothic works. In the 1820s, a few churchmen began to
view Gothic forms in architecture as a way of instilling
faith in their flocks. In 1823, John Henry Hopkins,
again an English immigrant, built a Gothic Revival church
in Pittsburgh. By 1836, then an Episcopal bishop of
Vermont, Hopkins published the seminal **Essay on Gothic
Architecture** in which he proselytized for the Gothic as a
way to inspire reverence.

Eighteen thirty-nine was a turning point for the Gothic
Revival in the United States for in that year Minard
Lafever designed the Dutch Reformed Church on Washington
Square, New York, and Richard Upjohn redesigned Trinity

Church on Wall Street. Even Upjohn was not a purist in restricting himself to church design: he published his **Rural Architecture** in 1852 which made explicit ways to adapt medieval forms to wooden, and even secular, structures. (See the DaCapo Press reprint of 1975.)

The 1830s then saw several important architects add Gothic to their repertory of styles. Minard Lafever built not only the Dutch Reformed Church (1839-40, mentioned above) in a Gothic mode for its minister, James Mathews, but also four other major churches in Manhattan and Brooklyn in the 1840s. Also in the 1830s, Mathews commissioned Ithiel Town and Alexander Jackson Davis to design New York University (1833-36). Davis and his associate, Andrew Jackson Downing, would soon lead the way in the revival of the Gothic cottage.

The New York Ecclesiological Society was organized in 1848 and for the next five years published **The New York Ecclesiologist**, which insisted upon the English Decorated style as the model for any truly Christian church. By contrast, in 1849, **The Christian Examiner** published a commentary on "The Artistic and Romantic View of the Middle Ages," (46 [May 1849]: 345-83) stressing the aesthetic (rather than moral) appeal of medieval forms for religious architecture. This, of course, was a departure from the belief that one employed fourteenth-century Gothic models for church designs because they most accurately reflected Christian truths. Actually, the moralist of the Gothic Revival found an unexpected and perhaps more democratic ally in the house builder. While the High Church in England promoted the Gothic Revival there and among Anglicans in Canada and the United States, professional architects and builders in America produced a quantity of books in the 1850s that fused Gothic decoration with the tranquility of nature and family harmony.

Preeminent among the architects who published pattern books was Andrew Jackson Downing, a noted landscape architect. **The Architecture of Country Houses** appeared in 1850. (See reprints by DaCapo Press in 1968 and Dover in 1969.) After Downing's death in 1852, his younger associate, A.J. Davis, continued to lead the field, not only in pattern books, but in the design and construction of Gothic Revival mansions. The genre of carpenters' guides and plans for amateurs flourished for the remainder of the century. Examples include Samuel

Sloan's **The Model Architect** (1852, DaCapo reprint, 1975)
and Oliver P. Smith's **The Domestic Architect** (1854,
American Life Foundation reprint, 1978.) The latter
resulted in a number of similar houses in western New
York State and Ontario. George Woodward's **Country Homes**
(1865) was a later version of the by-then ubiquitous
pattern book. (See the American Life Foundation reprint
of 1977.)

In about 1852, Ralph Waldo Emerson published praise for
the 1819 analysis of Gothic architecture by Georg Moller
and thereby introduced that German's ideas to the United
States. Moller's "An Essay on the Origin and Progress of
Gothic Architecture Traced in and Deduced from the
Ancient Edifices of Germany, with References to Those of
England, etc." was translated and published in England in
1824 and reprinted in 1836. Emerson applauded Moller's
notion that a building suited to its function would be
beautiful, whether beauty had been sought or not. (See
Don Gifford, ed., **The Literature of Architecture** [New
York: Dutton, 1966].) In a similar appreciation of
functional form, the architect and critic Leopold Eidlitz
(1823-1908) abstracted some of the ideas of his older
Gothic Revival contemporaries in his series of articles
"The Nature and Function of Art, More Especially of
Architecture," published in **The Crayon** between 1858 and
1861 (and then in book form in 1881; see the 1977 reprint
by New York's DaCapo Press.) Eidlitz's medievalism arose
from his admiration of the Gothic unity of architecture
and engineering. His theory of organic functionalism
differed from Ruskinian theory by advocating nature's
inspiration for the entire edifice. (**The Crayon,**
established in 1855, frequently featured writing on
medievalism in art.)

Just as the Gothic and nature had served to inspire
Ruskin and A.J. Downing, each quite differently, so did a
group of American architects and painters take note of
Ruskin, the English Pre-Raphaelites, and America's own
abundant wildness when they founded the Society for the
Advancement of the Cause of Truth in Art in 1863. The
resulting publication, **The New Path,** flourished only
briefly but praised the polychromed architectural designs
of Victorian Gothicists like Jacob Wrey Mould and P.B.
Wight. (See David H. Dickason, **The Daring Young Men: The
Story of the American Pre-Raphaelites** [Bloomington:
Indiana Univ. Press, 1953] and nos. 631, 640). The 1860s

saw not only the organization of the "American Pre-Raphaelites," as the Society for the Advancement of the Cause of Truth in Art was known, but also the beginning of James Jackson Jarves's collection of Italian primitives (paintings before Raphael's time) that was acquired (albeit reluctantly) by Yale University in 1871. Jackson published **The Art Idea** in 1864 where he noted the significance of the Duecento painters whose works he was collecting. (See James Jackson Jarves, **The Art Idea,** edited by Benjamin Rowland, Jr. [Cambridge: Belknap Press, 1960]).

We have discussed the fundamental importance of Charles Eastlake's book on the Gothic Revival; his **Household Hints** of 1868 also received recognition in this country when it was issued here in 1872 and subsequently had seven printings. Harriet Spofford further disseminated her version of Eastlake's ideas in **Art Decoration Applied to Furniture** of 1878. (See nos. 819 and 839). Eastlake-inspired furniture traced its ancestry to functional medieval wooden tables and benches; its production, however, used up-to-date technology of machine-milled lumber.

By the 1870s, French influences were making themselves felt in the United States, particularly through the writings of the architect, E.-E. Viollet-le-Duc. (See no. 940). Henry Van Brunt translated Viollet-le-Duc's **Discourses** in two volumes (1875 and 1881) and the subsequent English editions gave Viollet-le-Duc's theories on the preeminence of Gothic construction a wide professional audience. For example, George William Sheldon edited **Artistic Country Seats: Types of Recent American Villa and Cottage Architecture, with Instances of Country Club Houses** from 1879 to 1885 and liberally quoted from Viollet-le-Duc and John Ruskin in the text that accompanied the nearly one hundred house plans and views. (Sheldon's book was reprinted in 1979 by DaCapo Press.)

The 1870s marked a transition in American medievalism from a dependence on British ideas and practitioners toward a synthesis of various inspirations in designs and attitudes quite often separate from the source in Britain, France, Spain or Italy. We might term this broad-ranging medievalism a second wave, following closely upon the first. It is the medievalism of Charles Eliot Norton who wrote **Historical Studies of Church**

Building in the Middles Ages (1880); of Charles Herbert Moore, author of **The Development and Character of Gothic Architecture** (1890, second edition, 1899); and of Henry Adams, whose **Mont-Saint-Michel and Chartres** (1904) was a landmark of early twentieth century medievalism. Norton, professor of Fine Arts at Harvard, promoted the study of Dante and of medieval art and celebrated, in writing, the communal culture of late Gothic Italy. Moore, curator of the Fogg Museum, was a careful observer of architecture as well as a close reader of Viollet-le-Duc. His 1890 book admitted only the architecture of France as Gothic, and maintained that English "Gothic" was really no more than Anglo-Norman. Moore's 1912 opus, **The Medieval Church Architecture of England,** contended that Gothic was defined only by constructional innovations seen in medieval France. Moore's focus on technique was quite a contrast to Henry Adams's praise for the French Gothic. (See no. 849).

Henry Adams's very personal commentary on the medieval structures in France created a mystique about the Middle Ages that persists to this day. His reverence for the twelfth-century cathedral at Chartres and the unity and energy it represented for him gave the medieval era a utopian essence. Adams's medievalism and that of another historian, Herbert Baxter Adams, helped lay the foundation for medieval studies in America, one result being the creation of the Medieval Academy in America in 1925. (See S. Harrison Thompson, "The Growth of a Discipline: Medieval Studies in America," in **Perspectives in Medieval History,** edited by K.D. Drew and F.S. Lear [Chicago: Univ. of Chicago Press, 1963].) Adams also was closely associated with the painter, John LaFarge, and the architect, Henry Hobson Richardson. (See no. 738). Both of these artists contributed significantly to a revival of medieval forms in art.

Although **Mont-Saint-Michel and Chartres** appeared in 1904, Henry Adams "sat at the feet" (his words) of John LaFarge from 1872, when he was introduced to the painter by his new brother-in-law. Henry Hobson Richardson also was in this circle of friends, getting acquainted with Adams during the years he designed Boston's Trinity Church. Their friendship deepened in the next decade, and Richardson's house for the Adamses was completed by the architect's death in 1886 (see no. 880). By 1888, Mariana Van Rensselaer had written Richardson's first

biography. (See reprint, **Henry Hobson Richardson and His World**, Park Forest, Ill.: Prairie School Press, 1967.) Montgomery Schuyler wrote on the neo-Romanesque and noted Richardson's influence in two articles from 1891 in **The Architectural Record**: "The Romanesque Revival in New York," 1 (July–September 1891): 7–38; and "The Romanesque Revival in America," 1 (October–December 1891): 151–98.

Other architects who favored medieval revival styles were also the subject of monographs in the late nineteenth century. Montgomery Schuyler concentrated on Charles Haight's High Victorian Gothic work as early as 1895. (Reprinted in 1977, the original was part of the Architectural Record Company's series on Great American Architects, published between 1895 and 1899.) Schuyler's article on "Italian Gothic in New York," appeared in **The Architectural Record** 26 (July 1909): 46–54. Russell Sturgis devoted an article to the work of Peabody and Stearns in 1896, examining not only their Romanesque Revival buildings, but a Gothic Revival church and a castellated mansion, too. (See the 1971 DaCapo Press reprint of Sturgis's **A Critique of the Work of Peabody and Stearns**.)

In addition to Van Rensselaer's early biography of Richardson, John Root was remembered by his sister-in-law, Harriet Monroe, after his premature death in 1891. **John Wellborn Root: A Study of His Life and Work** appeared in 1896. Although Richardson and Root were both eclectic architects, Richardson did much to popularize Romanesque forms in domestic and monumental buildings.

Of all the medieval revival styles in North America, the Romanesque Revival was the most prevalent. While Richardson was not the first to use Romanesque forms (Wheaton Holden, no. 859, contends that the Boston firm of Peabody and Stearns influenced Richardson in the use of the Romanesque), the Romanesque Revival was associated with his career. This gave the style a coherence that the Gothic Revival never had. Further, as Walter Kidney (no. 647) has demonstrated, Romanesque was cheaper to build than Gothic. Lewis Mumford, that perennial challenger of the status quo, considered the medieval tradition in his classic **Sticks and Stones: A Study of American Architecture and Civilization** (1924) and, in a subsequent chapter, he sensitively, while critically, contrasted industry and romanticism, using Richardson's buildings as a focus.

Nineteenth century buildings and furniture often are
distinguished by fine detailing and quality craftwork,
whatever the stylistic sources may have been.
Particularly influential in North America in the late
nineteenth century was the example of William Morris in
England. The periodical, **The Craftsman**, was inspired by
Morris and was published between 1901 and 1916. Articles
related to the twentieth century use of medieval forms
included Frederick Stymetz Lamb's "Modern Use of the
Gothic: The Possibilities of New Architectural Style,"
The Craftsman 8 (May 1905): 150-70. Elbert Hubbard,
dubbed the "American William Morris," founded workshops
to create sturdy, hand-crafted furniture and artistic
books. Both Morris's activities and Hubbard's Roycroft
industries were modeled after medieval guilds. (See nos.
825-27, and 954.)

H.H. Richardson's near contemporary and fellow
Bostonian, Ralph Adams Cram, ushered in the new century
with a firm commitment to the Gothic and its potential to
rehabilitate all of society. Unlike his non-publishing
colleagues, Root and Richardson, Cram spoke for himself
eloquently and his many books allow one to receive his
own account. In the same decades that Cram was carefully
studying medieval architecture and culture (with his
peculiar, personal bias), a number of ground-breaking
studies appeared that gave greater depth to twentieth-
century understanding of the Gothic. For example, Arthur
Kingsley Porter's two-volume **Medieval Architecture: Its
Origin and Development** came out of Yale in 1908 (and has
been reprinted by Hacker Art Books [New York, 1966].)
Porter's analysis of materials and building methods
helped establish the relative chronology of previously
undatable medieval monuments. As a teacher, Porter
affected a generation of students, including the sculptor
Joseph Coletti (see no. 963.)

Ralph Adams Cram advocated a return to rural, agrarian
life in which Christian values reigned. The architect
believed neo-Gothic architecture could minister to
twentieth century Americans and, for nearly fifty years,
Cram persuasively carried out his schemes in
ecclesiastical and collegiate commissions and in writing.
Many of Cram's books and essays have been reprinted:
Architecture in Its Relation to Civilization ([1918]
Boston: Marshall Jones, 1978); **The Ministry of Art**
([1914] Freeport, New York: Books for Libraries, 1967);

and **My Life in Architecture** ([1936] Boston: Little Brown, 1969).

Despite Cram's efforts at creating a new Middle Ages, Gothic forms carried many meanings and the Gothic Revival did not have the predictability of the Romanesque Revival. (See nos. 641-42, 644, 676 and 753 for discussions of the shifts in taste and attitudes regarding the Gothic.) Even Cram's close associate, Bertram Grosvenor Goodhue, freely adapted Gothic motifs to suit various building programs. (See Charles Harris Whitaker, **Bertram Grosvenor Goodhue: Architect and Master of Many Arts** [New York, 1925] which was reprinted by DaCapo Press in 1976.) Others, like William Comstock, needed only a picturesque outline with a steep roof to label a building Gothic (no. 742). Clifford Clark (no. 625) explored Gothic Revival moralism in domestic architecture. Alan Gowans in **Building Canada: An Architectural History of Canadian Life** (Toronto: Oxford Univ. Press, 1966) argued that High Victorian Gothic nearly became Canada's national style. Gowans, as well as R.H. Hubbard (no. 604), contrasted the use of Gothic forms by Anglicans and Catholics in Canada. Authors Wayne Andrews (no. 621) and James Early (no. 630) took a different approach and contended that the structural honesty of the Gothic helped foster the functionalism of Louis Sullivan and then post-World War II steel-framed buildings.

During the same three decades that Ralph Adams Cram was pressing for a Gothic overhaul of American society, some of his colleagues were vigorously rejecting medievalism. Mention should be made of Joseph Hudnut's attack on collegiate Gothic architecture in his essay "The Gothic Universitie," which appeared in **The Columbia University Quarterly** of March 1934. (An essay in the same publication by Ralph Adams Cram had appeared in the March 1931 number.) Hudnut prayerfully pleaded at the end of his article: "Give us the courage to be men of our own time; ... and preserve us, dear God, from the Gothick Universitie" (p. 10). Given the hostility toward historicism in architecture during the 1930s and 1940s it is remarkable that any studies appeared of medieval revival styles. Yet, the decade of the 1930s is distinguished by the publication of Edna Donnell's "A.J. Davis and the Gothic Revival," **Metropolitan Museum Studies** 5 (September 1936): 183-233, and Agnes Addison

[Gilchrist's] **Romanticism and the Gothic Revival** (mentioned above) and **Richard Upjohn, Architect and Churchman**, a biography by Upjohn's great-grandson, Everard M. Upjohn (New York, 1939; reprinted by DaCapo Press, 1968). Theodore Sizer published "James Jackson Jarves: A Forgotten New Englander," in the **New England Quarterly** of June 1933 (v. 6, pp. 328-54), and revived interest in that pioneering collector.

The 'forties showed an upswing in interest in medievalism, starting with Oscar Cargill's "The Medievalism of Henry Adams" (in **Essays and Studies in Honor of Carleton Brown**, pp. 296-329 [New York: New York Univ. Press, 1940]). Agnes Addison [Gilchrist] published "Early American Gothic" in George H. Boas's edited volume, **Romanticism in America** (pp. 118-36, Baltimore: Johns Hopkins Univ. Press, 1940) and W.S. Rusk's essay, "The Influence of Norman Architecture in French Canada," appeared in **Bulletin de l'Institut français de Washington** No. 13 (December 1940): 11-21. Three other general publications reveal interest continuing through the decade: Wayne Andrews, "America's Gothic Hour," **Town and Country** 101, No. 4302 (November 1947): 144ff.; Theodore Bolton, "Gothic Revival Architecture in America: The History of a Style," **American Collector** 17, no. 3, 4, 6 (April-June 1948): 6-9; 15-18; 16-19; and Henry Chandlee Forman's **Architecture of the Old South: The Medieval Style**. 1585-1850 (1948, reprinted New York: Russell and Russell, 1967.) Roger Hale Newton's **Town and Davis, Architects: Pioneers in American Revivalist Architecture, 1812-1870** (New York: Columbia Univ. Press) came out in 1942. Darrell Garwood published a biography of Grant Wood in 1944: **Artist in Iowa: A Life of Grant Wood** (New York: W.W. Norton). Garwood noted that both Wood and his teacher, Ernest Batchelder, were admirers of Gothic architecture. (**Artist in Iowa** was reprinted in 1971 by Greenwood Press.) James Marston Fitch's survey of American architecture, **American Building: The Historical Forces that Shaped It**, first appeared in 1947, and discussed early settlers' building techniques as well as later medieval revival styles. (Fitch's book is now available in a second revised edition [1973] from Schocken Books.)

Scholars and artists in the 1950s began to turn away from the trends of the previous two decades and ask new questions of themselves. Hugh Morrison's **Early American**

Architecture: From the First Colonial Settlements to the National Period (New York: Oxford Univ. Press, 1952) is an excellent source of information on the survival of medieval construction techniques in American building. Narrower topics received attention too. Alan Gowans's monographic study of a major Canadian Gothic Revival cathedral was published in 1952: "Notre Dame de Montreal," JSAH 11 (March 1952): 20-26. Antoinette F. Downing and Vincent Scully co-authored **The Architectural Heritage of Newport, 1640–1915** (Cambridge: Harvard Univ. Press, 1952). The nineteenth century resort architecture of this seaport includes medieval revival buildings by Richard Upjohn, A.J. Davis, and Richard Morris Hunt. (Downing and Scully's book was reprinted by C.N. Potter in 1967.) Carroll L.V. Meeks wrote "The Romanesque Before Richardson in the United States," for **AB** 35 (March 1953): 17-33. R.H. Hubbard's article, "Canadian Gothic," in **The Architectural Review** of August 1954 (pp. 102-8) focused on institutional buildings in Gothic styles. Robert Koch examined "The Medieval Castle Revival: New York Armories," in JSAH 14 (October 1955): 23-29. John Maass's study of the Victorian era, **The Gingerbread Age**, appeared in 1957 (and has been reprinted by Greenwich House in 1983.)

James Jackson Jarves, who had been a "forgotten New Englander" in 1933, received a full biographical study in Francis Steegmuller's **The Two Lives of James Jackson Jarves** (New Haven: Yale Univ. Press, 1951). Other monographs on artists and architects appeared in the fifties: Agnes Addison Gilchrist's **William Strickland** (Philadelphia: Univ. of Pennsylvania, 1950); Francis W. Kervick's **Patrick Charles Keely, Architect** (South Bend, Ind.: Private Press, 1953); and Adolf Placzek's **Inventory of the Alexander Jackson Davis Collection** (New York: Avery Architectural and Fine Arts Library, 1955). (Placzek's **Inventory** was updated in 1974 by Jane B. Davies.) Two other publications that already have been cited in another context ought to receive mention in the citations for the 1950s: Hamlin's book on Latrobe (see p. xxxi) and Dickason's book on the American Pre-Raphaelites (see p. xxxiv). Finally, Benjamin West's decorative work at William Beckford's Fonthill was examined by Albert Ten Eyck Gardner in "Beckford's Gothic Wests," **Bulletin of the Metropolitan Museum of Art** (October 1954).

Two architectural projects reveal the renewed interest
in the 1950s in the medieval past. Minoru Yamasaki,
during his tenure at the Massachusetts Institute of
Technology, had his studio classes prepare proposals for
the completion of New York's St. John the Divine
Cathedral. (See Gavin Macrae-Gibson's "Reflections upon
the New Beginnings at the Cathedral Church of St. John
the Divine," **Architectural Record** 166 [November 1979]:
119-26.) St. John the Divine was not the only Gothic
church receiving attention. James G. Van Derpool
published his article, "The Restoration of St. Luke's,
Smithfield, Virginia," in **JSAH** 17 (March 1958): 12-18.
St. Luke's (1632) is one of the few survivals of European
Gothic in America. Despite this obvious abundance of
literature indicating a positive interest in medievalism,
John Burchard's and Albert Bush-Brown's **The Architecture
of America** (Boston: Little Brown), published in 1961,
spoke for a hefty proportion of architects in denouncing
the sham historicism of both the nineteenth and twentieth
centuries.

Quintessentially American, movies also perpetuated the
memory of the Middle Ages, however distorted by Hollywood
that image was. Robin Hood had two film versions, in
1922 and 1938; Orson Welles directed **Macbeth** in 1948.
Ivanhoe (1952) and **Quentin Durward** (1955) were both
directed by Richard Thorpe. More recently John Boorman
directed a film about King Arthur in 1981, **Excalibur.**

Once artistic forms have been removed from their
contexts and taken out of historical sequence, one may as
well borrow from around the globe from various centuries.
This indeed has happened increasingly in the architecture
and art of Canada and the United States since 1960. (It
is no coincidence that the Landmarks Preservation Act
passed in 1965 and Robert Venturi's **Complexity and
Contradiction in Architecture** appeared in 1966.)
Restoration and preservation efforts have increased on
medieval revival buildings of the nineteenth century and
new projects have been executed by architects as diverse
as Edward Larrabee Barnes and Philip Johnson that display
medievalized motifs. E.A. Sövik wrote of the challenges
of restoring historic churches ("A Problem in Church
Renewal: Christ Church Cathedral, St. Louis, MO," **Journal
of the Guild for Religious Architecture** 3 [April 1970]:
12-14); W. Miller discussed the renovation of the
University of Chicago's Gothic buildings in another

recent article ("A Glow on Old Gothic," **Architectural Record** 162 [July 1977]: 94-96.)

Current writings on revivalist work by E.L. Barnes, Burgee/Johnson, Lester Walker, and Minoru Yamasaki have not been cited in the bibliography because these articles merge with contemporary criticism. However, it seems useful to list some of them here. Mildred F. Schmertz wrote on Barnes's Cathedral of the Immaculate Conception in "Neo-Richardsonian Romanesque Cathedral by Edward L. Barnes," **Architectural Record** 165 (January 1979): 129-36. Several publications have taken a look at the recent work of John Burgee Architects with Philip Johnson: Donald Canty, "Historicist, Spired 'City of Glass' Around a Plaza," **Architecture** 73 (May 1984): 242-51; "Johnson/Burgee," **PA** 65 (February 1984): 65-100; Franklin K.B.S. Toker, "Philip Johnson and PPG: A Date with History/PPG Industries World Headquarters, Pittsburgh, Pennsylvania," **PA** 60 (July 1979): 60-61. Lester Walker's "new old house" derived from Gothic Revival cottages is discussed by James A. Murphy in "Optical Allusions," **PA** 56 (April 1975): 84-87. The late Minoru Yamasaki's neo-Gothic work has received considerable attention since the early 1960s: Paul Heyer, **Architects on Architecture: New Directions in America** (New York: Walker [1966] 1978); Ada Louise Huxtable, "Minoru Yamasaki's Recent Buildings," **Art in America** 50 (1962): 48-55; Giulia Veronesi, "Minoru Yamasaki and Edward Durrel Stone," **Zodiac** 8 (1961): 128-31; Minoru Yamasaki, **A Life in Architecture** (New York: Weatherhill, 1979).

Because the use of medieval forms in Canada and the United States was so scattered, a bibliography that collects the pieces is especially valuable. One is reminded of connections that might otherwise be forgotten in monographs or typological studies. For example, Ernest Batchelder taught Grant Wood; Joseph Coletti was a student of Arthur Kinglsey Porter; Raymond Hood worked in the office of Ralph Adams Cram; and John Root was employed by both James Renwick, Jr., and P.B. Wight. This bibliography, it is hoped, indicates both the gaps and the strengths in the study of medievalism. There are many challenging questions raised by authors cited herein. For an overview of some of the major issues, see Hubbard (nos. 604-6), Gleason (no. 631), Kenney and Workman (no. 644) and Williams (no. 665).

Ralph Waldo Emerson contemplated England's Dundee Church Tower and wrote in **English Traits** (1856): "In seeing old castles and cathedrals, I sometimes say ... 'this was built by another and better race than any that now look at it.'" (No. 738, p. 6). The United States and Canada are as far removed in direct experience from the fifteenth century as they are from the eleventh century. This stretch across time is central to medievalism because the temporal distance engendered a fascination as well as a humility in North Americans trying to recapture the spirit and/or substance of eras gone by. The publications cited address how the artists and architects of the last two centuries perceived those distant times and how those perceptions affected their work. As Norman Cantor reminds us:

... [T]he image of the Middle Ages which obtained at any given period tells us more about the difficulties and dilemmas, the intellectual commitments of the men of the period than it does about the medieval world itself. (Cantor, "Medieval Historiography as Modern Political and Social Thought," **Journal of Contemporary History** 3 [April 1968]: 55).

ABBREVIATIONS

The following abbreviations are used in the citations:

AAQ	Architectural Association Quarterly
AB	The Art Bulletin
AD	Architectural Design
AH	Art History
ArchH	Architectural History
AR	Architectural Review
ARec	Architectural Record
AJ	Art Journal
Burl	The Burlington Magazine
CL	Country Life
HABS	Historic American Buildings Survey
JSAH	Journal of the Society of Architectural Historians
PA	Progressive Architecture
PMLA	Publication of the Modern Language Association
VS	Victorian Studies
Warb	Journal of the Warburg and Courtauld Institutes

MEDIEVALISM

PART ONE: ARCHITECTURE AND THE ARCHITECTURAL CRAFTS
IN GREAT BRITAIN AND IRELAND

A. General Works

1. **The Buildings of England; The Buildings of Northern
 Ireland; The Buildings of Scotland; The Buildings
 of Wales.** Harmondsworth: Penguin Books, 1951-.

 A series of scholarly guides to the architecture of
 England, county by county: each volume contains
 historical and descriptive notices arranged
 alphabetically by location, a historical introduction
 (generally with a section on the Gothic Revival and
 Victorian architecture), maps, and indices of
 architects, craftsmen, and buildings. Begun by
 Sir Nikolaus Pevsner as **The Buildings of England,** the
 series is constantly under revision and is being
 extended to cover Wales (1979-), Scotland (1978-),
 and Northern Ireland (1979-); an invaluable reference
 work for researchers and travelers.

2. Cobb, Gerald. **English Cathedrals: The Forgotten
 Centuries. Restoration and Change from 1530 to the
 Present Day.** London: Thames and Hudson, 1980.

 Contains well-illustrated studies of Bath, Bristol,
 Beverley, Selby, Ely, Peterborough, Salisbury,
 Winchester, Lichfield, and Worcester.

3. Collins, Peter. **Changing Ideals in Modern
 Architecture 1750-1950.** Montreal: McGill-Queens
 Univ. Press, 1965.

Basic study focusing on architectural theory, with
sections on the Gothic Revival and related topics.

4. Crook, J. Mordaunt, and M.H. Port. **The History of the
 King's Works. Volume VI.** 1782-1851. London: Her
 Majesty's Stationery Office, 1973.

 Part of an authoritative history of English royal
 buildings, this volume covers (among other things) the
 surveyorship of James Wyatt, the building of the
 Houses of Parliament, the rebuilding of Windsor
 Castle, and the care of ancient monuments.

5. Darley, Gillian. **Villages of Vision.** London: The
 Architectural Press, 1975.

 General history of the planned village in England
 from the mid-eighteenth century through the Garden
 City movement, including a chapter on the "cottage
 orné" and picturesque village of the early nineteenth
 century, as well as discussions of such important
 Gothicizing examples as Blaise Hamlet (Nash), Holly
 Village (Darbyshire), Harlaxton (Salvin), Edensor
 (Paxton and Robertson), Great Tew (Loudon), and
 Akroydon (Scott and Crossfield).

6. Eastlake, Charles L. **A History of the Gothic Revival.**
 Edited with an introduction by J. Mordaunt Crook.
 Leicester: Leicester Univ. Press, 1970.

 A reprint of Eastlake's fundamental text, first
 published in 1872. In addition to the introduction,
 Crook provides additional illustrations, a
 bibliography, and an expanded index, as well as
 updating Eastlake's catalogue of buildings.

7. Fawcett, Jane. "A Restoration Tragedy: Cathedrals in
 the Eighteenth and Nineteenth Centuries." In **The
 Future of the Past. Attitudes to Conservation**
 1174-1974, edited by Jane Fawcett, pp. 75-116.
 London: Thames and Hudson, 1976.

Chronicles the destructive aspects of English cathedral restoration, focusing on Wyatt and Scott, but also including Cottingham, Burges, Blore, Salvin, Street, Pearson, and others.

8. Frankl, Paul. **The Gothic. Literary Sources and Interpretations through Eight Centuries.** Princeton: Princeton Univ. Press, 1960.

 A long and fundamental study of changing attitudes to Gothic architecture from the middle ages to the twentieth century.

9. Germann, Georg. **Gothic Revival in Europe and Britain: Sources, Influences, and Ideas.** Translated by Gerald Onn. London: Lund Humphries, 1972.

 An important theoretical study concentrating on the late eighteenth-mid nineteenth centuries.

10. Girouard, Mark. "The Castle Revival in English Architecture 1610-1870." In **Historismus und Schlossbau,** edited by Renate Wagner-Rieger and Walter Krause., pp. 83-86. Munich: Prestel-Verlag, 1975.

 Traces the castle style from Smythson to Burges.

11. ————. **The Return to Camelot. Chivalry and the English Gentleman.** New Haven and London: Yale Univ. Press, 1981.

 The nineteenth century revival of interest in chivalric lore and values, with much material on art and architecture.

12. Harvey, John. **Conservation of Buildings.** London: John Baker (Publishers), 1972.

 Chapters 9 and 10 trace the history of conservation practices in England from the fifteenth century

through the present, primarily with reference to
medieval buildings.

13. Hilling, John. **Plans & Prospects. Architecture in
 Wales** 1780-1914. Welsh Arts Council, 1975.

 Exhibition catalogue including important Gothic
 works by Wyatt, Scott, Burges, Pritchard and Seddon,
 and others.

14. Hitchcock, Henry-Russell. **Architecture: Nineteenth
 and Twentieth Centuries** (Pelican History of Art).
 Harmondsworth: Penguin Books, 1958 (4th edition,
 1977).

 General survey including several chapters on
 English and American Gothic revival.

15. Kennet, Wayland. **Preservation.** London: Temple Smith,
 1972.

 Though primarily concerned with contemporary
 issues, Chapter I provides a lively history of
 preservation legislation in England.

* Kenney, Alice P., and Leslie J. Workman. "Ruins,
 Romance, and Reality: Medievalism in Anglo-American
 Imagination and Taste, 1750-1840." Cited below as
 no. 644.

16. Lang, S. "The Principles of the Gothic Revival in
 England." **JSAH** 25 (1966): 240-67.

 Studies the nature of stylistic revival and its
 dependence on stylistic recognition; analyzes the
 growing knowledge of Gothic and attitudes to it from
 Elizabethan times through Pugin.

17. Little, Bryan. **Catholic Churches Since 1623.** London,
 1966.

Covers England; not available to the annotator.

18. Madsen, Stephan Tschudi. **Restoration and Anti-Restoration. A Study in English Restoration Philosophy.** Oslo: Universitetsforlaget, 1976.

 A history of restoration theory from Wyatt through Morris, and the S.P.A.B.

19. Patetta, Luciano. **L'Architecttura dell'Eclettismo: Fonti, Teorie, Modelli** 1750–1900. Milan: Gabriele Mazotta, 1975.

 Includes chapters on the Gothic Revival in England, France, Germany, Italy, and the United States.

20. Pevsner, Nikolaus. "Scrape and Anti-scrape." In **The Future of the Past** (no. 7), pp. 35–54.

 A history of the restoration of Gothic buildings in England from seventeenth century Oxford through William Morris.

21. ————. **Some Architectural Writers of the Nineteenth Century.** Oxford: Clarendon Press, 1972.

 Brief discussions of the writings of many leading nineteenth century theorists and architects, including Gothic revivalists like Britton, Rickman, Pugin, Ruskin, Scott, and the Ecclesiological Society.

22. ————. **Studies in Art, Architecture, and Design.** 2 vols. New York: Walker and Company, 1968.

 A collection of earlier articles, including "Richard Payne Knight" (discusses his castellated house, Downton Castle); "'Good King James's Gothic'" (eighteenth century view of Elizabethan-Jacobean architecture as a form of domestic Gothic); "Matthew Digby Wyatt" (his role in design reform, relationship to Pugin and Ruskin); "William Morris and Architecture" (Morris and the Gothic Revival, Ruskin,

Webb's Red House); "Art Furniture of the 1870s"
(includes Burges, Seddon, Morris, Webb, Eastlake,
Talbert, Godwin); "C.F.A. Voysey" (architecture and
decorative arts).

23. Richardson, Douglas Scott. **Gothic Revival**
 Architecture in Ireland. 2 vols. New York and
 London: Garland Publishing, 1983.

 Written as a doctoral dissertation in 1970, this is
 a vast and ambitious survey of untrodden territory.
 Begins with castellated houses of the late eighteenth
 century, continues through the early nineteenth
 century work of Francis Johnston and John Semple,
 concludes with High Victorian Gothic through the
 1880s. Attempts are made throughout to set regional
 developments in a broader context. Important
 sections include those on Nash's Irish castles; the
 works of his assistants, James and George Pain;
 Catholic and Protestant church architecture; Pugin's
 Irish churches and convents; Deane and Woodward; High
 Victorian works by English and Irish architects
 including Burges, E.W. Godwin, George Goldie, J.J.
 McCarthy, E.W. Pugin, Street, and White. Contains 539
 plates and exhaustive scholarly apparatus.

24. Rowe, Colin. "Character and Composition; or Some
 Vicissitudes of Architectural Vocabulary in the
 Nineteenth Century." In **The Mathematics of the**
 Ideal Villa and Other Essays, pp. 59-88.
 Cambridge, Mass.: MIT Press, 1976.

 Traces these two related theoretical concepts from
 their eighteenth century origins through their apogee
 in the picturesque and their reinterpretation in light
 of mid-victorian Gothic concepts of realism to their
 early twentieth century decline.

25. Royal Institute of British Architects. **Catalogue of**
 the Drawings Collection of the Royal Institute of
 British Architects. London: RIBA, 1968-.

 A series of catalogues raisonnés forming a
 fundamental source for English architecture: the

series, which is still in production, already includes
separate volumes devoted to the Pugin, Scott, and
Wyatt families, and Voysey (see nos. 172, 354, 361,
403), as well as smaller sections on many other
eighteenth-nineteenth century Gothicists. A
forthcoming volume on Waterhouse has been announced.

26. Summerson, John, ed. **Concerning Architecture. Essays
 on Architectural Writers and Writing Presented to
 Nikolaus Pevsner.** London: Allen Lane, The Penguin
 Press, 1968.

 Contains items 79, 83, 90, 104, 123, 348, 388, 411,
 640.

27. Taylor, Jeremy. **The Architectural Medal. England in
 the Nineteenth Century.** London: British Museum
 Publications, 1978.

 An illustrated catalogue raisonné, based on the
 collection in the British Museum, this volume provides
 an unusual source of information on many Gothic
 Revival buildings, as well as an interesting insight
 into the ways in which Gothic and Gothic Revival
 buildings were seen and depicted during the nineteenth
 century.

28. Thompson, M.W. **Ruins. Their Preservation and
 Display.** London: British Museum Publications,
 1981.

 Provides a brief history of ancient monuments
 legislation in England and the techniques of
 conservation and preservation; also contains numerous
 brief case histories of medieval ruins, many
 illustrated before and after preservation.

29. Watkin, David. **Morality and Architecture. The
 Development of a Theme in Architectural History and
 Theory from the Gothic Revival to the Modern
 Movement.** Oxford: Clarendon Press, 1977.

From Pugin through Pevsner, surveys the defense of particular architectural styles on the grounds of religion, sociology, politics, rationality, technology, or the **Zeitgeist**.

30. ————. **The Rise of Architectural History.** London: The Architectural Press, 1980.

Discusses many important eighteenth and nineteenth century commentators on Gothic architecture, as well as more recent historians.

31. [Weinreb, B.]. **Church Architecture and Architects in Britain.** Catalogue 31. London: B. Weinreb Architectural Books, 1976.

Annotated bibliography of over 600 books ranging from the sixteenth through the twentieth century, with a strong emphasis on Gothic and Gothic Revival; includes many of the major source books published for designers in the late eighteenth and nineteenth centuries; also includes some drawings and prints.

32. ————. **The Gothic of Gothick: English Church Building in Nineteenth Century Theory and Practice.** Comp. and ed. by Paul Breman. Catalogue 14. London: B. Weinreb, 1966.

Annotated bibliography of 300 primary and secondary sources, primarily books, but also including some drawings.

33. ————. **The Small English House. A Catalogue of Books.** Edited by Priscilla Wrightson. Catalogue 35. London: B. Weinreb Architectural Books, 1977.

Annotated bibliography of almost 700 books from the mid-eighteenth through the twentieth century; particularly relevant are sections on cottage design books, many expounding picturesque medieval treatments.

B. Before 1840

1. General Works

34. Aston, Margaret. "English Ruins and English History:
 The Dissolution and the Sense of the Past." **Warb**
 36 (1973): 231-55.

 Shows how nostalgia for the monastic past helped to
 shape antiquarian sensibilities during the sixteenth
 and seventeenth centuries.

35. Barton, Stuart, et al. **Monumental Follies. An
 Exposition on the Eccentric Edifices of Britain.**
 Worthing, Sussex: Lyle Publications, 1972.

 Many of the garden structures included here, dating
 mostly from the eighteenth and early nineteenth
 centuries, are in the Gothic or castellated style.
 The book is arranged as a gazeteer, with a photograph
 and brief text for each building.

36. Bath. Holburne of Menstrie Museum. **A Gleam of
 Gothic.** 1972.

 An inexpensively produced catalogue of an
 exhibition covering English decorative arts of the
 eighteenth and early nineteenth centuries.

37. Brighton. Royal Pavilion Art Gallery and Museum.
 Gothick, 1975.

 Catalogue of an exhibition covering English
 decorative arts of the eighteenth century.

38. Caisse Nationale des Monuments Historique et des Sites
 (Paris). **Le 'Gothique Retrouvé'avant Viollet-le-
 Duc,** 1979.

 Exhibition catalogue of paintings, decorative arts,
 and architectural drawings from the early eighteenth

century to the mid-nineteenth; though focusing on the
continent, includes a section devoted to England.

* Clarke, Basil F.L. **The Building of the Eighteenth
 Century Church.** Cited below as item 212.

39. Cocke, Thomas H. "Le Gothique Anglais sous Charles
 Ier." **Revue de l'art,** 30 (1975): 21-30 (English
 text, 93-95).

 Analyzes Gothicism in English seventeenth century
 church and college architecture in terms of religious
 controversies; glances also at early seventeenth
 century neo-feudalism and at contemporary French
 gothicism.

40. ————. "Pre-Nineteenth-Century Attitudes in England
 to Romanesque Architecture." **Journal of the
 British Archaeological Association** ser. 3, 36
 (1973): 72-97.

 Attitudes to Romanesque, especially in the late
 eighteenth century: identification, naming, dating,
 and appraisal of the style; approaches to restoration
 (Ely, Hereford, and Durham are considered in detail);
 Romanesque revival in Adam's castles and in works by
 Wyatt and S.P. Cockerell.

41. Colvin, Howard. **A Biographical Dictionary of British
 Architects 1600–1840.** London: John Murray, 2nd.
 ed., 1978.

 Greatly expanded edition of the standard and
 invaluable reference source for British pre-Victorian
 architects, first published in 1954.

42. Colvin, Howard, and John Harris, eds. **The Country
 Seat. Studies in the History of the British
 Country House Presented to Sir John Summerson on
 his Sixty-Fifth Birthday.** London: Allen Lane, The
 Penguin Press, 1970.

Contains items 73, 95, 124, 175, 187, 190.

43. Crook, J. Mordaunt. "Northumbrian Gothick." **Royal Society of Arts Journal**, 121 (1972-73): 271-83.

 Account of the eighteenth century reconstruction of Alnwick Castle (by Adam and others), accompanied by a brief survey of the Gothic Revival in Northumberland, ca. 1650-1850.

44. Davis, Terence. **The Gothick Taste.** Cranbury, N.J.: Associated University Presses, 1975.

 Very well-illustrated survey of eighteenth- early nineteenth century English Gothic Revival architecture and furnishings.

45. Dobai, Johannes. **Die Kunstliteratur des Klassizismus und der Romantik in England. Band 1: 1700–1750; Band 2: 1750–1790; Band 3: 1790–1840.** Bern: Benteli Verlag, 1974, 1975, 1977.

 An invaluable guide to the primary literature of painting, architecture, gardening, aesthetic theory, and art history; essays are accompanied by annotated bibliographies.

46. Downes, Kerry. **English Baroque Architecture.** London: A. Zwemmer, 1966.

 Includes a short discussion of the Gothic tradition in the seventeenth century and of the Gothic Revival, especially of the important works of Hawksmoor and Vanbrugh.

47. Frew, John M. "An Aspect of the Early Gothic Revival: The Transformation of Medievalist Research, 1770-1800." **Warb** 43 (1980): 174-85.

 Chronicles the growth and growing popularity of medieval antiquarian and architectural research in

late eighteenth century England, emphasizing the role
of the Society of Antiquaries.

48. Girouard, Mark. "Elizabethan Architecture and the
 Gothic Tradition." **ArchH** 6 (1963): 23-40.

 Argues for widespread appreciation of Gothic
 architecture among the Elizabethans and points to
 Gothic elements at Burghley and elsewhere.

49. Gloag, John. "Gentlemen's Gothic." **Antiques**, 95
 (1969): 682-88.

 Georgian Gothic furniture of the late eighteenth
 century.

50. Haslag, Josef. **"Gothic" im siebzehnten und
 achtzehnten Jahrundert; eine wort- und
 ideengeschichtliche Untersuchung.** Koln: Bohlau,
 1963.

 Not available to the annotator.

51. Hind, Charles. **English Architectural Pattern Books,
 1730-1810. A Bibliography.** Aberystwyth, 1979.

 Not available to the annotator.

52. Jervis, Simon. "Cottage, Farm and Villa Furniture."
 Burl 117 (1976): 848-59.

 Discusses various furniture styles, including
 Gothic and Tudor, in early nineteenth century England.

53. Jones, Barbara. **Follies and Grottoes.** London:
 Constable, 1974 (second edition, "heavily revised
 and enlarged").

 First published in 1953, this includes a gazeteer
 of surviving follies in England and Scotland.

54. Joy, Edward T. **English Furniture** 1800–1851. Toronto: Fitzhenry and Whiteside, 1977.

 A general history: includes a chapter on the Gothic Revival.

55. Krinsky, Carol H. "Romanesque Architecture and Some Eighteenth Century Critics." **Gesta: Annual of the International Center of Romanesque Art** 2 (1964): [20-21].

 Traces a strain of positive appreciation of Romanesque architecture from Sir Christopher Wren to Thomas Rickman; briefly discusses the writings of Thomas Gray, William Warburton, Thomas Warton, Andrew Ducarel, Francis Grose, and James Bentham.

56. Liscombe, Rhodri. "Economy, Character, and Durability: Specimen Designs for the Church Commissioners, 1818." **ArchH** 13 (1970): 43-57.

 Nash, Smirke, and Soane submitted designs. Nash's Gothic designs, reproduced here, are particularly interesting.

57. Macaulay, James. **The Gothic Revival** 1745-1845. Glasgow and London: Blackie, 1975.

 A thorough and significant study of Gothic revival architecture in Scotland and the north of England. Begins by setting out the economic and aesthetic background (including Gilpin and picturesque travel, and the question of revival vs. survival); important chapters center on Roger Morris's Inverary Castle; garden follies and pavilions; Alnwick, Ford and Raby castles. Robert Adam's castles and their influence on northern architects including John Paterson and Archibald and James Elliott, William Atkinson's Abbotsford; mansions, castles and churches in Scotland and the north of England; the works of James Wyatt, James Gillespie Graham, and William Burn. Other important figures discussed include John Carr, James Nisbet, Archibald Simpson, Sir Robert Smirke,

John Nash, Thomas Rickman, George Webster, John
Dobson, William Wilkins, John Smith and A.W.N. Pugin.

58. Malins, Edward, and The Knight of Glyn. **Lost
 Demesnes. Irish Landscape Gardening,** 1660–1845.
 London: Barrie and Jenkins, 1976.

 Illustrates some Gothic lodges, ruins, and follies.

59. McMordie, Michael. "Picturesque Pattern Books and
 Pre-Victorian Designers." **ArchH** 18 (1975): 44-60.

 Discusses early nineteenth century designers of
 cottages orneés and the books they published, setting
 them in the context of the architectural profession.

60. Oman, Charles. "The First Gothic Revival in English
 Church Plate." **Burl** 120 (1978): 226-29.

 Suggests that a group of apparently medieval
 chalices were actually made for Catholic recusants in
 the sixteenth century.

* Pevsner, Nikolaus. "'Good King James's Gothic.'" In
 Studies in Art, Architecture, and Design, Vol. 1
 (no. 22), pp. 156-63.

61. Piggott, Stuart. **Ruins in a Landscape. Essays in
 Antiquarianism.** Edinburgh: Edinburgh Univ. Press,
 1976.

 A collection of reprinted essays, whose topics
 include ruins and conceptions of Gothic architecture;
 Camden and his contemporaries; "Celts, Saxons, and
 Early Antiquaries"; "Ancestors of Jonathan Oldbuck"
 (on the antiquarian climate in which Sir Walter Scott
 was brought up); "The Origins of the English County
 Archaeological Societies" (mainly the 1840s).

62. Port, M.H. **Six Hundred New Churches. A Study of the Church Building Commission, 1818–1856, and its Church Building Activities.** London: SPCK, 1961.

 Though the Commissioners' Churches were in all styles, the opportunities the Commission created provided an invaluable boost to the Gothic Revival movement. This is the fundamental study on the subject.

63. Rowan, A.J. "Georgian Castles in Ireland I." **Quarterly Bulletin of the Irish Georgian Society** 7 (1964): 3–40.

 Between about 1770 and 1825, over one hundred castellated country mansions were built in Ireland. Rowan traces the evolution of the style, concentrating on symmetrical examples by Adam, Wyatt, and Francis Johnston. (Part II was never published.)

64. Summerson, John. **Architecture in Britain 1530–1830.** (Pelican History of Art). Harmondsworth: Penguin Books, 4th ed., 1963.

 A general survey which includes valuable discussions of the Gothic Revival from Wren to Walpole, late eighteenth century picturesque architecture, and Greek and Gothic after Waterloo. First published in 1953.

65. Wiebenson, Dora. "Greek, Gothic and Nature: 1750–1820." **Essays in Honor of Walter Friedlander (Marsyas: Supplement II)** (1965): 187–94.

 Focusing on Strawberry Hill and works by James Stuart, Soufflot, Ledoux, Boullée, and Schinkel, Wiebenson sets the rise of the Greek and Gothic styles in the context of a new conception of nature in terms of first principles and visual phenomena.

* Wilson, M.I., comp. **A Bibliography of Pre–Nineteenth Century Topographical Works** Cited below as no. 515.

66. Woodger, Andrew. "Post-Reformation Mixed Gothic in
 Huntingdonshire Church Towers and its
 Campanological Associations." **Archaeological
 Journal** 141 (1984): 269-308.

 Argues that medieval churches were not nearly so
 neglected during the late sixteenth and early
 seventeenth centuries as previous scholars have
 assumed but that much work of this period has been
 mistakenly attributed to earlier periods; traces the
 effects of changes in campanological techniques
 on the repair and rebuilding of towers and proposes
 that much Gothic work of this period must be
 understood not as survival but as deliberate revival.

67. Wrightson, Priscilla. **The English Picturesque: Villa
 and Cottage 1760-1860.** Indianapolis Museum of Art,
 1973. (Bulletin/Catalogue Vol. I, No. 3 - New
 Series).

 Includes both picturesque views and design books;
 surveys the fashion for eclectic house design in the
 years around 1800, with an emphasis on the Gothic,
 Tudor, and rustic styles.

2. **Monographs: Architects, Designers, Critics, Patrons**

ABRAHAM, ROBERT (1774-1850)

68. Hussey, Christopher. "Alton Towers, Staffordshire."
 CL 127 (1960): 1246-1249, 1304-1307.

 Part I describes the picturesque landscape garden,
 laid out in 1814-1827 and containing buildings in
 Grecian, Chinese and Gothic styles. Part II describes
 the house, a large and rambling Gothic structure built
 largely during the 1830s for the Earl of Shrewsbury.
 Hussey suggests Abraham as the architect, but Pugin
 also contributed some interiors. (For Pugin's work
 for the same patron nearby at Alton Castle and
 Hospital, see no. 332.)

ADAM, ROBERT (1728-1792)

The standard work on Adam remains A.T. Bolton, **The Architecture of Robert and James Adam** (2 vols., London, 1922). Other general treatments include John Swarbrick, **Robert Adam and his Brothers** (London, 1915); John Fleming, **Robert Adam and his Circle in Edinburgh and Rome** (London, 1962); Damie Stillman, **The Decorative Work of Robert Adam** (New York, 1966); and Geoffrey Beard, **Robert Adam's Country Houses** (Edinburgh, 1981). For Adam's Gothic works and his picturesque drawings, see A.T. Bolton, "The Classical and Romantic Compositions of Robert Adam" (**AR** 57, 1925: 28); P. Oppé, "Robert Adam's Picturesque Compositions" (**Burl** 80, 1942: 56-59); W. Ryle Elliot, "The Work of Robert Adam in Northumberland" (**Archaeologia Aeliana** ser. 4, 30, 1952: 106-17); and J. Fleming, "Adam Gothic" (**Connoisseur** 142, 1958: 75-79). For Adam's castles and their influence in Scotland and the north of England, see no. 57; and for their influence on John Clerk of Eldin, no. 90.

69. Fleming, J. "Robert Adam's Castle Style." CL 143 (1968): 356-59.

A brief illustrated survey of Adam's country houses in the castellated style.

70. Rowan, Alistair. "After the Adelphi: Forgotten Years in the Adam Brothers' Practice." **Journal of the Royal Society of Arts** 122 (1974): 659-710.

Includes a thorough survey of Adam's castellated country houses, from the 1760s through the major Scottish houses of the 1770s-1780s; also consideration of Adam's ideal geometrical villa plans, many of which are also Gothic or castellated.

71. ———. "Oxenfoord Castle, Midlothian." CL 156 (1974): 430-33.

Brief account of a castellated country house by Robert Adam, 1780-82.

72. ———. "Robert Adam's Last Castles." CL 156
 (1974): 494-97.

 Surveys a group of castellated houses of the 1780s-
 1790s: Dalquharran, Auchincruive, Pitfour, Mauldslie,
 Stobs.

73. ———. "Wedderburn Castle." In **The Country Seat**
 (no 42), pp. 145-49.

 Brief discussion of one of Adam's important castle-
 style country houses.

74. Scottish Arts Council (Edinburgh). **Robert Adam and
 Scotland. The Picturesque Drawings.** (1972).
 Exhibition Catalogue.

 Adam made numerous drawings of imaginary castles
 set in Claudian or picturesque landscapes; this
 catalogue also illustrates a few of his designs for
 Gothic buildings. Text by A.A. Tait substantially
 duplicates no. 75.

75. Tait, A.A. "The Picturesque Drawings of Robert Adam."
 Master Drawings 9 (1971): 161-71.

 Traces the evolution of Adam's drawing style,
 comparing it with that of his brothers and focusing on
 his Gothic designs and imaginary landscape views of
 picturesque castles. Text partially duplicates
 no. 74.

76. ———. "Robert Adam's Picturesque Architecture."
 Burl 123 (1981): 421-22.

 Studies the relationship between Adam's picturesque
 drawings and watercolors and his castellated designs
 for Barnbougle and Kirkdale, 1774-1787.

ATKINSON, WILLIAM (c. 1773-1839)

For Atkinson's work at Lismore Castle, see no. 23; and for Abbotsford and Atkinson's other work in Scotland, no. 57.

77. Wainwright, Clive. "Sir Walter Scott and his Collection." CL 172 (1982): 804-6, 886-88.

Focuses on the relationship between Scott's collecting and his writing and on the integration of his collections into the architecture of Abbotsford.

78. ———. "Walter Scott and the Furnishings of Abbotsford: or the Gabions of Jonathan Oldbuck." **Connoisseur** 194 (1977): 3-15.

A thorough account of the building and antiquarian furnishing of Scott's house, designed by the leading Scottish Gothicist, William Atkinson.

AUBREY, JOHN (1626-1697)

79. Colvin, H.M. "Aubrey's **Chronologia Architectonica**." In **Concerning Architecture** (no. 26), pp. 1-12.

Argues that Aubrey, writing in the 1670s, was the first to think historically about Gothic architecture.

BARDWELL, WILLIAM (1795-1890)

80. Tierney, Mark, and John Cornforth. "Glenstal Castle, Co. Limerick." CL 156 (1974): 934-37.

A large Norman castle begun by William Bardwell in 1838 and containing ornamental carving based on local Irish prototypes. Preliminary designs for Gothic villas prepared in 1833-1834 by James and George Pain, William O'Hara, and Decimus Burton are also illustrated.

BAXTER, JOHN (?-1798)

81. Simpson, Ann, and James Simpson. "John Baxter,
 Architect, and the Patronage of the Fourth Duke of
 Gordon." **Bulletin of the Scottish Georgian Society**
 2 (1973): 47-67.

 Baxter's greatest work was Gordon Castle (1769ff),
 a vast country mansion distinguished by a tower in the
 traditional Scottish style and by crenellated parapets
 having a vaguely Italian medieval air.

BENTHAM, JAMES (1708-1789)

82. Frew, John M. "James Bentham's **History of Ely**
 Cathedral: A Forgotten Classic of the Early Gothic
 Revival." **AB** 62 (1980): 290-92.

 Sets Bentham in the context of Walpole and Warton
 and argues for the importance of his book (published
 in 1771) for the developing taxonomy of Gothic
 architecture.

BRITTON, JOHN (1771-1857)

 The most comprehensive source for this seminal
 figure in the diffusion of Gothic learning and
 enthusiasm is still his own **Autobiography of John**
 Britton (1849-50).

83. Crook, J. Mordaunt. "John Britton and the Genesis of
 the Gothic Revival." In **Concerning Architecture**
 (no. 26), pp. 98-119.

 Britton was an architectural writer, publisher,
 topographer, and one of the most influential spokesman
 of Gothic architecture in early nineteenth century
 England.

BURTON, DECIMUS (1800-1881)

84. Miller, Philip. **Decimus Burton 1800-1881. A Guide to
 the Exhibition of his Work.** London: The Building
 Centre Trust, 1981.

 Primarily known as a classicist, Burton merits
 inclusion here because of the author's claim that his
 most significant contribution to the architecture of
 the 1830s was a group of hitherto almost unknown
 villas in the picturesque Gothic style: Miller argues
 that these were an important precedent for George
 Devey and the development of the Old English style in
 the 1850s, a movement which ultimately fed into the
 Queen Anne.

CARR, JOHN (1723-1807)

 See M.E. Ingram, "John Carr's Contribution to the
 Gothic Revival," **Georgian Society, East Yorkshire** 2
 (1947-48), part 3: 43-52; M.E. Ingram and W.A. Eden,
 "Carr of York and Gothic Taste," CL 106 (1949): 692,
 838, 910; and R.W. Wragg, "John Carr: Gothic
 Revivalist," **Studies in Architectural History** II,
 London and New York: York Institute of Architectural
 Study, 1956, pp. 9-34.

85. Hall, Ivan. "John Carr: A New Approach." **York
 Georgian Society's Report.** 1972.

 Not available to the annotator.

86. Hull. Ferens Art Gallery. **John Carr of York.** 1973.

 The leading architect in late eighteenth Yorkshire,
 Carr worked largely in the classical styles but also
 designed some important buildings in the Gothic,
 notably Grimston Garth and the pillared entrance hall
 at Raby Castle (ca. 1782). This is an inexpensively
 produced catalogue of a comprehensive exhibition of
 Carr's work, compiled by John Bradshaw and Ivan Hall,
 with an essay by Francis Johnston.

87. York. York Georgian Society. **The Works in
 Architecture of John Carr.** 1973.

 Pamphlet containing a catalogue raisonné of Carr's
 work, a list of sources, and about twenty-five
 illustrations.

CARTER, JOHN (1748-1817)

88. Frew, J.M. "Gothic is English: John Carter and the
 Revival of the Gothic as England's National Style."
 AB 64 (1982): 315-19.

 Contrasts Carter's wholehearted revivalism with the
 earlier views of Walpole and Essex, traces the
 evolution of his views from the 1770s, and describes
 his role in the early nineteenth century conflicts
 over the term "Gothic" and the nationality of the
 style.

89. Mowl, Timothy. "Designs by John Carter for Lea
 Castle, Worcestershire." **ArchH** 25 (1982): 47-55.

 Carter built a Gothic house for the nephew of
 Richard Payne Knight; here his rejected designs for a
 Norman castle (ca. 1812-15) are published and set in
 the context of other early nineteenth century
 Romanesque buildings.

CLERK, JOHN (of Eldin) (1728-1812)

90. Fleming, John. "A 'Retrospective View' by John Clerk
 of Eldin, with some Comments on Adam's Castle
 Style." In **Concerning Architecture** (no. 26),
 pp. 75-84.

 Clerk was Robert Adam's brother-in-law. Fleming
 interprets his comments on Norman, Romanesque, and
 Gothic architecture in light of Adam's castellated
 country houses.

COADE, ELEANOR (1732-1821)

91. Kelly, Alison. "Mrs. Coade's Gothic." **CL** 161 (1977): 1514-16.

 Coade stone was an artificial stone very popular for sculpture and architectural ornament in late eighteenth- early nineteenth century England. Here, Gothic examples are discussed and illustrated.

COTTINGHAM, LEWIS NOCKALLS (1787-1847)

92. Jervis, Simon. "Gothic Rampant: Designs by L.N. Cottingham for Snelston Hall." **V & A Album** 3 (1984): 322-31.

 Publishes Cottingham's furniture designs (1842-43) for his important Gothic mansion of 1827: Cottingham was a leading restorer of Gothic cathedrals, the author of several major works on Gothic architecture and ornament, and an important collector of Gothic and Elizabethan fragments.

CUNDY, THOMAS, SR. (1765-1825)

93. Cornforth, John. "Hawarden Castle, Flintshire." **CL** 141 (1967): 1516-19, 1608-11, 1676-80.

 A Georgian country house, greatly enlarged and Gothicized in 1809-10 by Thomas Cundy the Elder, based on a design of 1807 by Nash. Gladstone later owned and further enlarged the house.

DALLAWAY, JAMES (1763-1834)

94. Steer, Francis W. "Memoir and Letters of James Dallaway, 1763-1834." **Sussex Archaeological Collections Relating to the History and Antiquities of the County, Published by the Sussex Archaeological Society** 103 (1965): 1-48.

 Dallaway, a Sussex historian and antiquarian, wrote two important studies of medieval architecture in 1806 and 1833; this article published many of his letters

and sets them in the context of his life and work,
though it does not attempt to analyze his appreciation
of Gothic architecture.

DANCE, GEORGE JR. (1741-1825)

95. Stroud, Dorothy. "George Dance and Cole Orton House."
 In **The Country Seat** (no. 42), pp. 215-19.

 Brief account of the Gothic house built in 1802-05
 for the connoisseur and collector Sir George Beaumont.

96. ————. **George Dance, Architect, 1741-1825.** London:
 Faber and Faber, 1971.

 Largely a classicist, Dance also invented a highly
 personal Greco-Gothic style, seen in the City of
 London Guildhall.

DONTHORNE, WILLIAM JOHN (1799-1859)

 The most comprehensive account of Highcliffe Castle
 remains Christopher Hussey, "Highcliffe Castle,
 Hants.," **CL** 91 (1942): 806-9, 854-57, 902-5.

97. Powell, J.H. "Highcliffe Castle, Near Christchurch,
 Hampshire." **Transactions of the Ancient Monuments
 Society** 15 (1967/68): 83-94.

 An important early nineteenth century Gothic
 country house built by W.J. Donthorne for Lord Stuart
 de Rothesay, Ambassador to France; it incorporates
 pieces of the Chateau of Les Andelys, the Abbey of
 Jumièges, and St. Vigor, Rouen, as well as quantities
 of medieval paneling.

ELLIOTT, ARCHIBALD (1760-1823) and JAMES (1770-1810)

 For Taymouth and the Elliotts' other Scottish
 houses, see no. 57.

98. Rowan, Alistair. "Taymouth Castle, Perthshire." CL
 136 (1964): 912-16, 978-81.

 Probably the grandest castellated mansion in
 Scotland, Taymouth consists of three major sections:
 the central block, built by the Elliotts in 1806-1810
 and containing a tall central tower which just
 precedes Wyatt's similar tower at Ashridge; the east
 wing, by William Atkinson (1818-1821); and the west
 wing, remodeled by James Gillespie Graham in 1838-1842
 and containing richly decorated interiors in the
 style of Pugin and with decorative painting by
 Frederick Crace.

EMLYN, HENRY (ca. 1729-1815)

99. Bond, Shelagh M. "A Craftsman of Skill and Invention.
 Emlyn's Work at St. George's Chapel, Windsor." CL
 132 (1962): 607-8; reprinted with additions in
 **Report of the Society of Friends of St. George's
 Chapel, Windsor** 4 (1962).

 Henry Emlyn, best known for the "British Order" he
 invented, restored the late Gothic St. George's Chapel
 beginning in 1785: in addition to choirstalls, he
 designed the royal pew and Coade stone organ loft.

ESSEX, JAMES (1722-1784)

 See D.R. Stewart, "James Essex," **AR** 108 (1950):
 317-21.

100. Cocke, Thomas H. "James Essex, Cathedral Restorer."
 ArchH 18 (1975): 12-22.

 Discusses conditions of English cathedral
 restoration in general and describes Essex's work at
 Ely (1757ff) and Lincoln (1761ff).

101. ─────. "Scope and Scholarship at Ely. Cathedral
 Restoration." CL 162 (1977): 1904-5.

A brief description of Essex's restoration of Ely
Cathedral, 1757-1970, including his design of the
lantern tower, later replaced by Sir George Gilbert
Scott.

102. ————. "Tact with Medieval Architecture. Eighteenth
 Century Cathedral Restoration at Lincoln." CL 162
 (1977): 1724-25.

 In addition to Essex's thorough and generally
 sympathetic restoration, begun in 1761, Cocke also
 describes the changes carried out by Gibbs in the
 classical style in 1726-1727.

103. Doig, Allan. "James Adam, James Essex and an
 Altar-Piece for King's College Chapel, Cambridge."
 ArchH 21 (1978): 79-82.

 Adam submitted a Gothic and a classic design,
 1768-69, Essex a Gothic one; Essex's was preferred.

EVELYN, JOHN (1620-1706)

104. Downes, Kerry. "John Evelyn and Architecture: A First
 Inquiry." In **Concerning Architecture** (no. 26),
 pp. 28-39.

 Includes this seventeenth century observer's
 comments on Gothic, both for and against.

GARRETT, DANIEL (?-1753)

105. Leach, Peter. "In the Gothick Vein. The Architecture
 of Daniel Garrett." CL 156 (1974): 834-37.

 Part of a three-part series on Garrett, this
 article focuses on his Gothic work, arguing that he
 was Kent's principal heir in this vein, and examining
 his work at Wallington, Gibside, Raby, Kippax, and
 Aske.

GIBBS, JAMES (1682-1754)

106. Clarke, George. "Grecian Taste and Gothic Virtue.
Lord Cobham's Gardening Programme and its
Iconography." **Apollo** 97 (1973): 566-71.

The great landscape garden at Stowe: sets the
Gothic features, including Gibbs's famous temple
(1741) into the context of a literary and political
programme.

107. Friedman, Terry. **James Gibbs.** New Haven and London:
Yale Univ. Press, 1984.

Chapter 7 of this substantial monograph contains a
brief discussion of Gibbs's Gothic garden buildings,
especially the famous Temple of Liberty at Stowe.
Friedman links Gibbs's increasing interest in the
Gothic to his relationship with the Society of
Antiquaries, to which he was elected in 1726.

108. Gibbon, Michael. "Manifesto in Ironstone: The Gothic
Temple at Stowe." CL 151 (1972): 1416-17.

A brief account of Gibbs's famous Gothic garden
temple at Stowe, built for Lord Cobham between 1741
and 1745.

GRAHAM, JAMES GILLESPIE (1776-1855)

For Gillespie Graham's later work, see nos. 57,
339.

109. Macaulay, James. "James Gillespie Graham in Skye."
Bulletin of the Scottish Georgian Society 3
(1974-75): 1-14.

Reveals Gillespie Graham's earliest architectural
work, on the Isle of Skye in the years immediately
following 1800.

HALFPENNY, WILLIAM (?-1755)

110. Lees-Milne, James. "Stouts Hill, Uley and Hardwicke
 Court, Gloucestershire." CL 154 (1973): 16-20.

 Stouts Hill is a Gothic villa designed in 1743,
 probably by William Halfpenny, and containing fine
 plasterwork and stone chimneypieces.

HAWKSMOOR, NICHOLAS (ca. 1661-1736)

111. Downes, Kerry. **Hawksmoor.** Cambridge, Mass.: MIT
 Press, 1980. First published in 1959.

 Hawksmoor, like his counterpart Vanbrugh, was an
 early explorer of a gothicizing mode. Downes's study
 is general in scope. See also nos. 46, 152.

HIORNE, FRANCIS (of Warwick) (1744-1789)

 See nos. 182-83.

HOPPER, THOMAS (1776-1856)

 See R. Romilly Fedden, "Thomas Hopper and the
 Norman Revival," **Studies in Architectural History,**
 II. London and New York: York Institute of
 Architectural Study, 1956, pp. 58-69; and D.B. Hague,
 "Penrhyn Castle," **Transactions of the Caernarvonshire
 Historical Society,** 1959. For his Gothic conservatory
 at Carlton House, see no. 4.

112. Bayley, Stephen, and Quentin Hughes. "The Hall of the
 Mountain King." **AAQ** 8/4 (1976): 39-43.

 A brief descriptive analysis of Hopper's mighty
 Norman masterpiece, Penrhyn Castle.

113. Burton, Neil. "Thomas Hopper and Late Georgian
 Eclectism." **Architectural Association Files** 5
 (1984): 41-47.

Short survey of Hopper's work, illustrating his important Gothic conservatory at Carlton House (1807), his design for the Houses of Parliament competition (1836), the Tudor Margam Castle (1830), and the Norman Penrhyn Castle (1827-34).

JOHNSTON, FRANCIS (1760-1829)

114. Girouard, Mark. "Charleville Forest, Co. Offaly, Eire." CL 132 (1962): 710-14.

Francis Johnston's Gothic country house of 1800-1812 is one of the grandest castellated mansions in Ireland.

115. ————. "Tullynally Castle, Co. Westmeath." CL 150 (1971): 1780-83, 1834-37.

Chronicles the introduction during the nineteenth century of heating, plumbing, and other modern conveniences into this large country house, Gothicized by Francis Johnston around 1800 and briefly called Pakenham Hall Castle.

116. McParland, Edward. "Francis Johnston, Architect, 1760-1829." **Quarterly Bulletin of the Irish Georgian Society** 12 (1969): 61-139.

The leading architect in Dublin at the beginning of the nineteenth century, Johnston designed several important castellated country houses as well as the Chapel Royal, Dublin, one of the masterpieces of late Georgian ecclesiastical Gothic. McParland's survey is general in scope. (For the Gothic works, see also no. 23).

KEENE, HENRY (1726-1776)

For Keene's important work at Arbury Hall, see nos. 179-81.

117. Lees-Milne, James. "Hartlebury Castle Revisited." CL
 150 (1971): 672-75, 740-43.

 A medieval building, classicized in the seventeenth
 century, and then Gothicized in the 1750s: Henry
 Keene's chapel is particularly notable.

118. Mowl, Timothy. "The Case of the Enville Museum."
 Journal of Garden History 3 (1983): 134-43.

 Tentatively reattributes this Gothic garden
 building of the early 1750s from Sanderson Miller to
 Henry Keene. Using stylistic comparisons as well as
 documentary evidence, Mowl illuminates their working
 relationship and the role played by their aristocratic
 patrons.

KEMP, GEORGE MEIKLE (1795-1844)

 See Thomas Bonnar, **Biographical Sketch of George
 Meikle Kemp** (Edinburgh and London, 1892).

119. Wrinck, A.M. "George Kemp and the Scott Monument."
 CL 150 (1971): 322-23.

 Kemp designed the Scott Monument in Edinburgh, a
 two hundred foot Gothic tower, in 1836; the story of
 his life is briefly told here. For the competition
 (in which Rickman also submitted a Gothic design) see
 no. 591.

KENT, WILLIAM (?1685-1748)

 The standard monograph remains Margaret Jourdain,
 The Work of William Kent (London, 1948). For Kent's
 important Esher Place of 1729 (a recasting and
 extension of the late fifteenth century Waynflete's
 Tower), see J.W. Lindus Forge, "Kentissime," **AR** 106
 (1949): 186-88, and John Harris, "A William Kent
 Discovery. Designs for Esher Place, Surrey," CL 125
 (1959): 1067-68.

120. Allen, Juliet. "New Light on William Kent at Hampton Court Palace." **ArchH** 27 (1984): 50-58.

 Based on recently identified nineteenth century drawings, Allan reconstructs the appearance of the gate house in Clock Court as rebuilt in the Tudor style by Kent in 1732-34 and sets the work in the context of Kent's contemporary Gothic work at Esher Place.

121. Wilson, Michael I. **William Kent, Architect, Designer, Painter, Gardener, 1685-1748.** London, Boston, Melbourne, and Henley: Routledge & Kegan Paul, 1984.

 Chapter 6 of this general survey includes a brief account of Kent's involvement with the Gothic during the 1730s, centering on Merlin's Cave (a garden building designed for Queen Caroline), his illustrations to Spenser's **Fairie Queene,** paintings on themes from the life of Henry V, furnishings for Westminster Hall, Gloucester Cathedral, and York Minster, and the rebuilding of Esher Place.

KNIGHT, RICHARD PAYNE (1751-1824)

122. Clark, Michael, and Nicholas Penny. **The Arrogant Connoisseur. Richard Payne Knight 1751-1824.** Manchester: Manchester Univ. Press, 1982.

 Includes a chapter by Penny on Knight's important castellated country house, Downton Castle.

123. Lang, S. "Richard Payne Knight and the Idea of Modernity." In **Concerning Architecture** (no. 26), pp. 85-97.

 Sets forth Knight's interest in a mixed classic-Gothic style; follows the idea of wanting to be "modern" into the nineteenth century.

* Pevsner, Nikolaus. "Richard Payne Knight." In
 Studies in Art, Architecture, and Design, Vol. 1
 (no. 22), pp. 108-26.

124. Rowan, Alistair. "Downton Castle." In **The Country
 Seat** (no. 42), pp. 170-73.

 Publishes an early view of Knight's castellated
 country house, begun in 1773, and discusses the
 contributions of T.F. Pritchard and John Nash.

LANGLEY, BATTY (1696-1751)

125. Harris, Elaine. "Batty Langley: A Tutor to Freemasons
 (1696-1751)." **Burl** 119 (1977): 327-35.

 Compares Langley, usually known for his Gothic
 pattern books, to Hogarth, as a Rococo pioneer, an
 anti-Burlingtonian, a champion of English craftsmen,
 and an avid freemason.

126. Rowan, Alistair. "Batty Langley's Gothic." In
 Studies in Memory of David Talbot Rice, edited by
 Giles Robertson and George Henderson, pp. 197-215.
 Edinburgh: Edinburgh Univ. Press, 1975.

 Langley's life and work, with special attention to
 his attitudes to Gothic and to the critical history of
 his **Ancient Architecture Restored** (1742), his major
 Gothic pattern book.

MILLER, SANDERSON (1716-1780)

 See L. Dickins and M. Stanton (eds.), **An Eighteenth
 Century Correspondence**, 1910; Arthur Oswald, "Radway
 Grange, Warwickshire," CL 100 (1946): 440-43, 486-89;
 Gordon Nares, "Hagley Hall, Worcestershire," CL 122
 (1957): 546-59, 608-11. For Pomfret Castle, often
 attributed to Miller, see nos. 140-41.

127. Wood, Anthony C., and William Hawkes. **Sanderson
 Miller of Radway and his Work at Wroxton.** Banbury

Historical Society, 1969 (reprinted from **Cake and Cockhorse. The Magazine of the Banbury Historical Society**, vol. 4).

Brief but detailed biography of one of the leading mid-eighteenth century amateur Gothicists, followed by a careful account of his architectural work at Wroxton, which included Gothicizing the chapel at Wroxton Abbey and designing a new tower for the church (1747-1748). Appended to this pamphlet is **The Architectural Work of Sanderson Miller (1716-80)**, an unannotated list of buildings.

MORRIS, ROGER (1695-1749)

See Christopher Gotch, "Inverary Castle, Argyllshire," CL 113 (1953): 2060-63; and see also the important discussion in no. 57.

128. Cosh, Mary. "Building Problems at Inverary." **Bulletin of the Scottish Georgian Society** 2 (1973): 58-67.

Focuses on labor relations in the construction of Inverary Castle and the surrounding buildings.

129. ———. "Lord Ilay's Eccentric Building Schemes. Two Dukes and their Houses - II." CL 152 (1972): 142-45.

Building and gardening schemes of the Earl of Ilay (later Third Duke of Argyll) at Whitton, just west of London. Most interesting is a triangular Gothic tower, possibly designed by Gibbs but built by Roger Morris in the 1730s.

130. Lindsay, Ian G., and Mary Cosh. **Inverary and the Dukes of Argyll**. Edinburgh: Edinburgh Univ. Press, 1973.

A general history of the Argyll building projects in the late eighteenth and early nineteenth century, containing a thorough discussion of Roger Morris's

Inverary Castle, designed in 1744 and the most
ambitious of pre-Strawberry Hill Gothic houses. Its
design, construction, and later history are all
chronicled, together with its impact on architects
such as Robert Adam, Archibald Elliott, Sir Robert
Smirke, and William Burn.

NASH, JOHN (1752-1835)

For his Commissioners' Churches, see nos. 56, 62,
and for his role in Dunsany Castle, no. 192.

131. Davis, Terence. "John Nash in Ireland." **Quarterly
 Bulletin of the Irish Georgian Society** 8 (1965):
 55-64.

 Nash's four Irish castles, Lough Cutra,
 Kilwaughter, Shanbally, and Killymoon, are very
 briefly surveyed here, along with his classical
 country houses.

132. ————. **John Nash. The Prince Regent's Architect.**
 South Brunswick, N.J.: A.S. Barnes, 1966.

 Includes a chapter on Nash's Gothic and castellated
 houses.

133. Summerson, John. **The Life and Work of John Nash,
 Architect.** Cambridge: MIT Press, 1980.

 Nash was a leading government architect and a
 master of the picturesque, famous for his cottages
 ornés and castellated country houses. Summerson's
 definitive monograph follows his first book on the
 subject, published in 1935.

134. Temple, Nigel. **John Nash and the Village Picturesque,
 with Special Reference to the Reptons and Nash at
 the Blaise Castle Estate, Bristol.** Gloucester:
 Alan Sutton, 1979.

Blaise Hamlet is Nash's famous early nineteenth century village of picturesque cottages.

NEWDIGATE, SIR ROGER (1719-1806)

For his work as an architect at Arbury Hall, see nos. 179-81.

NORFOLK, 11TH DUKE OF

For his work as an architect at Arundel and Greystoke Castle, see nos. 182-83, 193.

NORTH, ROGER (?1653-1734)

135. North, Roger. **Of Building. Roger North's Writings on Architecture.** Edited by Howard Colvin and John Newman. Oxford: Clarendon Press, 1981.

North, a late seventeenth century amateur, left a substantial body of writing on architecture: his manuscript comments on the Gothic, largely critical in tone, are collected and published here.

PAIN, JAMES (ca. 1779-1877) and GEORGE RICHARD (ca. 1793-1838)

See also D.S. Richardson, no. 23.

136. Bence-Jones, Mark. "A Vanished Gothick Castle in Ireland." CL 133 (1963): 840-41.

Mitchelstown Castle, Co. Cork, was one of the grandest castellated houses in Ireland: begun in 1823 to designs of James and George Richard Pain, Nash's assistants, it was completed in two years for the Third Earl of Kingston, who wished to have it ready for King George IV on his next visit to Ireland.

137. Cornforth, John. "Adare Manor, Co. Limerick." CL 145 (1969): 1230-34, 1302-6, 1366-69.

A large, castellated country house built mainly
during the 1830s to the designs of James and George
Richard Pain. Pugin supplied some internal elements
shortly before 1850, and P.C. Hardwick did extensive
work during the 1850s.

138. Green, J.F. "James and George Richard Pain." **The
 Green Book: The Journal of the Architectural
 Association of Ireland**, 1965, pp. 4-10.

 Not available to the annotator.

PLAYFAIR, WILLIAM HENRY (1789-1857)

139. Walker, David. "The Donaldson's Hospital
 Competition and the Palace of Westminster." **ArchH**
 27 (1984): 488-502.

 Playfair's first design for this imposing Edinburgh
 building, produced in 1835, was in a mixed Tudor-
 Jacobean style. Walker chronicles the subsequent
 history of the competition and construction, noting
 connections with contemporary events at Barry and
 Pugin's London masterpiece.

POMFRET, LADY (------)

140. Cornforth, John. "A Countess's London Castle."
 Country Life Annual, 1970.

 Pomfret Castle; not available to the annotator.

141. Houfe, Simon. "Diaries of the Countess of Pomfret."
 CL 161 (1977): 728-30, 800-802, 1169-70, 1378-79.

 Lady Pomfret was well known as a connoisseur at the
 court of George II; her tastes are surveyed,
 particularly her growing appreciation of Gothic, which
 led her to build the remarkable Pomfret Castle, London
 (often attributed to Sanderson Miller) in 1757. At
 about the same time, she may have built the first
 neo-Gothic village, Hulcote.

PORDEN, WILLIAM (ca. 1755-1822)

142. Aclogue, Guy, and John Cornforth. "The Eternal Gothic
of Eaton." CL 149 (1971): 304-7, 360-64.

Architecture and furnishing of one of the largest
and most lavish Gothic houses of the early nineteenth
century, designed by William Porden, 1803-12 and
1820-25.

POTTER, JOSEPH, SR. (ca. 1756-1842)

143. Lockett, R.B. "Joseph Potter: Cathedral Architect at
Lichfield 1794-1842." **South Staffordshire
Archaeological and Historical Society, Transactions
for 1979-1980** 21 (1980): 34-48.

Argues that, whereas James Wyatt had acted
primarily as a consultant, his successor, Potter,
became a true cathedral architect, with continuing
responsibility for the fabric. Charts the course of
building work and expenditures during his tenure,
contrasting Potter's program of annual maintenance
with the more sweeping restoration campaigns
initiated at Lichfield by Wyatt or, in 1857, by Sir
George Gilbert Scott. (For Wyatt's work, see no. 163;
and for Scott, no. 366).

REPTON, HUMPHREY (1752-1818)

144. Carter, George, Patrick Goode, and Kedrun Laurie.
Humphrey Repton, Landscape Gardener 1752-1818.
Norwich: Sainsbury Center for Visual Arts, 1982.

Catalogue of an exhibition at Norwich and at the
Victoria and Albert Museum; touches on Repton's Gothic
garden structures.

* Pevsner, Nikolaus. "Humphrey Repton." In **Studies in
Art, Architecture, and Design,** Vol. 1 (no. 22),
pp. 138-55.

145. Stroud, Dorothy. **Humphrey Repton.** London: Country
 Life, 1962.

 A full monograph on the great landscape designer,
 including his Gothic country houses and garden
 structures.

RICKMAN, THOMAS M. (1776-1841)

 See T.M. Rickman, **Notes on the Life of Thomas
 Rickman,** 1901, and Marcus Whiffen, "Rickman and
 Cambridge," **AR** 98 (1945): 160-65. For his important
 New Court at St. John's College, Cambridge, see also
 nos. 185-86.

SHAW, HENRY (1800-1873)

146. Wainwright, C. "'Specimens of Ancient Furniture.'"
 Connoisseur 184 (1973): 105-13.

 Specimens ... , with an introduction by the
 antiquarian S.R. Meyrick and plates by Henry Shaw, was
 published in 1836. The contents of this important
 book are discussed and set in the context of
 antiquarian research and publishing; both men's
 careers are summarized, and the antiquarian decoration
 of Meyrick's Gothic Revival country house, Goodrich
 Court (by Blore), is described.

SMIRKE, SIR ROBERT (1781-1867)

147. Rowan, Alistair. "Eastnor Castle, Herefordshire." **CL**
 143 (1968): 524-27, 606-9, 668-71.
 A vast and sombre castellated mansion, Eastnor
 Castle was begun in 1811, its interiors largely
 completed or altered later in the nineteenth century:
 notable are Pugin's drawing room and Sir G.G. Scott's
 design for the Great Hall, only partially realized.

SMYTHSON, JOHN (? -1634)

148. Girouard, Mark. **Robert Smythson and the Architecture
 of the Elizabethan Era.** London: Country Life,

1966. (rev. ed., New Haven: Yale Univ. Press, 1983).

Includes an important chapter on John Smythson's work at Bolsover Castle and the revival of chivalry.

149. ———. "The Smythson Collection of the R.I.B.A." **ArchH** 5 (1962): entire issue.

Publication of drawings by Robert and John Smythson, including Bolsover Castle, as well as drawings for Gothic features such as rose windows. Also includes a few medieval drawings collected by the Smythsons.

SOANE, SIR JOHN (1753-1837)

The basic bibliography on Soane, the greatest English architect of his time though not a leading Gothicist, includes the following: A.T. Bolton, **The Works of Sir John Soane** (London, 1924); H.J. Birnstingl, **Sir John Soane** (London, 1925); A.T. Bolton, **The Portrait of Sir John Soane, R.A.** (Frome and London, 1927); Sir John Summerson, **Sir John Soane 1753-1837** (London, 1952); Dorothy Stroud, **The Architecture of Sir John Soane** (London, 1961); Pierre de la Ruffiniere du Prey, **John Soane, the Making of an Architect** (Chicago, 1982); **John Soane** (Architectural Monographs: London and New York, 1983); and Dorothy Stroud, **Sir John Soane, Architect** (London, 1984).

150. Carr, Gerald. "Soane's Specimen Church Designs of 1818: A Reconsideration." **ArchH** 16 (1973): 37-53.

Offers a correction to Liscombe's discussion of Soane's specimen designs (no. 56) and publishes a group of rough sketches.

STIRLING, WILLIAM (1772-1838) AND WILLIAM (ca. 1789-1876)

151. Walker, David. "The Stirlings of Dunblane and Falkirk. Fragments of Five Architectural

Biographies." **Bulletin of the Scottish Georgian Society** 1 (1972): 40-59.

The Stirlings built competent perpendicular-style churches and castellated country houses in the Adam manner. Walker focuses on the dynamics of provincial practice in Georgian Scotland.

VANBRUGH, SIR JOHN (1664-1726)

See Laurence Whistler, **Sir John Vanbrugh,** 1938, and **The Imagination of Vanbrugh and his Fellow Artists,** 1954.

152. Downes, Kerry. **Vanbrugh.** London: A. Zwemmer, 1977.

Vanbrugh, with Hawksmoor England's greatest Baroque architect, was also a pioneer of the medievalizing mode, most significantly at Vanbrugh Castle, his own house in Greenwich, begun in 1718. This book surveys the architect's entire career in considerable depth. See also nos. 46, 111.

WALPOLE, HORACE (1717-1797)

Walpole began the gothicization of Strawberry Hill in 1749. The basic study of this most famous of eighteenth century Gothic villas remains W.S. Lewis's "The Genesis of Strawberry Hill," **Metropolitan Museum Studies** 5, Part 1 (1934): 57-92.

153. Calloway, Stephen. "Horace Walpole and Strawberry Hill." **V & A Album** 1 (1982): 151-55.

Briefly describes and illustrates a few of Walpole's objects now in the Victoria and Albert Museum, notably medieval sculptures, Tudor miniatures, and a tracery-backed chair made about 1754 to a design by Walpole.

154. Crook, J. Mordaunt. "Strawberry Hill Revisited." **CL** 154 (1971): 1598-1602, 1726-30, 1794-97.

Crook describes Horace Walpole's Gothic villa in its original state, analyzes the contributions of Walpole, his friends, and designers, and studies the Victorian reconstruction under Lady Waldegrave.

155. Lewis, Wilmarth Sheldon. **Horace Walpole.** New York: Pantheon Books, 1961.

Text of a series of lectures by a leading Walpole scholar, including a chapter on Strawberry Hill.

156. London. Orleans House Gallery. **Horace Walpole and Strawberry Hill.** London: Borough of Richmond upon Thames, 1980.

Small exhibition catalogue containing essays on the design and construction of Strawberry Hill, including Walpole's relations with Adam, Bentley, Chute, Essex and Müntz (Michael Snodin); Walpole's collections (Clive Wainwright); and Walpole as reader, writer, and printer (Stephen Calloway). Exhibited items include views of Strawberry Hill, objects from Walpole's collection, books from his private press, Walpole's own writings, and biographical material relating to his life.

WILKINS, WILLIAM (1778-1839)

157. Liscombe, R.W. "Alma Mater. The Architecture of William Wilkins at Cambridge." AR 164 (1978): 42-46.

Focuses on Wilkins' important Perpendicular and Tudor collegiate buildings of the 1820s at King's, Trinity, and Corpus Christi.

158. ———. **William Wilkins, 1778-1839.** Cambridge: Cambridge Univ. Press, 1980.

More often thought of as a master of the Greek Revival, Wilkins was also an important designer of Tudor country houses and collegiate buildings in Cambridge.

WOOD, JOHN SR. (1704-1754)

For Wood's work at Llandaff Cathedral, see also N.
Pevsner, "John Wood at Llandaff," **AR** 115 (1954):
411-12; E.T. Davies, "John Wood's Italianate Temple,"
**Journal of the Historical Society of the Church in
Wales** 6 (1956); and D.R. Buttress, "Llandaff Cathedral
in the Eighteenth and Nineteenth Centuries," **Journal
of the Historical Society of the Church in Wales** 16
(1966).

159. Stevenson, Christine. "Solomon 'Engothicked': The
 Elder John Wood's Restoration of Llandaff
 Cathedral." **AH** 6 (1983): 301-14.

Relying on manuscript sources, Stevenson
demonstrates that Wood's Palladian refurbishing of
Llandaff Cathedral (1734-1752) was an attempt to
restore the original pre-medieval form of the church,
which Wood believed to have been based on the Temple
of Solomon. These conclusions are related to Wood's
Origin of Building.

WRIGHT, THOMAS (1711-1786)

160. Harris, Eileen. "The Architecture of Thomas Wright."
 CL 150 (1971): 492-95, 546-50, 612-15.

Parts two and three discuss and illustrate Wright's
Gothic garden buildings.

161. McCarthy, Michael. "Thomas Wright's Designs for
 Gothic Garden Buildings." **Journal of Garden
 History** 1 (1981): 239-52.

Discusses and illustrates Keene's designs for
Gothic prospect towers, gates, and lodges, from the
sketchbook contained in Avery Library, while arguing
that Wright lacked the serious interest in Gothic held
by Walpole, Henry Keene, or Sanderson Miller. (For
Wright's non-Gothic designs, see the same author's
article, "Thomas Wright's 'Designs for Temples' and
'Related Drawings for Garden Building,'" **ibid.**
pp. 55-67).

162. Wright, Thomas. **Arbours and Grottos. A Facsimile of
 the Parts of Universal Architecture (1755 and
 1758).** With a Catalogue of Wright's Works in
 Architecture and Garden Design by Eileen Harris.
 London: Scolar Press, 1979.

 The catalogue includes a number of Gothic follies,
 sham ruins, and park gates. A brief biography is also
 included.

WYATT, JAMES (1746-1813)

 For Wyatt, the standard biographies remain Antony
 Dale, **James Wyatt** (Oxford, 1956), and Reginald Turnor,
 James Wyatt 1746-1813 (London, 1950). For his work as
 a restorer, see also A.A. Cordingley, "Cathedral
 Innovations: James Wyatt, Architect, at Durham
 Cathedral 1795-97," **Transactions of the Ancient
 Monuments Society** 3 (1955): 31-55; for Fonthill
 Abbey, H.A.N. Brockman, "Fonthill Abbey," AR 95
 (1944): 49-56, and by the same author, **The Caliph of
 Fonthill** (London, 1956); for Plas Newydd, mostly
 designed by Wyatt though carried on by Joseph Potter
 of Lichfield, see Christopher Hussey, "Plas Newydd,
 Anglesey," **CL** 118 (1955): 1198-1201, 1252-56; and for
 his work in the north of England, no. 57.

163. Frew, John M. "Cathedral Improvements: James Wyatt at
 Lichfield Cathedral, 1787-1792." **South
 Staffordshire Archaeological and Historical
 Society, Transactions for 1977-1978** 19 (1979):
 33-46.

 A careful analysis of Wyatt's work, of the
 interaction of aesthetics and functional demands in
 the restoration, and of the role of Wyatt's assistant
 and successor at Lichfield, Joseph Potter. (For the
 relationship of Wyatt and Potter at Lichfield, see
 also no. 143).

164. ————. "The 'Destroyer' Vindicated?: James Wyatt and
 the Restoration of Henry VII's Chapel,
 Westminster." **Journal of the British
 Archaeological Association** 134 (1981): 100-106.

Shows Wyatt's partial conversion to the preservationist theory of restoration advocated by the Society of Antiquaries.

165. ————. "Gothic in Transition: Wyatt and Bernasconi at New College Chapel, Oxford, 1788-1794." **Burl** 126 (1984): 683, 689.

Reveals the difficulties Wyatt faced in finding craftsmen to carry out his Gothic designs, documents his working relationship with the stuccatori Bernato and Francis Bernasconi, and argues for the importance of the latter's expertise in fostering the increasing intricacy of Wyatt's late work.

166. ————. "James Wyatt's Choir Screen at Salisbury Cathedral Reconsidered." **ArchH** 27 (1984): 482-87.

Argues that the large size of Wyatt's choir screen, completed in 1792, was an attempt to correct the structural insecurity of the crossing piers, and that this strategy manifests Wyatt's growing responsiveness to Gothic structure.

167. ————. "Richard Gough, James Wyatt, and Late Eighteenth-Century Preservation." **JSAH** 38 (1979): 366-74.

Clarifies Wyatt's attitude to cathedral restoration, distinguishing between "necessary repairs" and "improvements"; describes the growth of preservationist opposition to Wyatt's methods on the part of Gough, Carter, and others.

168. ————. "Some Observations on James Wyatt's Gothic Style 1790-1799." **JSAH** 41 (1982): 144-49.

Notes a shift to greater archaeological awareness in Wyatt's architecture, argues for the impact of advanced archaeological research and of his restoration work.

169. Harris, John, and Boyd Alexander. "Fonthill, Wilts."
 CL 140 (1966): 1370-74, 1430-34.

 Brief but well-illustrated coverage of the giant
 Gothic house James Wyatt built for William Beckford.

170. Hussey, Christopher. "James Wyatt and Wilton House."
 CL 134 (1963): 314-17.

 Between 1800-1815, Wyatt performed substantial
 alterations at Wilton, including the insertion of a
 Gothic entrance hall and a two-story cloister
 passageway around the courtyard.

171. Lees-Milne, James. **William Beckford.** Tisbury,
 Wilts., Compton Russell, 1976.
 Includes two chapters on Beckford's great early
 nineteenth century Gothic house, Fonthill, designed by
 Wyatt.

172. Linstrum, Derek. **The Wyatt Family.** In **Catalogue of
 the Drawings Collection of the Royal Institute of
 British Architects,** vol. 13 (no. 25).

 Also includes Wyatt's nephew, Sir Jeffrey
 Wyatville.

173. Robinson, John Martin. **The Wyatts. An Architectural
 Dynasty.** Oxford: Oxford Univ. Press, 1979.

 James Wyatt was the famous member of the Wyatt
 family, but other significant contributors to the
 Gothic Revival, covered in this general history,
 include his nephew, Sir Jeffrey Wyatville (see
 nos. 176-78) and the Victorian Thomas Henry Wyatt, who
 designed the important Italian round-arched church at
 Wilton, as well as numerous Gothic churches and Tudor
 country houses.

174. Wilton-Ely, John. "The Genesis and Evolution of
 Fonthill Abbey." **ArchH** 23 (1980): 40-51.

Chronicles the development of Wyatt's masterpiece,
begun in 1796, focusing on the intentions of his
patron, the fabulously wealthy and eccentric collector
and author of Gothic novels, William Beckford.

175. ———. "A Model for Fonthill Abbey." In **The Country
 Seat** (no. 42), pp. 199-203.

Publication of a recently discovered model of
Wyatt's stupendous early nineteenth century Gothic
house.

WYATVILLE, SIR JEFFREY (1766-1840)

176. Bellaigue, Geoffrey de, and Pat Kirkham. "George IV
 and the Furnishing of Windsor Castle." **Furniture
 History** 8 (1972): 1-34.

During the 1820s, the architecture of Windsor
Castle was Gothicized by Wyatville; the new
furnishings, discussed here, included a number of
Gothic rooms, some with furniture designed by Pugin.

177. Hussey, Christopher. "Endsleigh, Devon." CL 130
 (1961): 246-49, 296-99.

Part I describes the gardens, by Repton, Part II
the house, a rambling and picturesque "cottage orné"--
one of the best surviving examples of its type--built
in 1810-11.

178. Linstrum, Derek. **Sir Jeffrey Wyatville, Architect to
 the King.** Oxford: Oxford Univ. Press, 1972.

The nephew of James Wyatt (he changed his name when
he was knighted), Wyatville was responsible for the
early nineteenth century Gothicization of Windsor
Castle, as well as designing a number of Gothic
cottages and villas.

* ————. **The Wyatt Family.** In **Catalogue of the Drawings Collection of the Royal Institute of British Architects,** vol. 13 (no. 25).

* Robinson, John Martin. **The Wyatts** ... (no. 173).

3. Monographs: Places and Buildings

ARBURY HALL

See Gordon Nares, "Arbury Hall, Warwickshire." **CL** 114 (1953): 1126-29, 1210-13, 1414-17.

179. McCarthy, Michael. "Sir Roger Newdigate: Drawings for Copt Hall, Essex, and Arbury Hall, Warwickshire." **ArchH** 16 (1973): 26-36.

Arbury Hall (1748-1798) is one of the most complete examples of eighteenth century Gothic; McCarthy chronicles its construction, documents Newdigate's reliance on Sanderson Miller and Walpole, and reproduces his drawings.

180. Musgrave, Clifford. "Arbury, Warwickshire. A Gothic Fantasy of the English Midlands." **Connoisseur** 163 (1966): 1-8.

Gothicized for Sir Roger Newdigate in the second half of the eighteenth century, Arbury Hall is one of the masterpieces of Georgian Gothic.

181. Wood, Anthony C. "The Diaries of Sir Roger Newdigate, 1751-1806." **Transactions and Proceedings, Birmingham Archaeological Society** 78 (1962): 40-54.

Publishes the principal entries relative to the design and construction of Newdigate's house at Arbury, together with a brief analysis of Newdigate's relationships with Sanderson Miller, Henry Keene,

Henry Couchman, and John Alcott; also sets Newdigate's
taste for Gothic in the context of his European
travels.

ARUNDEL CASTLE

182. [Arundel Castle]. **Connoisseur** 197 (1978): 155-216.
 (Special issue).

 Arundel Castle was subjected to successive waves of
 gothicization--under Francis Hiorne of Warwick,
 ca. 1787, the Eleventh Duke of Norfolk, ca. 1800, M.E.
 Hadfield, 1856ff., and Charles Alban Buckler,
 1875ff.--which left it one of the most impressive
 nineteenth century castles in Great Britain. Its
 architecture is studied in essays by John Martin
 Robinson and Clive Wainwright.

183. Robinson, John Martin. "Magna Carta, and Pretty
 Ladies' Maids. Architecture of the 11th Duke of
 Norfolk - II." **CL** 174 (1983): 46-47, 49.

 Having already built at Greystoke Castle (see
 no. 193), the Duke in 1787 began an extensive campaign
 of Gothic work at Arundel, for which again he acted
 largely as his own architect (though first consulting
 Francis Hiorne, Horace Walpole, and the antiquarian
 Richard Gough).

BIRR CASTLE

184. Girouard, Mark. "Birr Castle, Co. Offaly," **CL** 137
 (1965): 410-14, 468-61, 526-29.

 A large country house, Gothicized by Lord Rosse
 about 1800 and again in the 1830s.

BRISTOL

* Gomme, Andor, Michael Jenner, and Bryan Little.
 Bristol. An Architectural History. London: Lund
 Humphries, 1979. See no. 420.

CAMBRIDGE

185. Watkin, David. **The Triumph of the Classical.
 Cambridge Architecture 1804-1834.** Cambridge:
 Cambridge Univ. Press, 1977.

 Through a selection of architectural drawings, this
 exhibition catalogue traces the opposition of Gothic
 and classic in Cambridge architecture; the outcome is
 less assured than the title suggests.

CAMBRIDGE. ST. JOHN'S COLLEGE

186. Crook, Alec C. **From the Foundation to Gilbert Scott.
 A History of the Buildings of St. John's College,
 Cambridge, 1511 to 1885.** Cambridge: Printed for
 the College, 1980.

 A documentary history, very poorly illustrated, but
 valuable for its discussion of three important
 projects: the Library (1623-1628), possibly by Henry
 Man; New Court (1825-1831) by Rickman and Hutchinson;
 and the Chapel (1863-1869) by Sir George Gilbert
 Scott.

CASTLE GORING

187. Blutman, Sandra. "Castle Goring." In **The Country
 Seat** (no. 42), pp. 205-9.

 Brief discussion of a curious country house, one
 side Gothic, the other classic, designed for the
 eccentric Sir Bysshe Shelley about 1800.

CASTLEWARD

188. Girouard, Mark. "Castleward, County Down," **CL** 130
 (1961): 1260-63, 1320-23.

 Castleward, begun in 1762, has one classical and
 one Gothic front. The Gothic work, including several
 rooms with remarkable plaster ceilings, is among the
 earliest examples of Gothic Revival in Ireland.

CHOLMONDELEY CASTLE

189. Jackson-Stops, Gervase. "Cholmondeley Castle,
 Cheshire." CL 154 (1973): 226-30.

 A large and angular castellated house designed by
 the first Marquess of Cholmondeley (Horace Walpole's
 nephew) and a local architect, William Turner of
 Whitchurch, in 1801-1804. Later additions were made
 by Sir Robert Smirke in 1829-1830.

CLEARWELL CASTLE

190. Rowan, Alistair. "Clearwell Castle, Glouc." In **The
 Country Seat** (no. 42), pp. 145-49.

 Dating Clearwell to ca. 1735, Rowan emphasizes its
 importance to the Gothic Revival before Walpole.

CORSHAM COURT

191. Ladd, Frederick J. **Architects at Corsham Court. A
 Study in Revival Style Architecture and
 Landscaping, 1749-1849.** Bradford-on-Avon:
 Moonraker Press, 1978.

 Monograph on an important country house. Among the
 medievalist phenomena discussed are a Gothic bath
 house and Tudor façade by Capability Brown, designs
 for Gothic façades by Wyatt, and a Gothic façade and
 interiors by Nash and Repton.

DUNSANY CASTLE

192. Cornforth, John. "Dunsany Castle, Co. Meath," CL 149
 (1971): 1296-1301, 1364-67.

 A large Irish castle, Gothicized in the 1780s and
 again, perhaps to the designs of James Shiel, in the
 1830s.

GREYSTOKE CASTLE

193. Robinson, John Martin. "The Follies of Solomon.
 Architecture of the 11th Duke of Norfolk - I." **CL**
 173 (1983): 1796, 1798, 1800.

 Acting as his own architect, the 11th Duke began
 about 1780 to enlarge Greystoke Castle and to design a
 series of curious farm buildings and follies in the
 Gothic style. He also built at Arundel Castle (see
 no. 183).

LICHFIELD. RICHARD GREENE'S MUSEUM

194. Whiston, J.W. "The Lichfield Clock. A Musical Altar
 Clock from Richard Greene's Museum, Lichfield."
 **South Staffordshire Archaeological and Historical
 Society, Transactions for 1976-1977** 18 (1977):
 73-82.

 Descriptive account of a very large musical clock
 whose outer case, made about 1748, is in the form of a
 Gothic church tower. Greene was a collector whose
 museum of curiosities was opened to the public in the
 late eighteenth century.

LONDON

* Clarke, Basil F.L. **Parish Churches** ... Cited below
 as no. 423.

* London: Greater London Council. **The Survey of London.**
 Cited below as no. 424.

LONDON. ST. MARY, ALDERMARY

195. Colvin, Howard. "The Church of St. Mary Aldermary and
 its Rebuilding after the Great Fire of London."
 ArchH 24 (1981): 24-33.

 A documentary study of an important late
 seventeenth century Gothic building; Colvin concludes
 that the traditional attribution to Sir Christopher

Wren cannot be sustained, though he hesitates to propose another.

OXFORD. MAGDALEN COLLEGE

Ante-dating the period covered by the present work but too important to be entirely overlooked is T.S.R. Boase, "An Oxford College and the Gothic Revival, **Warb** 18 (1955): 145-88; among the architects discussed are Wyatt, Nash, Repton, Buckler, Pugin, and Bodley.

RABY CASTLE

See also the valuable discussion in no. 57.

196. Rowan, Alistair. "Gothick Restoration at Raby
 Castle." **ArchH** 15 (1972): 23-50.

Reconstructs the Gothic work of the 1740s-1780s, documents the contribution of Daniel Garrett, Thomas Wright, James Paine, and John Carr, publishes drawings.

SHIRBURN CASTLE

197. Mowl, Timothy, and Brian Earnshaw. "The Origins of
 Eighteenth-Century Neo-Medievalism in a Georgian
 Norman Castle." **JSAH** 40 (1981): 289-94.

The authors argue that Shirburn Castle, 1716-25, is the first significant Georgian castellated building; its significance and the reasons for its later neglect are explained.

TISSINGTON HALL

198. Jackson-Stops, Gervase. "Tissington Hall,
 Derbyshire." CL 160 (1976): 158-61, 214-17,
 286-89.

A Jacobean house partially Gothicized in 1757 with an ambitious mantelpiece based on designs by Batty

Langley and much Gothic furniture. Plans for
additions in the Tudor style were made by Wyatville in
1820 and Arnold Mitchell in 1900 (both illustrated).

WISTON HOUSE

199. White, Roger. "Wiston House Remodelled." **ArchH** 27
(1984): 241-54.

Shows how the great Hall of this Tudor country
house was remodeled and embellished by an unknown
designer of the mid-eighteenth century with a massive
Gothic fireplace and doorcases copied from Batty
Langley's pattern books, as well as with rococo
plasterwork.

C. After 1840

1. General Works

200. Angus-Butterworth, L.M. "The Early History of the
Ancient Monuments Society." **Transactions of the
Ancient Monuments Society**, n.s. 20 (1973): 49-84.

Traces the history of the Society, founded in 1924,
focusing on its intervention in the preservation of
buildings ranging from Roman ruins through Gothic
cathedrals to Elizabethan manor houses.

201. Anson, Peter F. **Fashions in Church Furnishings 1840-
1940.** London: Faith Press, 1960.

Standard study of the impact of ritualism and
ecclesiology on English church furnishing and
arrangement, including sections on most of the major
Victorian Gothic church architects.

202. Archer, Michael. "Gothic Wall-papers. An Aspect of
the Gothic Revival." **Apollo**, n.s. 78 (1963):
109-16.

English and French wallpapers of the early-mid-nineteenth century, including designs by Pugin and Owen Jones.

* ———. "Pre-Raphaelite Painted Furniture." Cited as
 481.

203. Aslet, Clive. **The Last Country Houses.** New Haven and
 London: Yale Univ. Press, 1982.

 English country houses, ca. 1890-1940; includes
 chapters on the Tudor style and the fashions for
 castle and cottages.

204. Aslin, Elizabeth. **The Aesthetic Movement. Prelude to
 Art Nouveau.** New York, Washington: Frederick A.
 Praeger, 1969.

 A survey of the Queen Anne style, the Aesthetic
 Movement and the Japanese taste in architecture and
 the arts, from their roots in the Gothic Revival to
 the Art Nouveau.

205. ———. **Nineteenth Century English Furniture.**
 London: Faber and Faber, 1962.

 A well-illustrated general survey.

206. Baker, Malcolm. "A Glory to the Museum: The Casting
 of the 'Portico de la Gloria.'" **V & A Album** 1
 (1982): 101-8.

 Chronicles the expedition mounted by the Victoria
 and Albert Museum in 1866 to make plaster casts of the
 twelfth century portal of Santiago de Compostela,
 exploring the interrelationship of Museum officials
 like Henry Cole and John Charles Robinson with the
 modeller Brucciani and the architect G.E. Street, and
 setting the Portico in the context of Museum study and
 collecting policies.

207. Brandon-Jones, John. "Architects and the Art Workers'
 Guild." **Royal Society of Arts Journal** 121 (1973):
 192-206.

 Tenets of the Art Workers' Guild, founded in 1884,
 including attitudes to craftsmanship and machines;
 Brandon-Jones, a pupil of Voysey, focuses on Voysey
 and Lethaby.

208. Bright, Michael. **Cities Built to Music. Aesthetic
 Theories of the Victorian Gothic Revival.**
 Columbus: Ohio State Univ. Press, 1984.

 Concentrating on written evidence, ranges over the
 entire gamut of Gothic Revival theory, from late
 eighteenth through early twentieth century. Topics
 include the search for a distinctive style of the age,
 the diversification of aesthetic standards, attempts
 to define modern society by reference to its origins,
 theories of mimesis, the expression of function and of
 the age, the use of architecture to instruct and
 improve. Each theme is placed within a broader
 context of aesthetic and literary theory.

209. Brocklebank, Joan. **Victorian Stone Carvers in Dorset
 Churches 1856-1880.** Stanbridge, Dorset, 1979.

 Not available to the annotator.

210. Bury, Shirley. **Copy or Creation. Victorian Treasures
 from English Churches.** Exhibition catalogue.
 London: Goldsmith's Hall, 1967.

 Exhibition of Victorian Gothic church plate,
 including works by all the major architects and
 designers from Pugin through the Arts and Crafts; few
 illustrations.

211. Bury, Shirley, Alexandra Wedgewood, and Michael
 Snodin. "The Antiquarian Plate of George IV: a
 Gloss on E.A. Jones." **Burl** 121 (1979): 343-53.

Analyzes a group of antiquarian silver plate made
by Rundell, Bridge and Rundell between 1824 and 1827,
linking the production and purchase of objects in the
Gothic and Northern Renaissance taste to the
furnishing of Windsor Castle (see no. 176) and
stressing the role of Pugin in their design. A Gothic
cup by Flaxman (1819) is also illustrated.

212. Clarke, Basil F.L. **The Building of the Eighteenth-**
 Century Church. London: Society for the
 Propagation of Christian Knowledge, 1963.

 Noteworthy in this context for Chapter 15 and
 Appendices IV and V, which deal with the interesting
 question of how nineteenth century Gothicists enlarged
 and altered the churches of the preceding century.

213. ———. "Church Restoration in the Nineteenth
 Century." CL 152 (1972): 1148, 1151-52, 1236,
 1239-40.

 Part I sets Ecclesiological theories of church
 restoration in the context of the movement's
 liturgical focus, emphasizing the contributions of
 Freeman and Scott. Part II surveys the changing
 aesthetic preferences of late nineteenth century
 restorers working under the influence of Morris and
 the Society for the Protection of Ancient Buildings.

214. ———. "Ecclesiastical Architecture." **Royal Society**
 of Arts Journal 121 (1972/73): 222-37.

 General survey of Edwardian church architecture,
 including Arts and Crafts examples by Lethaby, Wells,
 Caröe, Prior, and others.

215. Coulson, Anthony J. **A Bibliography of Design in**
 Britain 1851-1970. London: Design Council
 Publications, 1979.

 A very extensive annotated bibliography including
 both primary and secondary sources, and covering
 (among much else) many of the major Gothic Revival

designers and theorists, as well as topics such as
International Exhibitions, arts schools, color,
ornament and pattern, metalwork, furniture, and
textiles.

216. Creese, Walter L. **The Search for Environment. The
 Garden City: Before and After.** New Haven and
 London: Yale Univ. Press, 1966.

 Traces the development of garden city planning and
 ideals from the early nineteenth century suburbs
 through the early twentieth century. Relevant to this
 bibliography primarily for its excellent discussion of
 the role of medievalism, both formal and ideological,
 in the thought of Raymond Unwin, and in the quasi-
 Tudor architecture of Parker and Unwin. Also analyzes
 the neo-Gothic architecture of Akroydon (Sir G.G.
 Scott and W.H. Crossland,, 1861-63) and the
 contribution of E.W. Godwin and Richard Norman Shaw to
 Bedford Park.

217. Crook, J. Mordaunt. "Ruskinian Gothic." **The Ruskin
 Polygon** (no. 237), pp. 65-93.

 Discusses Millais' architectural designs, works of
 Deane and Woodward, Street, Scott, and commercial
 architecture of London, Bristol, and Manchester.

218. Cunningham, Colin. **Victorian and Edwardian Town
 Halls.** London: Routledge & Kegan Paul, 1981.

 A comprehensive study of politics, patronage,
 architecture, and decoration; includes some of the
 most famous (as well as some little known) Gothic
 examples.

219. Curl, James Stevens. **Victorian Architecture. Its
 Practical Aspects.** Newton Abbot: David and
 Charles, 1973.

 Includes chapters on Bassett Keeling (see no. 311)
 and on aspects of symbolism in neo-Gothic church
 architecture.

220. Darby, Elizabeth, and Nicola Smith. **The Cult of the
 Prince Consort.** New Haven and London: Yale Univ.
 Press, 1983.

 Surveys a wide range of commemorative art and
 architecture produced after Prince Albert's death in
 1861, including Sir George Gilbert Scott's Albert
 Memorial Chapel at Windsor (with an elaborate tomb by
 Baron Triqueti) and his famous Memorial in London,
 Ludwig Grüner's Romanesque-Renaissance Royal Mausoleum
 at Frogmore, and a host of sculptures, paintings,
 monuments, museums, hospitals, and schools, many
 adopting medieval styles and imagery.

221. Davey, Peter. **Architecture of the Arts and Crafts
 Movement.** New York: Rizzoli, 1980.

 A broad study of English Arts and Crafts
 architecture from Morris through the garden suburbs of
 Parker and Unwin; two chapters also on the continent
 and the United States.

222. Dellheim, Charles. **The Face of the Past: The
 Preservation of the Medieval Inheritance in
 Victorian England.** Cambridge: Cambridge Univ.
 Press, 1982.

 Explores the Victorians' fascination with their
 past and their reworking of it within an industrial
 society; includes discussions of the growth of local
 archaeology and history, the practice of restoration
 and preservation (especially in Leeds and York), and
 the neo-Gothic architecture of the industrial city
 (Manchester).

223. Dickinson, Gillian. **Rutland Churches Before
 Restoration. An Early Victorian Album of
 Watercolours and Drawings.** London: Barrowden
 Books, 1983.

 The drawings are juxtaposed with modern photographs
 and accompanied by a commentary on the intervening
 changes, making this an interesting side-light on
 Victorian restoration practices. Also includes brief

essays on Rutland churches in the middle ages, the
Anglican church in the early nineteenth century, and
the Ecclesiological Society and church restoration
(contributions by Richard J. Adams, Geoffrey K.
Brandwood, and R.P. Brereton).

224. Dixon, Robert, and Stefan Muthesius. **Victorian
Architecture.** New York and Toronto: Oxford Univ.
Press, 1978.

A short but useful survey and quick reference
source for the period.

225. Edwards, Tudor. "Victorian Castles." **History Today**
19 (1969): 225-31.

Not available to the annotator.

226. Elleray, D. Robert. **The Victorian Churches of Sussex.**
London and Chichester: Phillimore and Co., 1981.

Elleray estimates that over 600 churches and
chapels were built in Sussex between 1810 and 1914:
the vast majority were Gothic in style. Individual
chapters survey the Anglican Revival in Sussex,
ritualist controversies, architecture, and
preservation issues. Includes over 200 photographs
covering a wide range of types and styles, as
well as a checklist of Sussex churches and chapels,
1810-1914.

227. Fawcett, Jane, ed. **Seven Victorian Architects.**
London: Thames and Hudson, 1977.

Includes essays on three leading Victorian
Gothicists: John Loughborough Pearson (David Lloyd),
George Frederick Bodley (David Verey), and Alfred
Waterhouse (Stuart Allen Smith). Also essays on
William Burn (David Walker) and P.C. Hardwick
(Hermione Hobhouse), both prolific in the Tudor and
Jacobean styles.

228. Ferriday, Peter. "The Church Restorers." **AR** 136
 (1964): 87-95.

 Surveys the theory and practice of nineteenth
 century English church restoration, through Morris and
 the S.P.A.B.; outlines the mechanics of restoration
 campaigns in a social and historical context;
 describes the Gothicists' treatment of classic
 churches.

229. ————, ed. **Victorian Architecture.** Philadelphia and
 New York: J.B. Lippincott Company, 1964.

 When it was published, this was a ground-breaking
 collection of essays: most have been superseded by
 more recent research. Included are short general
 essays on Pugin (Alexandra Gordon Clark), Butterfield
 (Paul Thompson), Scott (David Cole), Burges (Charles
 Handley-Read; perhaps the most important essay in the
 collection), Street (Joseph Kinnaird), Webb (John
 Brandon-Jones), Voysey (John Brandon-Jones), and
 Bentley (Halsey Ricardo; this last an obituary
 notice).

230. Girouard, Mark. **Sweetness and Light. The "Queen
 Anne" Movement** 1860–1900. Oxford: Oxford Univ.
 Press, 1977.

 A comprehensive survey of an architectural style
 which softened the rigor of the Gothic Revival,
 blending some of its principles with English
 Renaissance and vernacular forms. Includes garden
 design, the decorative arts, and book illustration.

231. ————. **The Victorian Country House.** Rev. and enl.
 edition. New Haven and London: Yale Univ. Press,
 1979.

 A fundamental study of an important architectural
 type, including many fine Gothic examples by Burges,
 Butterfield, Pearson, Pugin, Salvin, Scott, Teulon,
 Webb, White, and others; first published in 1971.

232. Handley-Read, Charles. "Sculpture and Modelling in
 Victorian Architecture." **Royal Society of British
 Sculptors, Annual Report, 1960.** London (1961),
 pp. 36-42.

 Not available to the annotator.

233. Harrison, Martin. **Victorian Stained Glass.** London:
 Barrie and Jenkins, 1980.

 Scholarly history of English stained glass from the
 revival of the 1830s through the Arts and Crafts, with
 excellent photographs and apparatus including guide to
 primary sources and gazeteer.

234. Hersey, George L. **High Victorian Gothic. A Study in
 Associationism.** Baltimore and London: The Johns
 Hopkins Univ. Press, 1972.

 Beginning with a study of eighteenth and early
 nineteenth century theorists, Hersey interprets the
 architecture and writing of Pugin, Ruskin,
 Butterfield, and others, in terms of the theory of
 association, touching on themes of sexuality and
 sadomasochism.

235. Howell, Peter. **Victorian Churches.** Feltham: Country
 Life Books, 1968.

 A picture book illustrated with drawings in the
 collection of the Royal Institute of British
 Architects.

236. Jervis, Simon. **High Victorian Design.** Ottawa: The
 National Gallery of Canada, 1974.

 Catalogue of an important exhibition including much
 Gothic material, mainly furniture, metalwork,
 ceramics, books, and architecture.

237. Kaufman, Edward N. "'The Weight and Vigour of their
 Masses': Mid Victorian Country Churches and 'The

Lamp of Power.'" **The Ruskin Polygon. Essays on
the Imagination of John Ruskin,** edited by John
Dixon Hunt and Faith M. Holland, pp. 94-121.
Manchester: Manchester Univ. Press, 1982.

Interprets Gothic Revival church architecture of
the 1850s and 1860s in the context of Ruskin's **Seven
Lamps,** geology, theology, and Victorian concepts of
history.

238. Kornwolf, James D. "High Victorian Gothic; or, The
 Dilemma of Style in Modern Architecture." JSAH 34
 (1975): 34-47.

 Analyzes attitudes of recent scholars, including
 Summerson, Hitchcock, Pevsner, Hersey, and Muthesius.

239. Linstrum, Derek. **West Yorkshire. Architects and
 Architecture.** London: Lund Humphries, 1978.

 The chapter on Victorian churches is valuable for
 its discussion of several important buildings: St.
 Peter's, Leeds (R.D. Chantrell, 1837-1841: W.F.
 Hook's church and an early center of Ecclesiology);
 St. Savior, Leeds (J.M. Derick, 1842-1845: Pusey's
 church, with fittings by Pugin, Bodley, and Temple
 Moore); Mt. St. Mary, Leeds (J.A. Hansom and E.W.
 Pugin, 1852ff.: an important Catholic church);
 All Souls, Halifax (Sir G.G. Scott, 1856-1859). Also
 of interest is a very late church by Randall Wells as
 well as important buildings by Sir G.G. Scott,
 Lockwood and Mawson, and many others.

240. London. Victoria and Albert Museum. **Victorian
 Architectural Source Books Displayed in the
 Exhibition MARBLE HALLS. 2 August to 28 October
 1973.** Exhibition catalogue. 1973.

 Unillustrated typescript catalogue of architectural
 books, primarily useful for its bibliographic
 information on antiquarian studies of Gothic
 architecture, pattern books, design manuals, view
 books, and studies of Gothic ornament. (For
 Marble Halls, see no. 251.)

241. ———. **Victorian Church Art.** 1971.

Catalogue of an important exhibition covering the
architecture and liturgical arts of Pugin,
Butterfield, Burges, Street, Scott, Bodley, Morris,
and many other Gothicist or Arts and Crafts designers.

242. Meara, David. **Victorian Memorial Brasses.** London,
Boston, Melbourne, Henley: Routledge and Kegan
Paul, 1983.

The medieval art of brass engraving was revived at
the end of the 1830s, under Pugin's leadership, and
was prolifically practiced throughout the Victorian
period and beyond. Though covering the entire period,
Meara concentrates on Pugin and his Birmingham
collaborator, Hardman. Well illustrated, with
gazeteer, list of engravers, and details on the
leading firms.

243. Messenger, Michael. "Revival of a Medieval Technique.
Encaustic Tiles in the Nineteenth Century." CL 163
(1978): 214-15.

The revival of medieval tile making, 1830s-1880s;
Minton and other leading firms.

244. Meyer, André. "Englische Kirchen in der Schweiz."
**Zeitschrift für Schweizerische Archäologie und
Kunstgeschichte** 29 (1972): 70-81.

Late nineteenth century Anglican churches in
Switzerland are surveyed with reference to English
Gothic Revival design sources; includes one important
church by an English architect, R.P. Pullan's church
in Pontresina (1882).

245. Middleton, R. "Viollet-le-Duc's Influence in
Nineteenth-Century England." AH 4 (1981): 203-19.

Describes Viollet-le-Duc's trip to England in 1850,
his relationship with the Royal Institute of British

Architects, and with architects such as Burges,
Street, Scott, and Waterhouse.

246. Muthesius, Stefan. **Das englische Vorbild: Eine Studie
 zu den deutschen Reformbewegungen in Architektur,
 Wohnbau und Kunstgewerbe im späteren 19.
 Jahrhundert.** Munich: Prestel-Verlag, 1974.

 Though concentrating on late nineteenth century
 German architecture and decoration, Muthesius covers
 the English Gothic Revival of the 1830s-1850s and its
 influence.

247. ————. **The High Victorian Movement in Architecture
 1850-1870.** London and Boston: Routledge & Kegan
 Paul, 1972.

 A fundamental study of Victorian Gothic
 architecture and theory, starting with Pugin and
 Ecclesiology; concentrates mainly on religious
 architecture, but also includes a chapter on public
 and commercial architecture.

248. ————. "L'influence du rationalisme neo-gothique sur
 l'architecture populaire en Angleterre à la fin du
 XIXème siècle." **Actes du Colloque International
 Viollet Le Duc, Paris 1980.** Paris: Nouvelles
 Editions Latines, 1982, pp. 385-88.

 Focuses on changes in the façade treatment of
 English terrace housing.

249. ————. "The 'Iron Problem' in the 1850s." **ArchH** 13
 (1970): 59-63.

 Analyzes the responses of English Gothicists such
 as Deane and Woodward, Carpenter, Scott, and Ruskin,
 to cast iron.

250. Naylor, Gillian. **The Arts and Crafts Movement: A
 Study of its Sources, Ideals and Influences on
 Design Theory.** Cambridge, Mass.: MIT Press, 1971.

An extensively illustrated study of the decorative
arts, covering the formation of guilds; Morris and the
Pre-Raphaelites; Arts and Crafts sources in Pugin, the
Gothic Revival, Ruskin, and the South Kensington
Schools.

* Pevsner, Nikolaus. "Art Furniture of the 1870s." In
Studies in Art, Architecture and Design, Vol. 2
(no. 22), pp. 119-32.

251. Physick, John, and Michael Darby. **"Marble Halls."**
Drawings and Models for Victorian Secular
Buildings. London: Victoria and Albert Museum,
1973.

A major exhibition catalogue, organized by building
type; includes Barry and Pugin's Houses of Parliament,
Waterhouse's Manchester Town Hall, Sir George Gilbert
Scott's Government Offices, and other important Gothic
buildings. For books exhibited, see no. 240.

* Piggott, Stuart. "The Origins of the English County
Archaeological Societies." In **Ruins in a Landscape**
(no. 61).

252. Powell, H.J. "Herefordshire Churches of the Gothic
Revival." **Transactions of the Woolhope**
Naturalists' Field Club, Herefordshire 40, pt. III
(1972): 304-11.

Concentrates on the period ca. 1840-1900.

253. Read, Benedict. **Victorian Sculpture.** New Haven,
London: Yale Univ. Press, 1982.

Includes a discussion of Gothic Revival
architectural sculpture.

254. Richardson, Margaret. **The Craft Architects.**
New York: Rizzoli, 1982.

One of a series of well-illustrated books devoted
to the resources of the Royal Institute of British
Architects Drawings Collection, this volume on the
Arts and Crafts includes Gothicists like Bodley,
Sedding, and Temple Moore, as well as Shaw, Prior,
Voysey, and others.

255. Rose, Elliot. "The Stone Table in the Round Church
 and the Crisis of the Cambridge Camden Society."
 VS 10 (1966/67): 119-44.

 Analyzes the liturgical and architectural
 controversies which surrounded the Society (later the
 Ecclesiological Society) in the 1840s, focusing on the
 restoration of the Holy Sepulchre Church in Cambridge.

256. Royal Academy of Arts (London). **Victorian and
 Edwardian Decorative Art. The Handley-Read
 Collection.** London: The Royal Academy of Arts,
 1972.

 A major collection, containing numerous important
 medievalist pieces, such as furniture by Pugin,
 Street, Burges, and Bevan; also includes ceramics,
 glass, metalwork, textiles, book design, as well as
 paintings, drawings, prints, and sculpture.

257. Service, Alastair. **Edwardian Architecture. A
 Handbook to Building Design in Britain, 1890-1914.**
 London: Thames and Hudson, 1977.

 A brief survey of a period when Gothic still
 provided inspiration for many English architects.

258. Service, Alastair, et al. **Edwardian Architecture and
 its Origins.** London: Architectural Press, 1975.

 Collection of essays, mostly reprinted from earlier
 publications, covering a wide range of architects,
 styles, and building types.

259. Sewter, A.C. "Victorian Stained Glass." **Apollo** 76 (1962): 760-65.

 A brief appreciation of Victorian stained glass, mostly Gothic, up to Morris.

260. Sheehy, Jeanne. **The Rediscovery of Ireland's Past: The Celtic Revival** 1830-1930. London: Thames and Hudson, 1980.

 The revival of Irish medieval architecture and sculpture, metalwork, book illumination, and pictorial subjects.

261. Simpson, Duncan. "Beautiful Tudor." **A**R 162 (1977): 29-36.

 The Tudor fashion in English architecture and furnishing of the late nineteenth-early twentieth centuries, ranging from the Arts and Crafts to popular suburban mock-Tudor.

262. Stamp, Gavin. "The Battle of the Styles in Architectural Graffiti." ArchH 23 (1980): 141-42.

 Describes graffiti found in a Cambridge basement, signed "GGS" and dating from about 1862: a caricatural sketch of classical architecture, a statue of Prince Albert, and a reference to the architect Hardwick.

263. Stanton, Phoebe. "Architecture, History, and the Spirit of the Age." In **The Mind and Art of Victorian England**, edited by Josef L. Altholz, pp. 146-58. Minneapolis: Univ. of Minnesota Press, 1976.

 Studies the effects of historical knowledge on nineteenth century architectural thought, attitudes to the medieval past.

* Stern, Robert A.M., ed. **The Anglo-American Suburb**. AD **Profile**, 1981. Cited below as no. 661.

264. Summerson, John. **Victorian Architecture: Four Studies
 in Evaluation.** New York: Columbia Univ. Press,
 1970.

 Three lectures covering some of London's most
 famous Gothic revival buildings: churches by Street
 and Lamb, Scott's St. Pancras Station, Street's Law
 Courts; and a fourth lecture on the "Problem of
 Failure."

265. Symondson, Anthony. "Medieval Taste in Victorian
 Churches." CL 141 (1967): 1400, 1403.

 Victorian Gothic church plate from Pugin to Henry
 Wilson.

266. White, James F. **The Cambridge Movement, the
 Ecclesiologists and the Gothic Revival.** Cambridge:
 Cambridge Univ. Press, 1962.

 The basic study of the movement which merged
 liturgical revivalism with Gothic architecture in the
 1830s, definitively shaping the Gothic Revival.

267. Wight, Jane. **Medieval Floor Tiles: Their Design and
 Distribution in Britain.** London: J. Baker, 1975.

 Also covers the Victorian revival of encaustic
 tilemaking.

 2. **Monographs: Architects, Designers, Critics, Patrons**

ASHBEE, CHARLES ROBERT (1863-1942)

268. MacCarthy, Fiona. **The Simple Life. C.R. Ashbee in
 the Cotswolds.** Berkeley and Los Angeles: Univ. of
 California Press, 1981.

 This lively and perceptive book chronicles the life
 of Ashbee's Guild of Handicraft from its removal to
 Chipping Campden in 1902 until its dissolution in
 1907.

BALL, J.H. (1861-1931)

269. Taylor, Nicholas. "St. Agatha's, Landport: Basilica
 of the Nineties." **AR** 135 (1964): 343-49.

 The story of an unusual Early Christian basilica
 built for a controversial slum priest and missionary;
 the architect was J.H. Ball, a pupil of Waterhouse,
 and the decorations were by Morris' disciple, Heywood
 Sumner. Taylor discusses the liturgical controversies
 over the basilican scheme and sets it in the context
 of Victorian views of Romanesque and Early Christian
 architecture.

BARRY, SIR CHARLES (1795-1860)

 Primarily known as a classicist, Barry was the
 architect of the most important Gothic building of the
 first half of the nineteenth century, Westminster New
 Palace. For convenience, the bibliography on the
 Houses of Parliament, as the building is generally
 known, has been thrown in with the more extensive
 bibliography on A.W.N. Pugin, whose elegant gothic
 drawing helped Barry win the competition and
 who designed much of the detailing and furnishing.
 For Barry's Gothic Commissioners' Churches, see no. 62
 and Marcus Whiffen, **Stuart and Georgian Churches**,
 London, 1947-48.

BELLOT, PAUL (1876-1944)

270. Pevsner, Nikolaus. "Quarr and Bellot." **AR** 141
 (1967), 307-10.

 Quarr Abbey was designed in 1907 in an imaginative
 modernized Gothic style by a Frenchman, Paul Bellot,
 who later worked in Canada.

BENTLEY, JOHN FRANCIS (1839-1902)

 See Winifrede de l'Hopital, **Westminster Cathedral
 and its Architect**, London [1919], and W.W. Scott-
 Moncrieff, **John Francis Bentley**, London, 1924.

271. Butler, A.S.G. **John Francis Bentley. The
 Architecture of Westminster Cathedral. An Essay.**
 London: Burns & Oates, 1961.

 An appreciative analysis of Bentley's Byzantine
 masterpiece, begun in 1894, preceded by brief
 descriptions of several of his earlier Gothic
 churches.

272. Howell, Peter, ed. "Letters from J.F. Bentley to
 Charles Hadfield." **ArchH** 23 (1980): 95-137;
 ArchH 25 (1982): 65-97.

 These letters, written between 1862 and 1902 to the
 son of M.E. Hadfield (see no. 182), contain
 illuminating references to Bentley's works, as well as
 comments on polychromy, decorative arts, and the works
 of contemporary Gothicists. Howell provides a
 biographical introduction and extensive commentary.

273. Hunting, Penelope. "From Gothic to Red Brick. The
 Planning of Westminster Cathedral." CL 167 (1980):
 580-82.

 A brief history of the events leading up to the
 design of Bentley's masterpiece, including the
 Catholic Revival, the preparation of Henry Clutton's
 French Gothic design of 1868-73 (illustrated), and
 later negotiations (carried out at the behest of Sir
 Tatton Sykes--see no. 395) with the Viennese
 Gothicist Heinrich von Ferstel.

274. Robinson, John Martin. "Carlton Towers, Yorks."
 Connoisseur 190 (1975): 42-49.

 Contains magnificent interiors by J.F. Bentley,
 1874-76.

275. ———. "Carlton and the Stapletons: The History
 of a Recusant Family." **Connoisseur** 202 (1979):
 15-21.

 Expands on no. 274.

BODLEY, GEORGE FREDERICK (1827-1907)

See Edward Warren, "The Life and Work of George Frederick Bodley," **Journal of the Royal Institute of British Architects** 17 (1919): 305-40. For Bodley's work on Washington Cathedral, see nos. 929-31, 933-35.

276. Symondson, Anthony N.R. "G.F. Bodley and St. Salvador's, Dundee." **Bulletin of the Scottish Georgian Society** 1 (1972): 10-23; 2 (1973): 70-71.

Designed in stages from 1857 thrugh 1874, the school and church of St. Salvador's chart Bodley's progress towards his mature style. Focusing on painted decoration, Symondson analyzes Bodley's relationships with the decorative firms of C.E. Kempe, Burlison and Grylls, and Morris, reassessing his significance as a decorative designer.

* Verey, David. "George Frederick Bodley: Climax of the Gothic Revival." In **Seven Victorian Architects** (no. 227), pp. 84-101.

277. ———. "Two Early Churches by Bodley." CL 149 (1971): 1246-49.

Brief illustrated account of St. John the Baptist, France Lynch, 1854 (Bodley's first complete church), and All Saints, Selsley, 1861-1862. At Selsley, Bodley commissioned some of William Morris and Company's earliest stained glass: the overall scheme was devised by Philip Webb, the windows designed by Morris, Burne-Jones, Rossetti, and Ford Madox Brown.

BRYCE, DAVID (1803-1876)

278. Fiddes, Valerie, and Alistair Rowan. **David Bryce. 1803-1876.** Edinburgh: Univ. of Edinburgh, 1976.

Bryce was the leading exponent of the Scottish Baronial style. His work and career are surveyed in this exhibition catalogue, which contains essays by

Alistair Rowan, David Walker, John Gifford,
Christopher Christie, and Peter Blythe.

BUCKERIDGE, CHARLES (1832-1873)

279. Saint, A. "Charles Buckeridge and his Family."
 Oxoniensia 38 (1973/74): 357-572.

 A pupil of Scott and a Tractarian Goth, Buckeridge
 set up a practice in Oxford in 1856, working
 especially for the revived religious orders; at his
 death, his practice was inherited by Pearson; his son,
 a decorator, worked extensively for Bodley.

BUCKLER, CHARLES ALBAN (1824-1905)

 See no. 182.

BURGES, WILLIAM (1827-1881)

280. Crook, J. Mordaunt. "Knightshayes, Devon: Burges
 versus Crace." **National Trust Year Book** 1975-76.

 Careful study of the sumptuous decorative scheme
 for one of Burges's most important country houses.

281. ————, ed. **The Strange Genius of William Burges
 'Art-Architect,'** 1827-1881. Cardiff: National
 Museum of Wales, 1982.

 Catalogue of a major exhibition of architecture and
 decorative works by this major Victorian Gothic
 Revival designer. Essays by Clive Wainwright and
 Virginia Glenn, catalogue entries by Mary Axon and
 Virginia Glenn.

282. ————. "William Burges and the Dilemma of Style."
 AR 170 (1981): 8-15.

 The evolution of Burges's ideas, as shown in
 architecture, furnishings, and writings, on

eclecticism, Gothic, and the search for a new style of the nineteenth century.

283. ———. **William Burges and the High Victorian Dream.** London: John Murray, 1981.

A long and fundamental study of one of the most original of Victorian architects, covering his life, architecture, decorative arts, and writing.

284. Handley-Read, Charles. "Note on William Burges's Painted Furniture." **Burl** 105 (1963): 496-509.

Burges designed furniture which included decorative panels painted by E.J. Poynter, Stacy Marks, Simeon Solomon, Henry Holliday, Albert Moore, Fred Weekes, and others.

285. ———. "St. Fin Barre's Cathedral." **AR** 141 (1967): 422-30.

Built in 1862-83, Cork Cathedral is one of William Burges's masterpieces of Gothic architecture and decoration.

* ———. "William Burges." In **Victorian Architecture** (no. 229), pp. 185-220.

286. Taylor, Nicholas, and Anthony Symondson. "Burges and Morris at Bingley: A Discovery." **AR** 144 (1968): 34-38.

The furnishings and decoration of Oakwood, the home of a Yorkshire cloth merchant; the illustrations include selections from a volume of Burges's drawings found in the house.

BURN, WILLIAM (1789-1870)

For Burn's Scottish houses and his role in the
popularization of the Scottish baronial style, see
no. 57.

* Walker, David. "William Burn: The Country House in
 Transition." In **Seven Victorian Architects**
 (no. 227), pp. 8-31.

BUTTERFIELD, WILLIAM (1814-1900)

287. Summerson, John. "William Butterfield, or the Glory
 of Ugliness." **Heavenly Mansions and Other Essays
 on Architecture.** New York: W.W. Norton & Co.,
 1963.

 First published in **AR** in 1945 (with more
 illustrations), this is a pioneering attempt to
 interpret Butterfield's High Victorian Gothic
 aesthetic, focusing on All Saints, Margaret Street
 (1849-59).

288. Thompson, Paul. "All Saints Church, Margaret Street,
 Reconsidered." **ArchH** 8 (1965): 73-94.

 A close analysis of Butterfield's masterpiece,
 1849-59, with a reinterpretation of its architectural
 significance.

289. ————. "Butterfield's Masterpiece Re-Assessed." CL
 137 (1965): 60-62.

 A less scholarly counterpart to no. 288.

290. ————. "Exporting the Gothic Revival: Butterfield's
 Australian Cathedrals" and "The Building of
 Melbourne Cathedral." CL 150 (1971): 622-24,
 686-90.

 Butterfield designed two High Victorian Gothic
 cathedrals in Australia: Adelaide (1847, 1868), and

Melbourne (1878), the latter being one of his greatest polychrome Gothic interiors.

* ———. "William Butterfield." In **Victorian Architecture** (no. 229), pp. 165-74.

291. ———. **William Butterfield.** Cambridge, Mass.: MIT Press, 1971.

A substantial monograph on one of the greatest of the High Victorian Gothic architects, the designer of All Saints, Margaret Street and of Keble College, Oxford.

BYRNE, PATRICK (1783-1864)

292. Raftery, Patrick. "The Last of the Traditionalists. Patrick Byrne, 1783-1864." **Quarterly Bulletin of the Irish Georgian Society** 7 (1964): 48-67.

A brief survey of Byrne's work in both classic and Gothic styles, including St. John the Baptist, Blackrock (1842), one of the first Gothic Revival Catholic churches in Ireland.

CONDER, JOSIAH (?-1920)

293. Lerski, Hanna. "Josiah Conder's Bank of Japan, Tokyo." **JSAH** 38 (1979): 271-74.

Conder was a student of William Burges who emigrated to Japan. The building, begun in 1878, is quasi-Venetian in style. Lerski sets Conder's work in the context of Japanese traditions and of contemporary European aestheticism; also discusses his innovations in earthquake protection and provides further bibliography.

294. Suzuki, H. "Josiah Conder and England." **Kenchikushi Kenyu** 40 (1976-9): 1-15.

Not available to the annotator.

DAUKES, SAMUEL WHITFIELD (1811-1880)

295. Verey, David. "Samuel Whitfield Daukes." CL 154
 (1973): 1914-16, 2016-18.

 A Victorian eclectic, Daukes designed several Tudor
 and Gothic public buildings in Gloucestershire, as
 well as an important Romanesque church, St. Peter,
 Cheltenham.

DEANE, THOMAS NEWENHAM (1828-1899) and BENJAMIN WOODWARD
(1815-1861)

 See C.P. Curran, "Benjamin Woodward, Ruskin and the
 O'Sheas," **Studies: An Irish Quarterly Review of
 Letters, Philosophy & Science** 29 (1940): 255-68.

296. Blau, Eve. "The Earliest Work of Deane and Woodward."
 Architectura 9 (1979): 170-91.

 Before going on to the famous Oxford Museum, Deane
 and Woodward designed some large Gothic country houses
 in Ireland in the 1830s and 1840s.

297. ————. **Ruskinian Gothic. The Architecture of Deane
 and Woodward** 1845-1861. Princeton: Princeton Univ.
 Press, 1982.

 Concentrates on the firm's major Ruskinian Gothic
 buildings, Trinity College Museum, Dublin, the Oxford
 Museum, and the Oxford Union (site of the famous
 Pre-Raphaelite fresco cycle); also covers the firm's
 earlier Gothic works and the Ruskinian commercial
 buildings of the 1850s.

298. Ferriday, Peter. "The Oxford Museum." **AR** 132 (1962):
 408-16.

 Sketches the rise of the sciences at Oxford, the
 competition for the Oxford Museum, its design,
 construction, and decoration, including the
 participation of Ruskin and the sculptors Woolner and
 O'Shea.

299. Girouard, Mark. "Clontra, Co. Dublin." CL 157
 (1975): 1390-93.

 A suburban villa in a ruggedly Gothic style, built
 about 1860-1862 and containing rooms frescoed by John
 Hungerford Pollen in 1862.

DENISON, EDWARD BECKITT, LORD GRIMTHORPE (1816-1905)

 Peter Ferriday's biography, **Lord Grimthorpe**
 1816-1905 (London, 1957), contains a chapter on
 Denison's role as a Gothic revivalist and chronicles
 in some detail Denison's highly controversial
 restorations at St. Alban's and elsewhere.

DERICK, JOHN MACDUFF (?-1861)

 Derick's Gothic St. Saviour, Leeds, built for the
 Tractarian leader Pusey, is discussed in G.G. Pace,
 "Pusey and Leeds," **AR** 98 (1945): 178-80.

EMMETT, JOHN T. (1828-1898)

300. Emmett, John T. **Six Essays.** Introduction by J.
 Mordaunt Crook. New York and London: Johnson
 Reprint Corporation, 1972.

 A reprint of essays published between 1872 and
 1881, in which Emmett, fueled by a Ruskinian belief in
 the value and a Morrissian conviction of the goodness
 of medieval society, launched a stinging attack
 against the crass commercialism of nineteenth century
 architecture and workmanship. Crook's short
 introduction charts the progress of Emmett's thought
 and the storms of controversy which he aroused.

FOTHERGILL, WATSON (1841-1928)

301. Brand, Ken. **Watson Fothergill, Architect.**
 Nottingham: Nottingham Civic Society [1981].

 Fothergill (born Fothergill Watson) was
 Nottingham's leading exponent of a tough, typically

High Victorian Gothicism, which he continued to
practice with some Queen Anne modifications until
about 1900. This pamphlet surveys his life and work.

GIMSON, ERNEST (1864-1919)

See William Lethaby, Alfred Powell, and Frederick
Briggs, **Ernest Gimson, His Life and Work**, London,
1924.

302. Carruthers, Annette. **Ernest Gimson and the Cotswold
 Group of Craftsmen. A Catalogue of Works by Ernest
 Gimson, Edward and Sidney Barnsley and Peter Waals,
 in the Collections of Leicestershire Museums.**
 Leicestershire Museum Publications, No. 14, 1978.

 Catalogue of a leading group of Arts and Crafts
 designers.

303. Comino, Mary. **Gimson and the Barnsleys. "Wonderful
 Furniture of a Commonplace Kind."** London: Evans
 Brothers, 1980.

 While studying architecture, Gimson came under the
 influence of Morris and the Arts and Crafts and became
 interested in furniture and the decorative arts,
 working alongside Sidney and Ernest Barnsley, first
 with Kenton and Company and then in the Cotswolds.
 This thorough and well illustrated monograph traces
 their careers and analyzes their architecture and
 decorative arts, clients, and modes of production.

GODWIN, EDWARD WILLIAM (1833-1886)

For the work of this High Victorian gothicist
turned aesthetic, see Dudley Harbron, **The Conscious
Stone. The Life of Edward William Godwin** (London,
1949).

GOWANS, SIR JAMES (1821-1890)

304. McAra, Duncan. **Sir James Gowans, Romantic
 Rationalist.** Edinburgh: Paul Harris Publishing,
 1975.

 A brief interpretive survey of this highly
 individualistic Scottish architect whose search for a
 modular basis for design was conceived in emulation of
 the medieval master masons and whose handling of
 structure and materials owed much to the theories of
 Pugin and Viollet-le-Duc.

GRIMTHORPE, LORD

 See EDWARD BECKITT DENISON, LORD GRIMTHORPE

HADFIELD, MATTHEW ELLISON (1812-1885)

 See no. 182. For his and his son Charles's
 relationship with J.F. Bentley, see no. 272.

HARDWICK, PHILIP CHARLES (1822-1892)

* Hobhouse, Hermione. "Philip and Philip Charles
 Hardwick: An Architectural Dynasty." In **Seven
 Victorian Architects** (no. 227), pp. 32-49.

HARDY, THOMAS (1840-1928)

305. **The Architectural Notebook of Thomas Hardy.** Foreword
 by Sir John Summerson. Introduction by C.J.P.
 Beatty. Dorchester: Dorset Natural History and
 Archaeological Society, 1966.

 The great novelist was apprenticed to London
 architect A.W. Blomfield from 1862 to 1867 and
 practiced architecture briefly in Dorset during the
 following years. His surviving notebook, reproduced
 here in facsimile, sheds light on the world of a young
 Gothicist in the 1860s, containing both design and
 antiquarian studies. The introduction relates
 Hardy's sketches to the development of Gothicism in

the 1860s and describes his work as a restorer of
medieval churches.

306. Beatty, C.J.P. **Thomas Hardy and the Restoration of
 St. Peter's Church, Dorchester, 1856-7.** St. Peter
 Port (Guernsey): Toucan Press, 1978.

 Booklet containing reprints of contemporary
 newspaper accounts of the restoration, carried out by
 local architect John Hicks and his assistant, Hardy.
 The accompanying commentary sets the project in
 context of Hardy's work as architect and novelist and
 of the local situation in Dorchester. Hardy's plan of
 the church is reproduced.

HAYWARD, CHARLES FORSTER (1830-1905)

307. Jervis, S. "Gothic at No. 95 Piccadilly. New Lights
 on the Taste of John James." **Apollo,** n.s. 95
 (1972): 206-11.

 Publishes four fine bookcases designed by the
 architect C.F. Hayward, ca. 1858-62, in a freely
 Gothic style with increasingly Ruskinian ornament; one
 is decorated with roundels by Rossetti.

HENSZLMANN, IMRE (1813-?)

308. Zador, Anna. "Henszlmann and the Theory of
 Gothicism." **AR** 140 (1966): 423-26.

 Henszlmann was a Hungarian scholar who fled to
 London after the 1848 revolution; in 1852, a lecture
 on his theory of proportion in Gothic architecture was
 received with great interest by the Royal Institute of
 British Architects; the text is reprinted here with
 commentary.

JACKSON, THOMAS GRAHAM (1835-1924)

 For the life and work of this High Victorian
 Gothicist who helped pioneer the shift to the lighter,
 more eclectic style of the late nineteenth century,

see **Recollections of Thomas Graham Jackson, 1835–1924,** arr. and ed. by Basil H. Jackson (Oxford, 1950).

309. Crook, J. Mordaunt. "T.G. Jackson and the Cult of Eclecticism." **In Search of Modern Architecture: A Tribute to Henry–Russell Hitchcock.** Edited by Helen Searing. Cambridge, Mass.: MIT Press, 1982, pp. 102–20.

Thomas Graham Jackson, pupil of Scott and author of **Modern Gothic** (1873), moved from High Victorian Gothicism to become the leading exponent of an eclectic style rooted in the English Renaissance.

310. Thomas, John. "Sir Thomas Graham Jackson and the Church of Hagia Sophia." **ArchH** 25 (1982): 98–101.

Notes Jackson's annotations of Lethaby and Swainson's **Church of Sancta Sophia** (1894) and his 1910 trip to Istanbul, speculating on Byzantine influence on his 1898 design for Giggleswick School chapel.

KEELING, BASSETT (1837–1882)

311. Curl, James Stevens. "An Inventive Architect, or, Acrobatic Gothic, Freely Treated." In **Victorian Architecture. Its Practical Aspects** (no. 219).

Covers essentially the same material as no. 312.

312. Curl, James Stevens, and John Sambrook. "E. Bassett Keeling, Architect." **ArchH** 16 (1973): 60–70.

Keeling was an imaginative designer of Gothic churches of a non-tractarian nature and varied secular buildings.

LETHABY, WILLIAM RICHARD (1857–1931)

See Royal Institute of British Architects, London: Library. **William Richard Lethaby, 1857–1931: A Bibliography of his Literary Works.** London, 1950.

313. Backmeyer, Sylvia, and Theresa Gronberg, eds. **W.R.
 Lethaby 1857-1931. Architecture, Design and
 Education.** London: Lund Humphries Publishers,
 1984.

 This exhibition catalogue contains essays on
 Lethaby and the Central School of Arts and Crafts
 (Theresa Gronberg), Lethaby and the Art-Workers' Guild
 (John Brandon-Jones), Lethaby's theory of architecture
 (Peter Fuller), his relationship to modernist theory
 (Gillian Naylor), his architecture (Godfrey Rubens),
 and his first book, **Architecture, Mysticism, and Myth**
 (Julian Holder).

314. Rubens, Godfrey. **William Richard Lethaby. His Life
 and Work.** London: Architectural Press, 1984.

 Not available to the annotator.

LITTLE, THOMAS (1801-1859)

315. Curl, James Stevens. "Nunhead Cemetery, London."
 Transactions of the Ancient Monuments Society,
 n.s. 22 (1977): 28-89.

 One of London's most important Victorian
 cemeteries, Nunhead has a Gothic chapel designed by
 Thomas Little in 1844.

LOCKWOOD, HENRY FRANCIS (1811-1878) and RICHARD MAWSON
 (1834-1904)

316. Webb, Igor. "The Bradford Wool Exchange: Industrial
 Capitalism and the Popularity of Gothic." **VS** 20
 (1976-77): 45-68.

 Sets this important building, along with Ruskin's
 lecture "Traffic," in the context of class conflict
 and the struggle for political and cultural
 legitimacy.

LUTYENS, SIR EDWIN (1869-1944)

The basic bibliography on Lutyens includes the
following: Lawrence Weaver, **Houses and Garden** by E.L.
Lutyens (London, 1914; reprint, Woodbridge Suffolk,
1981); A.S.G. Butler, **The Architecture of Sir Edwin
Lutyens** (3 vols., London, 1950; reprint, Woodbridge,
Suffolk, 1984); Christopher Hussey, **The Life of Sir
Edwin Lutyens** (London, 1950). More recent works
include Roderick Gradidge, **Edwin Lutyens, Architect
Laureate** (London, 1981); London: Arts Council of Great
Britain, **Lutyens** (exhibition catalogue, 1981-82); and
Daniell O'Neill, **Sir Edwin Lutyens Country Houses**
(London, 1980).

317. Inskip, Peter. "The Compromise of Castle Drogo." **AR**
 165 (1979): 220-26.

 Evolution of an imposing and romantic castle
 designed by Lutyens between 1910 and 1930.

MCCARTHY, JAMES JOSEPH (1817-1882)

318. Sheehy, Jeanne. **J.J. McCarthy and the Gothic Revival
 in Ireland.** Ulster Architectural Heritage Society,
 1977.

 McCarthy was Pugin's most fervent disciple in
 Ireland; Sheehy presents a short monograph accompanied
 by an illustrated catalogue raisonné.

OGDEN, WILLIAM SHARP (1844-1926)

319. Girouard, Mark. "Acrobatic Architecture: William
 Sharp Ogden and Others." In **In Search of Modern
 Architecture** (no. 309), pp. 121-34.

 Ogden practiced in Manchester in the 1870s-1890s,
 putting forth an individual and energetic form of
 Gothic, especially in his design books; Girouard
 studies these in the context of other Victorian
 individualists like Harris and Roumieu.

PARKER, BARRY (1867-1947) and RAYMOND UNWIN (1863-1940)

320. Creese, Walter L. "Parker and Unwin: Architects of
 Totality." **JSAH** 22 (1963): 161-70.

 Focuses on Parker and Unwin's domestic
 architecture, stressing their links with the crafts
 movement, the social message of William Morris, and
 contemporary architects such as Voysey and Baillie
 Scott.

321. Hawkes, Dean. "The Architectural Partnership of Barry
 Parker and Raymond Unwin. 1896-1914." **AR** 163
 (1978): 327-32.

 Analyzes their architecture and town planning in
 the context of their writings.

322. Hawkes, Dean, and Nicholas Taylor. **Barry Parker and
 Raymond Unwin Architects.** London: Architectural
 Association, 1980.

 Brief exhibition catalogue focusing on the
 partners' domestic architecture.

PAXTON, JOSEPH (1803-1865)

323. Girouard, Mark. "Lismore Castle, Co. Waterford." **CL**
 136 (1964): 336-40, 388-93.

 A seventeenth century house, restored and partially
 Gothicized by William Atkinson in 1811 and more
 ambitiously in 1850-58 by Paxton, with interiors by
 John Gregory Crace. Pugin supplied many designs for
 furniture and decoration.

PEARSON, JOHN LOUGHBOROUGH (1817-1897)

* Lloyd, David. "John Loughborough Pearson: Noble
 Seriousness." In **Seven Victorian Architects**
 (no. 227), pp. 66-83.

324. Quiney, Anthony. **John Loughborough Pearson.** New
 Haven and London: Yale Univ. Press, 1979.

 Pearson was one of the greatest Victorian designers
 of churches: this monograph concentrates on his church
 architecture, including his extensive activity as a
 restorer.

PRITCHARD, JOHN (1817-1876)

325. Tyack, Geoffrey. "A Victorian Architectural
 Correspondence." **ArchH** 22 (1979): 78-87.

 The story of Ettington Park, 1858, by John
 Pritchard, a masterpiece of High Victorian Gothic
 polychromy; also publishes a design by G.E. Street.

PUGIN, AUGUSTUS WELBY NORTHMORE (1812-1852)

 The literature on Pugin is extensive. In addition
 to Benjamin Ferrey's early biography, reprinted in
 1978 and listed below, see S. Ayling, **Photographs of
 Sketches from the Notebooks of Augustus Welby N.
 Pugin,** London, 2 vols., 1865; E. W. Pugin, **Who was the
 Art Architect of the Houses of Parliament,** 1867;
 August Reichensperger, **Augustus Welby Northmore Pugin,**
 Freiburg im Breisgau, 1877; Paul Waterhouse, "The Life
 and Work of Welby Pugin," **AR** 3 (1898): 167-75, 211-21,
 264-73; **AR** 4 (1898): 23-27, 67-73, 115-18, 159-65;
 R. Dell, "Who was the Architect of the Houses of
 Parliament? New Light on an Old Controversy,"
 Burl 8 (1906): 403-20; W.A. Wickham, "Pugin and the
 Re-building of Winwick Chancel," **Transactions of the
 Historical Society of Lancashire and Cheshire** 23
 (1908): 132-60; Canon Greaney, "Oscott: The Buildings
 and Furniture," **The Oscotian** 19 (1919): 119-27;
 Michael Trappes-Lomax, **Pugin, a Medieval Victorian,**
 1932; John Piper, "St. Marie's Grange: the First Home
 of A.W.N. Pugin," **AR** 98 (1945): 90-93; James
 Pope-Hennessey and Hans Wild (photographs), **The Houses
 of Parliament,** London, 1945; Dennis Gwynn, **Lord
 Shrewsbury, Pugin, and the Catholic Revival,** 1946;
 John Summerson, "Pugin at Ramsgate," AR 103 (1948):
 163-67; Phoebe Stanton, "Pugin at Twenty-one: Drawings
 of an Imaginary Deanery," **AR** 110 (1951): 187-90;

Phoebe Stanton, "Some Comments on the Life and Work of
Augustus Welby Northmore Pugin," **Journal of the Royal
Institute of British Architects,** s. 3, 60 (1952):
47-54; T.S.R. Boase, "The Decoration of the New Palace
of Westminster," **Warb** 17 (1954): 319-58; Henry-Russell
Hitchcock, "Pugin as Church Architect," in **Early
Victorian Architecture** I, New Haven, 1954, pp. 56-96;
Phoebe Stanton, "Pugin: Principles of Design versus
Revivalism," JSAH 13 (1954): 20-25; T.S.R. Boase, "An
Oxford College and the Gothic Revival," **Warb** 18
(1955): 145-88; Mark Girouard, "Scarisbrick Hall,
Lancashire," CL 123 (1958): 506-9, 580-83. For the
Houses of Parliament and their decorations and
furnishing (both Pugin's and later) see, in addition
to the items listed above, nos. 4, 113, 330-31,
338-39, 344-45, 351-52, 355-56, 528-30, 568-69, 806.

326. Bright, Michael. "A Reconsideration of A.W.N. Pugin's
 Architectural Theories." **VS** 22 (1978-79): 151-72.

 Reads Pugin from the point of view of pragmatic and
 expressive theories of art; studies his theory of
 truth; compares his views with Ruskin's.

327. Bryson, John. "The Balliol that Might Have Been.
 Pugin's Rejected Designs." CL 133 (1963): 1558-61.

 In 1843, Pugin prepared designs for Balliol
 College, Oxford, which he bound up in a little volume
 like a medieval missal; they (and it) caused a storm
 of controversy and were not carried out.

328. Bury, Shirley. "In Search of Pugin's Church Plate.
 Part 1: Pugin, Hardman, and the Industrial
 Revolution." **Connoisseur** 165 (1967): 29-35.

 Recreates a corpus of Pugin church plate,
 chronicles the operation of Hardman's metalworking
 firm, compares Pugin's medievalist polemics with the
 realities of industrial techniques of production.

329. ————. "Pugin and the Tractarians." **Connoisseur** 179
 (1972): 15-20.

A sequel to no. 328, follows the story of Pugin's church plate, his relationship with the firm of Hardman, Hardman's working practices, and Pugin's relations with patrons both Catholic and Anglican, the latter including Thomas Willement (see nos. 414-15).

* Clark, Alexandra Gordon. "A.W.N. Pugin." In **Victorian Architecture** (no. 229), pp. 137-52.

330. Cormack, Patrick. **Westminster Palace and Parliament.** London: 1981.

General history of Houses of Parliament and the institutions they house.

331. Ferrey, Benjamin. **Recollections of A.W.N. Pugin and his Father Augustus Pugin, with an Appendix by E. Sheridan Purcell and an Introduction and Index by Clive and Jane Wainwright.** London: The Scolar Press, 1978.

A reissue of the standard biography, published in 1861, with a new index and introduction on Pugin and his biographer, a pupil and a Gothic revival architect of note.

332. Girouard, Mark. "Alton Castle and Hospital, Staffordshire." CL 128 (1960): 1226-29.

In 1840, Pugin began to design the Hospital of St. John--actually a combination of chapel, schools, and almshouses--for the Earl of Shrewsbury. In 1847, he began a new house for the same patron on an adjacent site. Both are important examples of Pugin's secular Gothic and are described and illustrated here. (For Robert Abraham's work for the same patron at Alton Towers, see no. 63).

333. Glancey, Jonathan. "Pugin Reunion." **AR** 176/2 (1983): 58-63.

An important collection of furniture and ceramics design by Pugin for his own house, The Grange in Ramsgate, and discovered in an Oxfordshire rectory, is here published; the pieces have been acquired for the Palace of Westminster.

334. Harries, John Glen. **Pugin. An Illustrated Life of Augustus Welby Northmore Pugin** 1812-1852. Aylesbury, Bucks.: Shire Publications, 1973.

A short, popular account of the architect's life and work.

335. Jordan, R.F. "Pugin's Clients." **Cornhill Magazine** (Autumn 1962).

Not available to the annotator.

336. Lambourne, Lionel. "Pugin and the Theatre." CL 163 (1978): 1646, 1648.

Traces Pugin's early and passionate involvement with the theater, especially his design of sets and costumes for a production of a ballet based on Sir Walter Scott's **Kenilworth** in 1831; also indicates the influence of the theater on Pugin's later work.

337. Linstrum, Derek. "Pugin Furniture at Lotherton." **Leeds Art Calendar** 70 (1972): 26-29.

Not available to the annotator.

338. London: Victoria and Albert Museum. **A Report by the Victoria and Albert Museum Concerning the Furniture in the House of Lords. Presented to the Sub-Committee of the Offices Committee on Works of Art in the House of Lords.** London: Her Majesty's Stationery Office, 1974.

A documentation of surviving furniture designed by Pugin for the House of Lords and the adjoining parts

of Westminster New Palace: pamphlet with fourteen plates.

339. Macaulay, James. "The Architectural Collaboration Between J. Gillespie Graham and A.W. Pugin." **ArchH** 27 (1984): 406-20.

For the Houses of Parliament competition of 1835, Pugin supplied drawings for two competitors, Barry and Gillespie Graham. Macaulay shows that Pugin's association with Graham began as early as 1829 and that Pugin supplied a good many designs for him.

340. Mostyn, Elfrida. "Abney Hall, Cheshire." CL 133 (1963): 846-49, 910-13.

Abney Hall, a Tudor villa (with Norman elements) designed in 1847 by an unknown architect, was bought in 1849 by the industrialist James Watts. It was then altered and richly decorated by the firm of J.G. Crace in the manner of Pugin, using some of Pugin's designs and furniture.

341. O'Donnell, Roderick. "Pugin in France: Designs for St. Edmund's College Chapel, Douai (Nord) 1840." **Burl** 125 (1983): 607-11.

Built for a colony of English Benedictines, the Chapel has remained virtually unknown: O'Donnell theorizes that, though based on Pugin's preliminary design and partly decorated by Hardman in 1850, it was carried out by a local architect.

342. ————. "Pugin's Designs for Downside Abbey." **Burl** 123 (1981): 231-32.

Publishes drawings for Pugin's first monastic design (1839-42), which would have been one of his largest church schemes.

343. Patrick, James. "Newman, Pugin, and Gothic." **VS** 24 1980-81): 185-208.

Newman's changing attitude to Gothic, and to
architecture in general, is set in the context of his
evolving doctrinal ideas; the growing antagonism
between Newman and Pugin is explained.

344. Port, M.H., ed. **The Houses of Parliament.** New Haven
 and London: Yale Univ. Press, 1976.

A complete discussion of Sir Charles Barry's Gothic
landmark (designed with A.W.N. Pugin's help),
including architecture, decoration, mechanical
innovations, politics, and influence; with
contributions by Phoebe Stanton, Benedict Read, T.S.R.
Boase, Clive Wainwright, Priscilla Metcalf, Shirley
Bury, and others.

345. Rorabaugh, W.J. "Politics and the Architectural
 Competition for the Houses of Parliament,
 1834-1837." **VS** 17 (1973/74): 155-76.

Places the design in the context of Parliamentary
politics, the press, and the structure of the
architectural profession.

346. Schwartz, Rudolf. **A Pugin Bibliography.** American
 Association of Architectural Bibliographers,
 Publication No. 25, Spring, 1963.

Inexpensively produced pamphlet listing works by
Pugin (including later editions and translations) and
about Pugin; the latter interesting as reflecting the
state of research at the beginning of the period
covered in the present work.

347. Stanton, Phoebe. **Pugin.** New York: The Viking Press,
 1972.

A short but fundamental monograph on the
architecture and writing of early nineteenth century
England's most important Gothic revivalist.

348. ———. "The Sources of Pugin's Contrasts." In
 Concerning Architecture (no. 26), pp. 120-39.

 Sets Pugin's Gothic apologia, published in 1836, in
 the context of earlier architectural writing,
 antiquarian research, social criticism, utopian
 theory, and satirical art.

349. Van Lemmen, Hans. "Pugin's Ceramic Stove for the 1851
 Great Exhibition." **Glazed Expressions** 7/8 (1984):
 1-2.

 Brief description and illustration of the massive
 tilework stove that Pugin designed for his Medieval
 Court in the Crystal Palace.

350. Wainwright, C. "A.W.N. Pugin's Early Furniture."
 Connoisseur 191 (1976): 3-11.

 Pugin's Gothic and Jacobean furniture and pattern
 books up to 1837.

351. ———. "The Speaker's State Bed." **V & A Album** 2
 (1983): 68-73.

 Wainwright sets this elaborate piece of furniture,
 designed in 1858 for the Houses of Parliament, in the
 context of revived regal pageantry; traces the bed's
 recent rediscovery, restoration, and reinstallation.

352. Walker, R.J.B. "The Palace of Westminster After the
 Fire of 1834." **The Walpole Society** 44 (1972-74):
 94-122.

 A catalogue raisonné of views taken during and
 after the fire that prompted the erection of Barry and
 Pugin's Gothic masterpiece, accompanied by a brief
 history of the Palace up to the fire, and of the
 events immediately following it.

353. Watkin, D.J., ed. **Sale Catalogues of Libraries of
 Eminent Persons. Vol. 4 - Architects.** London,
 1972.

 Includes Wren, Hawksmoor, Chambers, Adam, Dance,
 Smirke, and of special interest, Pugin.

354. Wedgewood, Alexandra. **The Pugin Family.** In **Catalogue
 of the Drawings Collection of the Royal Institute
 of British Architects,** vol. 16 (no. 25).

 Also includes Pugin's father, Augustus Charles
 Pugin, and his son, Edward Welby Pugin.

355. ————. "The Throne in the House of Lords and its
 Setting." **ArchH** 27 (1984): 59-73.

 Through a study of drawings and documents, reveals
 the working relationship between Barry and Pugin,
 establishing that the general outlines of the throne,
 one of the most splendid ensembles of Gothic Revival
 design, were supplied by Barry, ca. 1843, while Pugin
 helped with the subsequent design and drawings.

356. Weitzman, George H. "The Utilitarians and the Houses
 of Parliament." **JSAH** 20 (1961): 99-107.

 Focuses on the attitudes of Joseph Hume,
 Parliamentary spokesman for Utilitarianism, to the new
 designs for the Houses of Parliament in the 1830s, and
 the relationship between Utilitarianism and a
 functional view of architecture.

PUGIN, EDWARD WELBY (1834-1875)

* Wedgewood, Alexandra. **The Pugin Family.** In **Catalogue
 of the Drawings Collection of the Royal Institute
 of British Architects,** vol. 16 (no. 25).

SAVAGE, JAMES (1779-1852)

357. Crook, J. Mordaunt. "The Restoration of the Temple
 Church: Ecclesiology and Recrimination." **ArchH** 8
 (1965): 39-51.

 Focuses on the professional controversies
 surrounding James Savage and the restoration
 (1830s-1840s) of this important medieval church in
 London.

SCOTT, SIR GEORGE GILBERT (1811-1878)

 See Scott's own **Personal and Professional
 Recollections by the Late Sir George Gilbert Scott,
 R.A., Edited by his Son, G. Gilbert Scott**, with an
 introduction by the Very Reverend John William Burgon,
 B.D. (London, 1879; reprinted New York, 1977). For
 the Albert Memorial, see the excellent discussion in
 no. 424; for the Chapel of St. John's College,
 Cambridge, no. 186.

358. Bayley, Stephen. **The Albert Memorial. The Monument
 in its Social and Architectural Context.** London:
 Scolar Press, 1981.

 Thorough monograph on Sir George Gilbert Scott's
 Gothic masterpiece, including the competition,
 architecture, sculpture, and other decoration.

* Cole, David. "Sir Gilbert Scott." In **Victorian
 Architecture** (no. 229), pp. 175-84.

359. ————. **The Work of Sir Gilbert Scott.** London: The
 Architectural Press, 1980.

 A general monograph, covering Scott's life, secular
 and sacred architecture, and restorations; includes a
 catalogue of works.

360. Ferriday, Peter. "Syllabus in Stone." **AR** 135 (1964):
 422-28.

A brief history of the design and construction of
Scott's famous Albert Memorial, with references to
other memorials sponsored by Queen Victoria.

361. Fisher, Geoffrey, Gavin Stamp, et al. **The Scott
 Family.** In **Catalogue of the Drawings Collection of
 the Royal Institute of British Architects,** Vol. 15
 (no. 25).

 In addition to Sir George Gilbert Scott, this
 volume covers the work of his sons and grandsons: John
 Oldrid Scott, George Gilbert Scott, Sir Giles Gilbert
 Scott, Adrian Scott.

362. Handley-Read, Charles. "The Albert Memorial
 Re-Assessed." CL 130 (1961): 1514-16.

 Most interesting for its spirited defense of the
 Memorial against the tradition of facetious and
 scornful dismissal started by Lytton Strachey.

363. Haskell, Francis. "Un Monument et ses Mystères.
 L'Art Français et l'Opinion Anglaise dans la
 Première Moitié du XIXe Siècle." **Revue de l'Art**
 30 (1975): 61-76. (English text, 104-10).

 Considers the pantheon of artists carved around the
 base of Sir George Gilbert Scott's Albert Memorial as
 a reflection of English taste.

364. Howell, Peter. "Protestant Martyrs." **A**R 142 (1967):
 251-52.

 Very brief discussion of Scott's Oxford Martyrs'
 Memorial, centering on Pugin's strongly anti-
 Protestant role in the pamphlet wars that surrounded
 its construction.

365. Jordan, William J. "Sir George Gilbert Scott R.A.,
 Surveyor to Westminster Abbey 1849-1878." **ArchH** 23
 (1980): 60-85.

A detailed and sympathetic study of Scott's impact on the Abbey, cloisters, and chapter house.

366. Lockett, R.B. "Sidney Smirke, George Gilbert Scott and the Rearrangement of Lichfield Cathedral." **Bulletin of the Institute for the Study of Worship and Religious Architecture,** University of Birmingham, 1980.

Not available to the annotator.

367. ————. "The Victorian Restoration of Worcester Cathedral." **Medieval Art and Architecture at Worcester Cathedral,** British Archaeological Association; Transactions for the Year 1975 (1978), pp. 161-85.

Focuses on the work of the local architect A.E. Perkins, starting in 1844, and Scott's later involvement, interpreting their work in light of changing attitudes to restoration.

368. ————. "George Gilbert Scott, the Joint Restoration Committee, and the Refurbishing of Worcester Cathedral, 1863-1874." **Transactions of the Worcestershire Archaeological Society,** ser. 3, 6 (1978): 7-42.

Through a close documentary study, Lockett clarifies the course of the restoration, shifting responsibility for many damaging alterations from Scott to the local architect A.E. Perkins, who began a structural restoration in 1844.

369. London: Victoria and Albert Museum. **Sir Gilbert Scott (1811-1878). Architect of the Gothic Revival.** 1978.

Small exhibition catalogue, containing sections on Scott's life (Julian Litten), architecture (David Cole), restorations (S.E. Dykes Bower), office and heirs (Gavin Stamp).

370. Sidey, Tessa. **'Simple, Bold and Effective.' An
 Architectural History of the Albert Institute,
 Dundee.** Dundee: City of Dundee District Council,
 Civic Amenities Division, 1978.

 Scott's Albert Institute (1864ff.), a powerful
 essay in the early Gothic style, was built to house a
 library and related civic functions. The Institute's
 development, its role in Dundee and in Scott's
 architecture, are briefly chronicled in this short
 illustrated booklet.

371. Simmons, Jack. **St. Pancras Station.** London: George
 Allen and Unwin, 1968.

 Well-rounded study of Scott's largest secular
 Gothic building.

372. Smith, Nicola C. "George Gilbert Scott and the
 Martyr's Memorial." **Warb** 42 (1979): 195-206.

 Sets Scott's important Oxford Memorial (1840-43)
 and the concomitant rebuilding of St. Mary Magdalene,
 in the context of the Eleanor Crosses which inspired
 it, and of contemporary religious controversies.

373. ————. "Imitation and Invention in Two Albert
 Memorials." **Burl** 123 (1981): 232-37.

 Thomas Worthington's Albert Memorial, Manchester
 (1862-67), and Scott's more famous Memorial in London.

374. Stamp, Gavin. "Sir Gilbert Scott and the
 'Restoration' of Medieval Buildings."
 Architectural Association Files 1 (1981/82): 89-97.

 Beginning with a synopsis of restoration theory
 before Scott, and of the condition of English churches
 in the 1840s, Stamp surveys Scott's published views on
 restoration and chronicles his work at Ely and
 Salisbury Cathedrals, Westminster and St. Alban's
 Abbeys; compares his restorations of the two abbeys

favorably with succeeding work by Pearson and Lord Grimthorpe.

375. ————. "Sir Gilbert Scott's Recollections." **ArchH** 19 (1976): 54-74.

A sympathetic reading of Scott's **Personal and Professional Recollections,** based on the manuscript, from which unpublished passages are quoted at length.

376. Toplis, Ian. "Sir Gilbert Scott's Classical Work in Buckinghamshire." **Records of Bucks** 20 (1975): 93-98.

Early works: an interesting sidelight on a leading Gothicist.

377. Wells, J.P. "The Martyr's Memorial." **Oxford Magazine** 2 (February 1968): 161-64.

Not available to the annotator.

SCOTT, SIR GILES GILBERT (1880-1960)

* Fisher, Geoffrey, Gavin Stamp, et al. **The Scott Family.** In **Catalogue of the Drawings Collection of the Royal Institute of British Architects,** vol. 15 (no. 25).

378. Thomas, John. "The Style Shall be Gothic." **AR** 158 (1975): 155-62.

The competition for the design of Liverpool Cathedral, 1901, and the debates over the stipulation of the Gothic style.

SCOTT, JOHN OLDRID (1841-1913)

* Fisher, Geoffrey, Gavin Stamp, et al. **The Scott Family.** In **Catalogue of the Drawings Collection of**

the Royal Institute of British Architects, vol. 15
(no. 25).

SCOTT, MACKAY HUGH BAILLIE (1865-1945)

379. Kornwolf, James D. **M.H. Baillie Scott and the Arts
 and Crafts Movement. Pioneers of Modern Design.**
 Baltimore and London: Johns Hopkins Press, 1972.

 Thorough monograph on a leading Arts and Crafts
 architect and designer whose work often shows the
 influence of the Tudor style.

380. Medici-Mall, Katherina. **Das Landhaus Waldbühl von
 M.H. Baillie Scott. Ein Gesamtkunstwerk** zwischen
 Neugotik und Jugendstil. Berne: Gesellschaft fur
 Schweizerische Kunstgeschichte, 1979.

 Detailed monograph on a major Arts and Crafts
 country house in Switzerland; summary in English.

SEDDON, JOHN POLLARD (1827-1906)

381. Darby, Michael. **John Pollard Seddon.** London:
 Victoria and Albert Museum, 1983.

 Catalogue of almost 2000 drawings by this leading
 High Victorian Gothicist in the Victoria and Albert
 Museum. Includes a brief biography and chronology of
 works, lectures, exhibits, events. Includes applied
 arts as well as architecture. (Though the catalogue
 is only partially illustrated, a complete set of
 microfiche illustrations, not seen by the annotator,
 is available from Ormonde Publishing, London.)

SHARPE, EDMUND (1809-1877)

382. Jolley, Robert. "Edmund Sharpe and the 'Pot'
 Churches." AR 146 (1969): 426-31.

 A small group of Gothic Revival churches designed
 by Sharpe in the 1840s and 1870s boasts an innovative
 large scale use of structural terra cotta.

383. ————. **Edmund Sharpe, 1809-1877. A Lancaster Architect.** Univ. of Lancaster Visual Arts Centre, 1977.

In addition to designing the interesting group of terra cotta churches discussed in no. 382, Sharpe wrote several influential and scholarly books on Gothic architecture. This brief unillustrated booklet also covers his activities as a railway engineer and proponent of sanitary reform. A list of buildings and publications is included.

SHAW, RICHARD NORMAN (1831-1912)

384. Saint, Andrew. **Richard Norman Shaw.** New Haven and London: Yale Univ. Press, 1976.

A fundamental study of an architect who moved from High Victorian Gothicism to become the leader of the Queen Anne movement and later a master of the Edwardian baroque.

SMITH, JOHN (1781-1852) and WILLIAM (1817-1891)

For Balmoral, Smith's best known building, see Ivor Brown, **Balmoral: the History of a Home,** 1955; and for Smith's other Scottish houses, no. 57.

385. Clark, Ronald W. **Balmoral. Queen Victoria's Highland Home.** London: Thames and Hudson, 1981.

A well-illustrated account of this early and socially prominent example of the Scottish Baronial style, designed by John Smith of Aberdeen in 1834-1839 and enlarged by his son William for Queen Victoria in 1853-1856; focuses mainly on royal life in the Highlands.

STREET, GEORGE EDMUND (1824-1881)

The standard biographical source for G.E. Street remains the **Memoir of George Edmund Street, R.A., 1824-1881; by his Son Arthur Edmund Street** (London,

1888); see also **George Edmund Street: Unpublished
Notes and Reprinted Papers, with an Essay by Georgiana
Goddard King** (New York, 1916). For Street's churches,
see James Bayly, **Four Churches in the Deanery of
Buckrose, Restored or Rebuilt by George Edmund
Street for Sir Tatton Sykes** (London, 1894).

386. Brownlee, David B. "'To Agree Would be to Commit an
 Act of Artistic Suicide ...': The Revision of the
 Design for the Law Courts." JSAH 42 (1983):
 168-88.

 Traces the evolution of Street's design from his
 winning competition entry of 1866 through the complex
 negotiations with government officials and critics.
 Essentially excerpted from no. 387.

387. ————. **The Law Courts. The Architecture of George
 Edmund Street.** New York, Cambridge (Mass.), and
 London: The Architectural History Foundation and
 MIT Press, 1984.

 Street won the competition for this immense
 building, often called the last monument of High
 Victorian Gothic, in 1867, but it was not completed
 until after his death. Brownlee sets the entire
 project in the context of Victorian legal reform,
 charts the evolution of the design and the
 political factors which shaped it, and analyzes the
 construction of the building and its lighting,
 heating, and ventilating technology. Amply
 illustrated with photographs and design, competition,
 and contract drawings.

388. Clarke, Basil F.L., and John Piper. "Street's
 Yorkshire Churches and Contemporary Criticism." In
 Concerning Architecture (no. 26), pp. 209-25.

 Quotations from early criticism, historical
 commentary on the churches by Clarke, photos by Piper.

389. Germann, Georg. "George Edmund Street et la Suisse."
**Zeitschrift für Schweizerische Archäologie und
Kunstgeschichte** 29 (1979): 118-30.

Street's relations with Switzerland, his churches
for Anglicans at Berne (1857), Lausanne (1875), Mürren
(1878), and Vevey (1880).

390. Gubler, Jacques, and Ivor Davies. "Street and
Viollet-le-Duc." **AR** 160 (1976): 189.

Churches by Street at Kingston (Dorset) and
Lausanne, Viollet-le-Duc's Scots Kirk at Lausanne and
his restoration of Lausanne Cathedral.

391. Hitchcock, Henry-Russell. "G.E. Street in the 1850s."
JSAH 19 (1960): 145-71.

The works of this leading High Victorian Gothicist
during the 1850s include important city and country
churches, a theological college, projects for the
Government Offices and the Oxford Museum, and several
important theoretical essays, all dealt with here.

392. Jackson, Neil. "The Un-Englishness of G.E. Street's
Church of St. James-the-Less." **ArchH** 23 (1980):
86-94.

Detailed analysis of continental Gothic design
sources of one of London's great High Victorian
churches (1858), setting them in the context of
Street's writings, travels, and design theory.

* Kinnaird, Joseph. "G.E. Street, the Law Courts and
the 'Seventies." In **Victorian Architecture**
(no. 229), pp. 221-34.

393. Millon, Henry A. "G.E. Street and the Church of St.
Paul's in Rome." In **In Search of Modern
Architecture** (no. 309), pp. 85-101.

Detailed study of one of Street's two High

Victorian Gothic churches in Rome, focusing on his
drawings and the working methods they reveal.

394. Port, M.H. "The New Law Courts Competition, 1866-67."
 ArchH 11 (1968): 75-94.

The eleven designs submitted for this competition,
one of the most prestigious in Victorian England, were
all Gothic; here, the process of the competition is
analyzed from documents, and the designs (by
Waterhouse, Brandon, Barry, Burges, Scott, Seddon,
Lockwood, Garling, and Deane), are reproduced and
compared; the winner was G.E. Street.

SYKES, SIR TATTON (-1913)

395. Long, E.T. "Churches of a Victorian Squire." **CL** 144
 (1968): 770-72.

Sir Tatton Sykes founded, rebuilt, or restored
seventeen churches in Yorkshire between 1856 and 1910,
including major examples of G.E. Street and Temple
Moore.

TEULON, SAMUEL SANDERS (1812-1873)

396. Girouard, Mark. "Acrobatic Gothic." **CL** 148 (1970):
 1282-86.

Teulon's two greatest country houses, Elvetham
(1859-1862) and Bestwood Lodge (1862-1864), are
discussed in terms of the architect's relationship to
the Ecclesiological Society and the problem of
originality and eccentricity in Gothic revival
architecture of the 1860s.

USHER, JOHN (1822-1904)

397. Wildman, Richard. "The Houses of Usher." **AAQ** 2/1
 (1970): 70-74.

Briefly reconstructs the career of Bedford's
leading local architect, whose work shifted in the

late 1860s from classicism to a vigorous Gothicism influenced by Ruskin, Street, and Butterfield.

VOYSEY, CHARLES FRANCIS ANNESLEY (1857-1941)

* Brandon-Jones, John. "C.F.A. Voysey." In **Victorian Architecture** (no. 229), pp. 267-88.

398. ————, et al. **C.F.A. Voysey: Architect and Designer, 1857-1941.** London: Lund Humphries (in association with Art Gallery and Museums and the Royal Pavilion, Brighton), 1978.

Catalogue of an exhibition including architecture, furniture, pattern design, and metalwork.

399. Gebhard, David. **Charles F.A. Voysey Architect.** Art Galleries, Univ. of California at Santa Barbara, 1970.

Exhibition catalogue includes biography and descriptive text, accompanied by a chronological list of Voysey's writings, a bibliography of writings about Voysey, and extensive illustrations.

400. ————, ed. **Charles F.A. Voysey, Architect.** Los Angeles: Hennessey and Ingalls, 1975.

An anthology of the architect's writings.

401. Johnson, Alan. "C.F.A. Voysey and the Architecture of Moral Reform." **AAQ** 9/4 (1977): 26-34.

Traces Voysey's belief in the symbolic content of architectural forms and in their moral efficacy back to the influence of his father's religious beliefs, of Carlyle's transcendentalism, and of his Gothic revival training, especially his exposure to Pugin and Ruskin.

* Pevsner, Nikolaus. "C.F.A. Voysey." In **Studies in
 Art, Architecture and Design,** Vol. 2 (no. 22),
 pp. 141-52.

402. Simpson, Duncan. **C.F.A. Voysey, An Architect of
 Individuality.** New York: Watson-Guptill, 1981.

 A well-illustrated study focusing on Voysey's
 purified Tudor-vernacular country houses and
 furnishings, ca. 1890-1910.

403. Symonds, Joanne. **C.F.A. Voysey.** In **Catalogue of the
 Drawings Collection of the Royal Institute of
 British Architects,** vol. 18 (no. 25).

WATERHOUSE, ALFRED (1830-1905)

 For Waterhouse's Manchester Town Hall, see also
 nos. 218, 222.

404. Girouard, Mark. **Alfred Waterhouse and the Natural
 History Museum.** New Haven and London: Yale Univ.
 Press, 1981.

 Begun in 1873, the Museum is one of London's great
 public buildings, combining a Romanesque round-arched
 style with the latest in architectural technology.
 Girouard's study is brief but very well illustrated.

405. ———. "Blackmoor House, Hampshire." CL 156 (1974):
 554-57, 614-17.

 House, church, school, vicarage, and cottages were
 all designed by Waterhouse, along with a quantity of
 furnishings, starting in 1868. The work began in a
 strict Gothic style but soon showed the influence of
 Richard Norman Shaw's Old English manner and of the
 "art furniture" designers.

406. Jenkins, Frank. "The Making of a Municipal Palace -
 Manchester Town Hall." CL 141 (1967): 336-39.

Designed by Waterhouse, the Manchester Town Hall (1866-77) is the grandest of Victorian town halls and the climax of High Victorian Gothic public architecture.

407. Maltby, Sally, Sally MacDonald, and Colin Cunningham. **Alfred Waterhouse 1830-1905.** London: RIBA, 1983.

One of the most prolific of Victorian architects, Waterhouse was a leader in the secular application of the Gothic Revival. This exhibition catalogue, illustrated with drawings in the RIBA collection, contains short essays on his clients, his design sources, planning principles, materials, decoration, furniture, and finally, on the development of a distinct corporate image in his many designs for Prudential Assurance.

* Smith, Stuart Allen. "Alfred Waterhouse: Civic Grandeur." In **Seven Victorian Architects** (no. 227), pp. 102-21.

WEBB, PHILIP SPEAKMAN (1831-1915)

See the biography by his disciple, W.R. Lethaby, **Philip Webb and his Work,** London, 1935. (New edition: London, 1979.)

* Brandon-Jones, John. "Philip Webb." In **Victorian Architecture** (no. 229), pp. 247-66.

408. Jackson, Neil. "A Church for SPAB?" **AR** 162 (1977): 69-70.

Interprets Philip Webb's church of St. Martin, Brampton, begun in 1875, in the context of the Society for the Protection of Ancient Buildings, as a programmatic statement on principles of restoration.

WHALL, CHRISTOPHER (1849-1924)

409. Cormack, Peter D. **Christopher Whall, 1849-1924. Arts
 and Crafts Stained Glass Worker.** Walthamstow,
 London: William Morris Gallery, 1979.

 Exhibition catalogue of a leading Arts and Crafts
 glassmaker.

410. ───────. "Christopher Whall, Founder of the English
 Glass Renaissance." **Stained Glass** 76 (1981-82):
 318-22.

 Briefly chronicles Whall's discovery of a religious
 vocation, his dedication to the fusion of design and
 craftsmanship, his ties with the Arts and Crafts
 movement, and his theories of stained glass and
 decoration.

WHITE, WILLIAM (1825-1900)

411. Thompson, Paul. "The Writings of William White." In
 Concerning Architecture (no. 26), pp. 226-37.

 A reappraisal of an influential Ecclesiological
 Gothic architect and writer of the 1850s.

WILKINSON, WILLIAM (1819-1901)

412. Locker, Reto. "Schloss Neu-Buonas am Zugersee."
 **Zeitschrift für Schweizerische Archäologie und
 Kunstgeschichte** 29 (1972): 111-17.

 A large Tudor house in Switzerland, designed by the
 leading Oxford Gothicist William Wilkinson and carried
 out by a local architect.

413. Saint, Andrew. "Three Oxford Architects." **Oxoniensia**
 35 (1970): 53-102.

 Included are William Wilkinson, a leading Gothicist
 (Viollet-le-Duc illustrated five of his houses), and
 Clapton Crabb Rolfe (1845-1907), author of quasi-

mystical pamphlets on altars, incense, and other liturgical matters.

WILLEMENT, THOMAS (1786-1871)

414. Wainwright, Clive. "Davington Priory, Kent." CL 150
 (1971): 1650-53, 1716-19.

 Davington Priory was restored and decorated in the
 1840s by Thomas Willement, a major early Victorian
 stained glass artist, decorative painter, and
 designer.

415. ————. "Thomas Willement's Stained Glass Windows in
 the Choir Aisles." **Report of the Society of the
 Friends of St. George and the Descendants of the
 Knights of the Garter** 5 (1971-72): 105-18.

 Publishes Willement's own notes, with commentary,
 on his important cycle of windows for St. George's
 Chapel, Windsor, completed in the 1840s. The windows
 present the history of the British monarchy through
 heraldry and figures dressed in historical costume.

WILLIS, ROBERT (1800-1875)

416. Mark, Robert. "Robert Willis, Viollet-le-Duc and the
 Structural Approach to Gothic Architecture."
 Architectura 7 (1977): 52-64.

 Willis published a seminal paper on medieval vault
 construction in 1842; Mark analyzes his approach to
 architecture and structure and compares it with
 Viollet-le-Duc's.

417. Pevsner, Nikolaus. **Robert Willis.** Northampton,
 Mass.: Smith College, 1970.

 Text of a lecture on one of the foremost Victorian
 scholars of English Gothic cathedral architecture.

WOODYER, HENRY (1816-1896)

418. Verey, David. "The Building of Highnam Church." CL
 149 (1971): 1160-62.

 Designed in the Ecclesiological fourteenth century
 style by Woodyer in 1848, Highnam is one of the great
 Victorian country churches; its patron, Thomas
 Gambier-Parry, not only amassed a famous collection of
 medieval and early Renaissance art but also decorated
 the interior himself, in a method he invented and
 called "spirit fresco."

WYATT, SIR MATTHEW DIGBY (1820-1877)

* Pevsner, Nikolaus. "Matthew Digby Wyatt."
 In **Studies in Art, Architecture and Design**, Vol. 2
 (no. 22), pp. 96-108.

3. Monographs: Places and Buildings

ARUNDEL CASTLE

 [Arundel Castle]. **Connoisseur** 197 (1978): 155-216
 (Special Issue). See no. 182.

BRISTOL

419. Crick, Clare. **Victorian Buildings in Bristol.**
 Bristol: Bristol and West Building Society (1975).

 Especially useful are the chapters on religious and
 commercial architecture.

420. Gomme, Andor, Michael Jenner, and Bryan Little.
 Bristol. An Architectural History. London: Lund
 Humphries, 1979.

Includes valuable discussions of late eighteenth century "Gothick" (including several unusual churches), and of nineteenth century Gothic works by local architects and by Street, Pearson, E.W. Godwin, and the engineer Isambard Kingdom Brunel (Temple Meads Railway Station). Also a well illustrated chapter on Victorian warehouses and commercial buildings. Finally, a brief discussion of Sir George Oatley's University buildings, among the last monumental works of the Gothic Revival in England.

CAMBRIDGE. HOLY SEPULCHRE

See no. 255.

DUBLIN

421. Kennedy, Tom ed. **Victorian Dublin.** Dublin: Albertine Kennedy with the Dublin Arts Festival, 1980.

Not available to the annotator.

GLASGOW

422. Gomme, Andor, and David Walker. **Architecture of Glasgow.** London: Lund Humphries, 1968.

A chapter on "Victorian Gothic" covers churches by J.T. Emmett, J. Burnet, and others, as well as Sir George Gilbert and John Oldrid Scott's vast University.

LONDON

423. Clarke, Basil F.L. **Parish Churches of London.** London: Batsford, 1966.

History and description, with some photographs, of every Anglican parish church in London; a fundamental reference source and guide.

424. London: Greater London Council. **The Survey of London.**
 40 vols. London, 1900- .

 A massively detailed survey of London's
architecture, begun in 1900 by the London County
Council, continued until very recently by its
successor, the Greater London Council, and still in
progress. Earlier volumes paid little attention to
Victorian architecture, but more recent ones provide a
mine of information on Gothic Revival churches and
other monumental buildings, as well as mansions and
the more modest housing of estate developments. Also
to be noted is an excellent discussion of Sir. G.G.
Scott's Albert Memorial. Recent volumes have appeared
under the general editorship of F.H.W. Sheppard and
have been published by The Athlone Press.

425. Metcalf, Priscilla. **Victorian London.** New York,
 Washington: Praeger, 1971.

 A decade-by-decade survey of architecture and urban
development.

426. Stamp, Gavin, and Colin Amery. **Victorian Buildings of
 London 1837-1887. An Illustrated Guide.** London:
 The Architectural Press, 1980.

 Historical and descriptive accounts of 101
buildings of all types, including important Gothic
Revival works of Pugin, Scott, Carpenter, Butterfield,
Brandon, Pearson, Street, Waterhouse, Lamb, and many
others.

LONDON. VICTORIA AND ALBERT MUSEUM

* Baker, Malcolm. "A Glory to the Museum ... " Cited
 above as no. 206.

MANCHESTER

 No bibliography of Victorian Gothicism would be
complete without mention of two books by Cecil
Stewart: **The Architecture of Manchester. An Index of**

the Principal Buildings and their Architects, 1800–
1900, Manchester: Libraries Committee, 1956; and **The
Stones of Manchester**, London: Arnold, 1956.

OXFORD. MAGDALEN COLLEGE

See T.S.R. Boase, "An Oxford College and the Gothic
Revival," **Warb** 18 (1955): 145-88.

PART TWO: JOHN RUSKIN AND WILLIAM MORRIS

JOHN RUSKIN (1819-1900)

It would be futile to attempt to provide a capsule bibliography of works on Ruskin published before 1960; instead, the reader is referred to nos. 428, 438, 440, 445.

427. Arts Council (London). **Ruskin and his Circle.** 1964.

Catalogue of an exhibition structured around Ruskin's life and activities, including personal memorabilia, manuscripts, books, photographs, and works of art by Turner, Prout, the Pre-Raphaelites, and others.

428. Beetz, Kirk H. **John Ruskin: A Bibliography, 1900-1974.** Metuchen, N.J.: The Scarecrow Press, 1976.

Includes editions of works, criticism and scholarship; unannotated.

429. Brooks, Michael. "John Ruskin, Coventry Patmore, and the Nature of Gothic." **Victorian Periodical Review** 12 (1979): 130-40.

Surveys Patmore's reviews of Ruskin's writings on architecture between 1849 and 1854, his conversion from a protagonist of a new style to a Gothicist, the dialogue between the two men over the issues of *aspiration and foliage in Gothic architecture.*

430. Clegg, Jeanne. **Ruskin and Venice**. London: Junction
 Books, 1981.

 Studies each of Ruskin's eleven visits to Venice,
 as well as his writings on the subject; also includes
 a chapter on the English view of Venice before Ruskin.

431. Cole, Bruce. "Ruskin at Assisi." **Connoisseur** 191
 (1976): 133-38.

 Ruskin's discovery of Cimabue, and his reaction, on
 a visit of 1874, to the restoration of the frescoes at
 Assisi.

432. Conner, Patrick R.M. "Pugin and Ruskin." **Warb** 41
 (1978): 344-50.

 Supports Ruskin's claim that he owed little to
 Pugin; analyzes the distinctions between their thought
 and exposes Pugin's debts to earlier writers.

433. Conner, Patrick. **Savage Ruskin**. Detroit: Wayne State
 Univ. Press, 1979.

 Focuses on Ruskin as a critic, analyzing his
 responses to (among other things) Gothic architecture,
 the Pre-Raphaelites, and the state of modern society.

* Crook, J. Mordaunt. "Ruskinian Gothic." **The Ruskin
 Polygon**. Cited above as no. 217.

434. Fitch, Raymond E. **The Poison Sky. Myth and
 Apocalypse in Ruskin**. Athens, London: Ohio Univ.
 Press, 1982.

 Seeing Ruskin primarily as a prophet of doom, Fitch
 studies the use of myth and apocalypse in each of his
 major works, including the **Seven Lamps of Architecture**
 and the **Stones of Venice**.

435. Garrigan, Kristine Ottesen. **Ruskin on Architecture.
 His Thought and Influence.** Madison: Univ. of
 Wisconsin Press, 1973.

 A close study, supported by extensive quotes, of
 Ruskin's writings on architecture; also includes
 chapters on the Gothic Revival before Ruskin and on
 Ruskin's influence as an exponent of the Gothic
 Revival.

436. Greenberg, Robert A. "Ruskin, Pugin, and the
 Contemporary Context of 'The Bishop Orders His
 Tomb.'" **PMLA** 84 (1969): 1588-1594.

 A reading of Browning's poem, and Ruskin's approval
 of it, in the context of Pugin's views of the middle
 ages and Catholicism, and of the Oxford and Cambridge
 movements and the religious controversies they stirred
 up.

437. Hardman, Malcolm. "Ruskin's Massy Commonsense."
 British Journal of Aesthetics 16 (1976): 137-43.

 Deals with Ruskin's functionalism, making
 comparisons with Pugin. Not available to the
 annotator.

438. Harmon, Robert B. **The Impact of John Ruskin on
 Architecture: A Selected Bibliography.** Vance
 Bibliographies, 1982.

 Not available to the annotator.

439. Hauck, Alice H.R. "John Ruskin's Uses of Illuminated
 Manuscripts: The Case of the Beaupré Antiphonary,
 1853-1856." **Arts Magazine** 56 (September 1981):
 79-83.

 Ruskin's didactic uses of a medieval manuscript in
 lectures and writings between 1853 and 1856; his
 personal identification with it.

440. Helsinger, Elizabeth K. **Ruskin and the Art of the
 Beholder.** Cambridge (Mass.), and London: Harvard
 Univ. Press, 1982.

 Mostly concerned with Ruskin's ways of looking at
 art and language, and with Ruskin as a writer,
 Helsinger also comments on his views on architecture.

441. Hewison, Robert. **Art and Society. Ruskin in
 Sheffield 1876.** London: Bentham Press, 1981.

 Text of a lecture on aspects of Ruskin's career as
 a social and artistic reformer, including the early
 history of St. George's Guild.

442. ————. **Ruskin and Venice.** Louisville, Ky.: J.B.
 Speed Art Museum, 1978.

 Exhibition catalogue organized around a
 chronological account of Ruskin's association with
 Venice, including his studies of Venetian
 architecture, the **Stones of Venice**, and his attempts
 to document and preserve Venetian monuments.

443. ————, ed. **New Approaches to Ruskin. Thirteen
 Essays.** London: Routledge and Kegan Paul, 1981.

 The essays cover Ruskin's involvement with art,
 architecture, politics, and autobiography; includes
 "Ruskin and the 'Ancient Masters' in **Modern Painters**"
 (Patrick Conner: touches on Ruskin's attitude to the
 Italian primitives), and "Ruskin, the Workman and the
 Savageness of Gothic" (John Unrau).

* Hitchcock, Henry-Russell. "Ruskin and American
 Architecture, or Regeneration Long Delayed."
 In **Concerning Architecture.** Cited below as
 no. 640.

444. Holcombe, A.M. "A.F. Rio, Anna Jameson and Some
 Sources of the Second Volume of **Modern Painters** by
 Ruskin (1846)." **Gazette des Beaux Arts** ser. 6, 91
 (1978): 35-38.

Discounting the influence of Lord Lindsay on
Ruskin's early views of Italian primitive painting,
Holcombe argues for the importance of Rio's **De la
poésie chrétienne** (1936) and Jameson's **Memoirs of the
Early Italian Painters** (1845).

445. Hunt, John Dixon. **The Wider Sea. A Life of John
Ruskin.** New York: Viking Press, 1982.

Thorough and insightful biographical and critical
study of Ruskin's life and work.

446. Jervis, Simon. "Ruskin and Furniture." **Furniture
History** 9 (1973): 97-109.

Ruskin's views on furniture as expressed in his
writings and in his dwellings; his influence on
designers like Deane and Woodward and C.F. Hayward.

* Kaufman, Edward N. "'The Weight and Vigour of their
Masses': Mid Victorian Country Churches and 'The
Lamp of Power.'" In **The Ruskin Polygon.** Cited
above as no. 237.

447. Links, J.G. **The Ruskins in Normandy. A Tour in 1848
with Murray's Hand-book.** London: John Murray,
1968.

A largely anecdotal account, touching on Ruskin's
reaction to continental Gothic architecture and
restoration.

448. Mullaly, Terence. **Ruskin a Verona.** Verona: Museo di
Castelvecchio, 1966.

Catalogue of an exhibition of Ruskin's drawings of
art and architecture in Verona.

449. Penny, J. "Ruskin's Ideas on Growth in Architecture
and Ornament." **British Journal of Aesthetics** 13
(1973): 276-86.

Explores Ruskin's theories on the organic
relationship between ornament and architecture in view
of his preference for Gothic architecture, and of
earlier theories of Gothic.

450. Pevsner, Nikolaus. **Ruskin and Viollet-le-Duc.**
 Englishness and Frenchness in the Appreciation of
 Gothic Architecture. London: Thames and Hudson,
 1969.

 Text of a lecture, illustrated with Ruskin's
 drawings and Viollet-le-Duc's buildings and drawings.

451. Rosenberg, John D. **The Darkening Glass. A Portrait**
 of Ruskin's Genius. New York and London: Columbia
 Univ. Press, 1961.

 Critical study of Ruskin's thought, focusing on
 Modern Painters, Stones of Venice, Unto this Last,
 Fors Clavigera, and **Praeterita.**

452. Stefano, Roberto Di. **John Ruskin Interprete**
 dell'Architettura e del Restauro. Naples: Edizioni
 Scientifiche Italiane, n.d.

 Not available to the annotator.

* Stein, Roger B. **John Ruskin and Aesthetic Thought**
 in America, 1840–1900. Cited below as no. 660.

453. Unrau, John. **Looking at Architecture with John**
 Ruskin. London: Thames and Hudson, 1978.

 Ruskin as a critic, analyst, and observer of
 architecture; largely steering clear of ethical,
 religious, and historical issues, Unrau focuses on
 space, construction, and ornament.

454. ————. "A Note on Ruskin's Reading of Pugin."
 English Studies 48 (1967): 335–37.

Argues that Ruskin, despite his denial of Pugin's influence, must have carefully read **True Principles**.

455. ———. **Ruskin and St. Mark's.** London: Thames and Hudson, 1984.

Collects Ruskin's writings, both published and unpublished, on St. Mark's in Venice and arranges them with commentary in the form of descriptive analyses of the building. Particular attention is paid to Ruskin's role in the controversy over the restoration and to the development of his ideas leading to the **Stones of Venice.** Extensively illustrated with Ruskin's drawings and contemporary photographs. (For Ruskin and St. Marks, see also Paolo Costantini, "Ferdinando Ongania and the Golden Basilica: A Documentation Programme in 19th century Venice," **History of Photography** 8 (1984): 315-28.

456. Vinciguerra, Mario. **John Ruskin ed i Preraffaelite.** Milan: Quaderni dell'Osservatore, 1969.

Not available to the annotator.

457. Walton, Paul H. **The Drawings of John Ruskin.** Oxford: Clarendon Press, 1971.

A standard study of Ruskin's drawings and watercolors, focusing on his landscapes and architectural studies.

458. Whittick, Arnold, ed. **Ruskin's Venice.** London: George Godwin, 1976.

An amplified reprint of the "Venetian Index" from Ruskin's **Stones of Venice,** together with a map and prefatory material.

WILLIAM MORRIS (1834-1896)

As with Ruskin, the early literature on Morris defies easy encapsulation; instead, the reader is

referred to no. 478.

459. Banham, Joanna, and Jennifer Harris, eds. **William
 Morris the Middle Ages: A Collection of Essays,
 Together with a Catalogue of Works Exhibited at the
 Whitworth Art Gallery**. Manchester: Manchester
 Univ. Press, 1984.

 Not available to the annotator.

460. Clark, Fiona. **William Morris. Wallpapers and
 Chintzes**. London: Academy Editions, 1973.

 Catalogue raisonné of designs, with illustrations.

461. Cromey-Hawke, N. "William Morris and Victorian
 Painted Furniture." **Connoisseur** 191 (1976): 32-43.

 Unravels the involvement of Morris and his
 associates, especially Webb and Rossetti, in the
 production of painted furniture in the late 1850s;
 clarifies their relationship to the architect William
 Burges.

462. Design Council (London). **William Morris and
 Kelmscott**. 1981.

 Exhibition catalogue of paintings, prints,
 drawings, books, and decorative arts, with short
 essays on Kelmscott Manor and its furnishing,
 Rossetti, Morris and Victorian decorative arts, Morris
 furniture, Philip Webb, and the Kelmscott Press.

463. Dufty, A.R. **Kelmscott. An Illustrated Guide**.
 London: Society of Antiquaries, 1969.

 Guidebook to William Morris's country house and its
 content.

464. Fairclough, Oliver, and Emmeline Leary. **Textiles by William Morris and Morris & Company, 1861-1940.** London: Thames and Hudson, 1981.

 A thorough study, with extensive illustrations and catalogue, of embroideries, printed and woven fabrics, carpets, and tapestries.

465. Goldzamt, Edmund. **William Morris und die sozialen Ursprunge der modernen Architektur.** Dresden: VEB Verlag der Kunst, 1976.

 Morris's ideas and their impact on modern architecture, especially the Bauhaus and International style in Poland and Russia. First published in Polish (with summaries in English and Russian) in 1967.

466. Henderson, Philip. **William Morris. His Life, Work, and Friends.** New York: McGraw-Hill Book Co., 1967.

 A comprehensive study of Morris's life and work.

467. **Journal of the William Morris Society,** 1961-.

 Specialized journal containing a wide range of articles, mostly short, on its subject.

468. Lemire, Eugene D., ed. and comp. **The Unpublished Lectures of William Morris.** Detroit: Wayne State Univ. Press, 1969.

 Texts of ten lectures delivered between 1877 and 1896, including two on the Gothic Revival and several on art.

469. McColgan, Denise. "Nationalism in the Wallpaper Designs of William Morris." **Arts Magazine** 56 (September, 1981): 142-49.

 Studies Morris's revolutionary pattern designs in the context of Ruskin and Rossetti.

470. Marshall, Roderick. **William Morris and his Earthly Paradises**. New York: George Braziller, 1981.

Traces Morris's search for a better world throughout his career, including his writing, artwork, politics, and the decoration of Kelmscott Manor; psychobiographical inferences are drawn.

471. Meier, Paul. **William Morris. The Marxist Dreamer**. Translated by Frank Gubb. 2 vols. Hassocks, Sussex: The Harvester Press, 1978.

First published in 1972 as **La pensée utopique de William Morris,** this lengthy study includes a chapter on "Medievalism and its Utopian Ferments."

472. Parry, Linda. **William Morris Textiles**. London: Weidenfeld and Nicolson, 1983.

Not available to the annotator.

* Pevsner, Nikolaus. "William Morris and Architecture." In **Studies in Art, Architecture and Design,** Vol. 2 (no. 22), pp. 109-17.

473. Robinson, Duncan. **William Morris, Edward Burne-Jones, and the Kelmscott Chaucer**. London: Gordon Fraser, 1982.

A monographic study of the Kelmscott Press's masterpiece, illustrated with selections from the book as well as preparatory studies and related drawings.

474. Robinson, Duncan, and Stephen Wildman. **Morris and Company in Cambridge**. Cambridge: Cambridge Univ. Press and the Fitzwilliam Museum, 1980.

Catalogue of an exhibition of work in Cambridge collections and work executed in Cambridge, including several important decorative schemes; includes sections with essays on the Kelmscott Press, Burne-Jones and the Pre-Raphaelites, Morris's collaboration

with the leading Gothic Revival architect G.F. Bodley, and the Gothic Revival in Cambridge.

475. Schorske, Carl E. "The Quest for the Grail: Wagner and Morris." **The Critical Spirit: Essays in Honor of Herbert Marcuse,** edited by Kurt H. Wolff and Barrington Moore, pp. 216-32. Boston: Beacon Press, 1967.

Compares Morris's and Wagner's dissatisfaction with modern civilization and their opposite evolutions to (Wagner) and from (Morris) a medievalizing religious aestheticism.

476. Sewter, Charles A. **The Stained Glass of William Morris and his Circle.** 2 vols. New Haven and London: Yale Univ. Press, 1974, 1975.

A comprehensive study of Morris, his associated designers, and the stained glass they produced, illustrated with over 600 plates; the scholarly apparatus includes a catalogue raisonne, gazeteer, and indices of subjects, donors, and persons commemorated.

477. Thompson, E.P. **William Morris, Romantic to Revolutionary.** New York: Pantheon Books, 1976.

First published in 1955, this is a fundamental biography, covering Morris's relations with Ruskin and the Pre-Raphaelites, the Red House, his work as artist and designer, attitudes to architecture, political theories, and literary works.

478. Thompson, Paul. **The Work of William Morris.** New York: The Viking Press, 1967.

Individual chapters deal with aspects of Morris's work in literature, politics, and art, including architecture, furniture, pattern design, stained glass, and book design.

* Thompson, Susan Otis. **American Book Design and
 William Morris.** Cited below as no. 954.

479. Watkinson, Ray. **William Morris as Designer.** London:
 Studio Vista, 1967.

 A survey of Morris's work in stained glass, pattern
 design, textiles, and printing, with a brief notice of
 precursors and Arts and Crafts followers.

PART THREE: PAINTING AND SCULPTURE IN GREAT BRITAIN

A. General Works

480. Archer, M. "Pre-Raphaelite Painted Furniture." CL
 137 (1965): 720-22.

 Brief survey of the furniture of Morris, Rossetti,
 Brown, and Hunt, ca. 1860.

481. Baden-Baden: Staatliche Kunsthalle. **Präraffäeliten.**
 1973-74.

 Catalogue of an extensive exhibition of paintings
 and drawings.

482. Caudron, Simone. "Connoisseurs of Champlevé Limoges
 Enamels in Eighteenth Century England." In
 **Collectors and Collections. The British Museum
 Yearbook 2**, pp. 9-33. London: British Museum
 Publications, 1977.

 Traces the fate of some important enamels, focusing
 on three major collectors: William Stukeley, Gustavus
 Brander, and Thomas Astle.

483. Chapeaurouge, D. De. "Die 'Kathedrale' als modernes
 Bildthema." **Jahrbuch der Hamburger Kunstsammlungen**
 18 (1973): 155-72.

 Not available to the annotator.

484. Cherry, Deborah. "The Hogarth Club: 1858-1861."
 Burl 122 (1980): 237-44.

 The Hogarth Club, an exhibition society and social
 club, was a hub of Pre-Raphaelite activity in the
 pictorial and decorative arts.

485. Christian, John. "Early German Sources for Pre-
 Raphaelite Designs." **Art Quarterly** 36 (1973):
 56-83.

 The importance of early German art, especially
 Dürer and Holbein, to William Bell Scott, Rossetti,
 Burne-Jones, and others; Ruskin's influence as a
 collector and admirer of Dürer.

486. ————. **The Oxford Union Murals.** Chicago and London:
 Univ. of Chicago Press, 1981.

 A thorough history and description of the famous
 Pre-Raphaelite attempt to revive fresco decoration;
 includes a chapter on the fresco revival in Germany
 and England; accompanied by specially taken color
 photographs (in microfiche) of the murals.

487. Cooper, Robyn. "The Popularization of Renaissance Art
 in Victorian England: The Arundel Society." **AH** 1
 (1978): 263-92.

 The Arundel Society's attempts to popularize
 Italian art of the trecento and quattrocento included
 a ground-breaking set of reproductions of Giotto's
 Arena Chapel frescos, with a text by Ruskin. Cooper
 reveals the Society's intentions, setting it in the
 context of the developing taste for early Italian
 painting and the growing interest in art history.
 Austen Henry Layard's involvement with the Society and
 his crusade for the preservation of Italian frescos
 are also discussed, as are the various means of
 reproduction employed by the Society.

488. ————. "The Relationship between the Pre-Raphaelite
 Brotherhood and Painters before Raphael in English

Criticism of the Late 1840s and 1850s." **VS** 24
(1981): 405-38.

Sets the question in the context of Early Victorian
views of medieval art and religion, assesses
revivalist elements in early Pre-Raphaelite art, and
analyzes critical responses to it, including Ruskin's.

* Darby, Elizabeth, and Nicola Smith. **The Cult of the
 Prince Consort.** Cited as no. 220.

* Dobai, Johannes. **Die Kunstliteratur des Klassizismus
 und der Romantik in England.** Cited as no. 45.

489. Fredeman, William E. **Pre-Raphaelitism. A
 Bibliocritical Study.** Cambridge, Mass.: Harvard
 Univ. Press, 1965.

 A standard reference source for historical and
 critical writings and collections of Pre-Raphaelite
 art; extensively annotated.

490. ————, ed. **The P.R.B. Journal. William Michael
 Rossetti's Diary of the Pre-Raphaelite Brotherhood
 1849-1853, Together with Other Pre-Raphaelite
 Documents.** Oxford: Clarendon Press, 1975.

 A basic source for the early years of the
 Pre-Raphaelites.

491. Grieve, Alastair. "A Notice on Illustrations to
 Charles Kingsley's 'The Saint's Tragedy' by Three
 Pre-Raphaelite Artists." **Burl** 111 (1969): 291-93.

 Publishes drawings by Millais, Rossetti, and
 Collinson, illustrating Kingsley's account of St.
 Elizabeth of Hungary, published in 1848.

492. ————. "The Pre-Raphaelite Brotherhood and the
 Anglican High Church." **Burl** 111 (1969): 294-95.

Interprets major works of Rossetti, Millais, and
Collinson in the context of religious controversies,
and explores their personal relations with
Tractarians.

493. Haskell, Francis. **Rediscoveries in Art. Some Aspects
 of Taste, Fashion and Collecting in England and
 France.** Ithaca, New York: Cornell Univ. Press,
 1976.

 Chapter 3, "The Two Temptations," compares the
 revivals of taste for the Italian primitives and the
 French rococo.

494. Hawes, Louis. **Presences of Nature. British Landscape
 1780–1830.** New Haven: Yale Center for British Art,
 1982.

 Chapter 3 is a general survey of ruin painting in
 this period.

495. Hilton, Timothy. **The Pre–Raphaelites.** New York:
 Harry N. Abrams, 1970.

 A short, well-illustrated survey.

496. Honour, Hugh. **Romanticism.** New York: Harper and Row,
 1979.

 A very general survey including a chapter on
 medievalism in art and architecture; covers England
 and Europe.

497. Hunt, John Dixon. **The Pre–Raphaelite Imagination
 1848–1900.** London: Routledge and Kegan Paul, 1968.

 A fundamental interpretive study of Pre-Raphaelite
 poetry and painting, including a chapter on
 medievalism.

498. Ingamells, John. "York Minster and the Artist." CL
152 (1972): 230-32.

Notice of an exhibition at the York City Art
Gallery (no. 502) of topographical depictions of the
Minster from the mid-seventeenth through the early
nineteenth century.

499. Irwin, David. **English Neoclassical Art. Studies in
Inspiration and Taste.** London: Faber and Faber,
1966.

Includes a chapter on the Gothic Revival, covering
medieval history painting, Flaxman and medieval
sculpture, and Fuseli and the Gothic.

500. **Journal of Pre-Raphaelite Studies,** 1980-.

Specialized journal containing a wide range of
articles, mostly short, on its subject.

501. London: Fine Art Society. **The Earthly Paradise.**
1969.

Exhibition catalogue of the Birmingham School,
including Joseph Southall (no. 588). Not available to
the annotator.

502. Longley, Katharine M., and John Ingamells. **The
Beautifullest Church. York Minster 1472-1972.**
York: York City Art Gallery, 1972.

Small exhibition catalogue containing, in addition
to historical materials relating to the history of the
building, its repairs and restorations, a catalogue of
York Minster views, 1650-1850, and an essay, "York
Minster and the Artist, 1650-1850," both by John
Ingamells.

503. Lygon, Dorothy, and Francis Russell. "Tuscan
Primitives in London Sales: 1801-1837." **Burl** 122
(1980): 112-17.

A discussion of early nineteenth century attitudes
to Italian primitive painting, backed up with precise
documentation.

504. Munby, A.N.L. **Connoisseurs and Medieval Miniatures,**
 1750-1850. Oxford: Clarendon Press, 1972.

 Analyzes the growth of appreciation of medieval
 miniatures as works of art, chiefly in England.

505. Newcastle upon Tyne: Tyne and Wear County Council
 Museum. **The Picturesque Tour in Northumberland and**
 Durham, c. 1720-1830.

 Artists including Francis Place, S.H. Grimm,
 Girtin, and Turner recorded the medieval monuments of
 Newcastle, Durham, and the North of England. This
 exhibition catalogue places their work in the context
 of the picturesque tour and of antiquarian research
 into local history.

506. Nicoll, John. **The Pre-Raphaelites.** London: Studio
 Vista, 1970.

 Brief introduction to Pre-Raphaelite painting,
 concentrating on Rossetti, Millais, and Hunt.

507. Parris, Leslie, ed. **Pre-Raphaelite Papers.** London:
 The Tate Gallery, 1984.

 Includes three relevant essays: John Christian,
 "'A Serious Talk': Ruskin's Place in Burne-Jones's
 Artistic Development" (pp. 184-205); Rosalie Mander,
 "Rossetti and the Oxford Murals" (pp. 170-83); and
 Julian Treuherz, "The Pre-Raphaelites and Medieval
 Illuminated Manuscripts" (pp. 153-69); this latter
 about the influence of manuscripts, especially on
 Brown, Collins, Burne-Jones, Rossetti, Ruskin, and
 Morris, with remarks on the literature on manuscript
 painting available at mid-century.

* Read, Benedict. **Victorian Sculpture.** Cited as
 no. 253.

508. Rosenblum, Robert. **The International Style of 1800.
 A Study in Linear Abstraction.** New York and
 London: Garland Publishing, 1976.

 First written as a dissertation in 1956, this study
 of the linear style in English and European art around
 1800 touches on the influence of medieval sculpture
 and Italian primitive painting.

509. Sambrook, James, ed. and intro. **Pre-Raphelitism. A
 Collection of Critical Essays.** Chicago and London:
 Univ. of Chicago Press, 1974.

 Reprints essays ranging from the 1850s (W.M.
 Rossetti, F.G. Stephens, Ruskin), to the 1970s (John
 Dixon Hunt).

510. Strong, Roy. **Recreating the Past. British History
 and the Victorian Painter.** London: Thames and
 Hudson, 1978.

 Includes chapters on history-writing and painting,
 artist-antiquarians, Scott and the historical novel,
 Gothic architecture and the 'style troubadour,' and
 favorite historical themes from the middle ages.

511. Sussman, Herbert. "The Pre-Raphaelites and the 'Mood
 of the Cloister.'" **Browning Institute Studies** 8
 (1980): 45-55.

 Not available to the annotator.

512. Sutton, Denys. "The English and Early Italian Art."
 Apollo 81 (1965): 254-56.

 A brief survey of nineteenth century English
 collectors and protagonists of trecento and
 quattrocento art, including Sir Charles Eastlake,
 William Young Ottley, Lord Lindsay, and others.

* Treuherz, Julian. "The Pre-Raphaelites and Medieval
 Illuminated Manuscripts." In **Pre-Raphaelite Papers**
 (no. 507), pp. 153-69.

513. Vaughan, William. **German Romanticism and English Art.**
 New Haven and London: Yale Univ. Press, 1979.

 A comprehensive study, covering the influence of
 the Nazarenes, the German outline style, and the
 woodcut style, Dyce and ecclesiastical art, and the
 Pre-Raphaelites.

514. Watkinson, Raymond. **Pre-Raphaelite Art and Design.**
 Greenwich, Ct.: New York Graphic Society, 1970.

 In addition to the paintings and graphic works of
 the major figures, discusses briefly the Pre-
 Raphaelites' relationship to the Morris firm and their
 involvement in the decorative arts.

515. Wilson, M.I., comp. **A Bibliography of Pre-Nineteenth
 Century Topographical Works Including Facsimile
 Editions Relating Chiefly to England, Scotland and
 Wales in the National Art Library, Victoria and
 Albert Museum.** [London: Victoria and Albert
 Museum], 1977.

 Inexpensively produced bibliography of 266 items,
 mainly of the eighteenth century, arranged
 chronologically under counties with an index of
 authors. Bibliographical entries are brief but
 indicate illustrative material.

516. Wood, Christopher. **The Pre-Raphaelites.** New York:
 The Viking Press, 1981.

 An opulently illustrated survey of the original
 Brotherhood, plus associates and followers like
 Morris, Burne-Jones, Dicksee, Holliday, Sandys, Crace,
 and Waterhouse.

B. Monographs: Artists, Critics, Collectors

BLAKE, WILLIAM (1757-1827)

517. Bentley, G.E., Jr., and Martin K. Nurmi. **A Blake
 Bibliography. Annotated Lists of Works, Studies,
 and Blakeana.** Minneapolis: Univ. of Minnesota
 Press, 1964.

 Lists Blake's own works, books owned by Blake,
 reproductions, and studies of his works.

518. Bindman, David. "Blake's 'Gothicized Imagination' and
 the History of England." In **William Blake. Essays
 in Honor of Sir Geoffrey Keynes,** edited by Morton
 D. Paley and Michael Phillips, pp. 29-49. Oxford:
 Clarendon Press, 1973.

 Studies Blake's pictures of English historical
 subjects, reexamining the significance of his contact
 with Gothic sculpture.

519. ─────. **William Blake. His Art and Times.** New
 Haven: Yale Center for British Art, and Toronto:
 Art Gallery of Ontario, 1982.

 A major exhibition catalogue covering the full
 range of Blake's work.

520. Essick, Robert N., and Donald Pearce, eds. **Blake in
 his Time.** Bloomington (Ind.), and London: Indiana
 Univ. Press, 1978.

 Includes essays by Roger R. Easson and Edward J.
 Rose on Blake and the Gothic.

521. Klonsky, Milton. **Blake's Dante. The Complete
 Illustrations to the 'Divine Comedy'.** New York:
 Harmony Press, 1980.

The plates, mostly reproduced in black and white, are accompanied by the appropriate passages and prefaced by an interpretive essay.

522. Pace, Claire. "Blake and Chaucer. Infinite Variety of Character." **AH** 3 (1980): 388-409.

Surveys Chaucer's growing reputation from the time of Dryden and the responses of artists including Barry, Mortimer, and Stothard; focusing on Blake's "Canterbury Pilgrim" and the "Descriptive Catalogue" to his exhibition of 1809, analyzes Blake's interest in Chaucer's powers of characterization, to which he saw analogies in his own artistic techniques.

523. Taylor, Irene. **Blake's Illustrations to the Poems of Gray.** Princeton: Princeton Univ. Press, 1971.

Extensive commentary accompanied by complete black-and white reproductions; includes the "Elegy Written in a Country Churchyard."

BONINGTON, RICHARD PARKES (1801-1826)

524. Peacock, Carlos. **Richard Parkes Bonington.** New York: Taplinger Publishing Company, 1980.

A leading romantic landscape and topographical painter who lived in Paris, Bonington published a collection of lithographs entitled **Restes et Fragments d'Architecture du Moyen Age** in 1824. Peacock concentrates, however, on Bonington's landscapes in watercolor and oils.

BOYS, THOMAS SHOTTER (1803-1874)

525. Roundell, James. **Thomas Shotter Boys, 1803-1874.** London: Octopus Books, 1974.

Boys was one of the most important architectural topographers of the early nineteenth century; his pioneering volumes of chromolithographs are rich in images of continental Gothic architecture. He also

prepared some of the illustrations for Baron Taylor's
Voyages Pittoresques and for Ruskins' **Stones of
Venice**. Roundell provides a substantial and well-
illustrated account of his life and work.

526. Smart, Alastair, comp. **Thomas Shotter Boys** (1803-
 187**4**). **Centenary Exhibition**. Nottingham and
 London: Nottingham University Art Gallery and Thos.
 Agnew and Sons, 1974.

 A well-documented and illustrated catalogue,
 complementary to no. 525.

527. Von Groschwitz, Gustave. "The Prints of Thomas
 Shotter Boys." In C. Zigrosser, **Prints**,
 pp. 191-215. London, 1963.

 Short commentary and chronological checklist of
 Boys' work.

BRANGWYN, SIR FRANK (1867-1956)

528. Brangwyn, Rodney. **Brangwyn**. London: William Kimber
 and Company, 1978.

 A general biography which includes a chapter on
 Brangwyn's decorations for the Houses of Parliament,
 begun in 1925.

529. Cardiff. National Museum of Wales (Cardiff) and Welsh
 Arts Council. **Frank Brangwyn Centenary**. (1967).

 Brangwyn designed stained glass, murals (including
 some for the Houses of Parliament), and painted
 furniture, as well as easel pictures; this small
 exhibition catalogue touches on his work as a
 decorative designer.

530. Galloway, Vincent. **The Oils and Murals of Sir Frank
 Brangwyn R.A.** 1867-1956. Leigh-on-Sea: F. Lewis,
 1962.

An illustrated catalogue raisonné of a painter who
provided murals for the Houses of Parliament and also
designed furniture. A companion volume by James D.
Boyd (1967) covers his drawings.

BROWN, FORD MADOX (1821-1893)

531. Rabin, Ludy Feiden. **Ford Madox Brown and the
 Pre-Raphaelite History-Picture.** New York and
 London: Garland Publishing, 1978.

 Concentrates on the period before 1852.

BURNE-JONES, SIR EDWARD COLEY (1833-1898)

532. Arts Council of Great Britain (London). **Burne-Jones.
 The Paintings, Graphic and Decorative Work of Sir
 Edward Burne-Jones, 1833-98.** 1975.

 Catalogue of a comprehensive exhibition of this
 major Pre-Raphaelite painter and decorative designer.

533. [Burne-Jones]. **Apollo,** n.s. 102 (1975): 314-61.
 Special issue.

 Includes articles by Ronald Parkinson on early
 altarpieces, Linda Parry on tapestries, and Duncan
 Robinson on "Burne-Jones, Fairfax Murray and Siena."

534. Christian, John. "Burne-Jones Studies." **Burl** 115
 (1973): 93-109.

 Publishes some of Burne-Jones' earliest drawings,
 his medievalizing designs for Maclaren's **Fairy Family;**
 discusses his early relationship with Ruskin and
 Rossetti.

535. ————. "Musée des Beaux-Arts de Strasbourg, VI.
 Deux Cartons de Vitraux par Edward Burne-Jones."
 Revue du Louvre 22 (1972): 525-30.

 Cartoons for windows at Rottingdean, acquired by

the Museum in 1968, are published and compared with the executed windows and with related cartoons.

* ———. "'A Serious Talk': Ruskin's Place in Burne-Jones's Artistic Development." In **Pre-Raphaelite Papers** (no. 507), pp. 184-205.

536. Dearden, James S. "Edward Burne-Jones--Designer to John Ruskin." **Connoisseur** 170 (1969): 89-94.

At Ruskin's request, Burne-Jones designed a set of stained glass windows (made by Morris) for Whitelands Training College; Dearden also discusses other, abortive, collaborations and chronicles the friendship between the two men.

537. Dorment, Richard. "Burne-Jones's Roman Mosaics." **Burl** 120 (1978): 72-82.

In 1881, Burne-Jones began an extensive mosaic scheme in St. Paul's Within the Walls, the American Church in Rome, a Gothic Revival church by G.E. Street.

538. Harrison, Martin, and Bill Waters. **Burne-Jones.** New York: G.P. Putnam's Sons, 1973.

A comprehensive and well-illustrated monograph, including the artist's paintings, drawings, graphic works, stained glass, and other important decorative work for the Morris firm.

CLERK, JOHN (of Eldin) (1728-1812)

539. Bertram, J. Geoffrey. **John Clerk of Eldin 1728-1812. Etchings and Drawings.** Edinburgh: The Author, 1978.

In addition to being Robert Adam's brother-in-law and a scholar of Gothic architecture, John Clerk of Eldin was an expert topographical draughtsman in the Sandby style and a prolific etcher. This slender

exhibition catalogue illustrates a small selection of
his views of Scottish medieval castles and churches.

540. Tait, A.A. "Robert Adam and John Clerk of Eldin."
 Master Drawings 16 (1978): 53-56.

 Explores Adam's informal collaboration with Clerk
 in drawing and etching, contrasting Adam's picturesque
 style with Clerk's dryer, topographical manner.

CONSTABLE, JOHN (1776-1837)

541. Beckett, R.B. "John Constable's Hadleigh Castle."
 Art Quarterly 26 (1963): 419-28.

 Publishes the recently rediscovered major painting
 of Hadleigh Castle (ca. 1828), along with related
 pictures of this medieval ruin.

542. Hawes, Louis. "Constable's Hadleigh Castle and
 British Romantic Ruin Painting." **AB** 65 (1983):
 455-70.

 Places Constable's great canvas in the context of
 his career and sets off its ambitious scale and
 content from the tradition of ruin painting as
 practiced by English topographical and picturesque
 artists.

* **Paintings and Drawings of Salisbury Subjects by Turner
 and Constable.** Cited as no. 593.

COTMAN, JOHN SELL (1782-1842)

543. Hemingway, Andrew. "Cotman's 'Architectural
 Antiquities of Normandy': Some Amendments to
 Kitson's Account." **Walpole Society** 46 (1976/78):
 164-85.

 The great watercolorist John Sell Cotman was
 largely occupied with antiquarian publishing from
 1811-1822, leading to the monumental **Architectural**

Antiquities of Normandy 1819-1822). Hemingway reveals
the circumstances of the book's creation, disputing
Kitson's interpretation of 1937 and revaluing Cotman's
etchings as works of art.

544. ————. "'The English Piranesi': Cotman's
Architectural Prints." **The Walpole Society** 48
(1980-82): 210-44.

A thorough analysis of the style and technique of
Cotman's work, setting it in the context of early
nineteenth century printmaking and topographical art,
and of Cotman's own watercolors.

545. ————. "Meaning in Cotman's Norfolk Subjects." **AH** 7
(1984): 57-77.

In an argument which engages fundamental issues of
art historical methodology, Hemingway seeks to restore
to the appreciation of Cotman's art an understanding
of its subject matter, whether landscape or
architecture, and of its significance in terms of the
association theory of aesthetics and of the political,
economic, and social consciousness of early nineteenth
century Norwich.

546. Holcombe, Adele M. **John Sell Cotman.** London: British
Museum Publications, 1978.

An illustrated survey of the British Museum's
extensive holdings of drawings and watercolors,
accompanied by a general essay on Cotman's life and
work.

547. Rajnai, Miklos. **John Sell Cotman. Drawings of
Normandy in Norwich Castle Museum.** Norwich:
Norfolk Museum Service, 1975.

Cotman visited Normandy in 1817, 1818, and 1820,
preparing the plates for the **Antiquities of Normandy.**
This catalogue reproduces many of his finished and
preparatory drawings of medieval architecture and
provides a close study of his work in Normandy.

548. ———, ed. **John Sell Cotman 1782-1842.** London:
 The Herbert Press, 1982.

 Cotman, as well as being a great watercolor
 landscape artist, was one of the leading topographical
 and architectural delineators of the early nineteenth
 century. This major exhibition catalogue of his
 watercolors and drawings includes essays on his
 publications projects, including the **Architectural
 Antiquities of Norfolk** 1812-1818) and the **Antiquities
 of Normandy** (1819-1822) (by Andrew Hemingway), and on
 Cotman and Normandy (by Marjorie Allthorpe-Guyton).

DARLEY, GEORGE (1795-1846)

549. Cooper, Robyn. "The Growth of Interest in Early
 Italian Painting in Britain: George Darley and the
 Athenaeum, 1834-1846." **Warb** 43 (1980): 201-20.

 Establishes Darley's importance as an early
 proponent of the Italian primitives, analyzes his
 Purist view of their art and his committment to art
 education and moral improvement.

DYCE, WILLIAM (1806-1864)

550. Pointon, Marcia. "William Dyce as a Painter of
 Biblical Subjects." **AB** 58 (1976): 260-68.

 Discusses the thematic content and artistic
 qualities of the Biblical pictures of this High
 Anglican painter who was influenced by the Italian
 primitives and the Nazarenes; emphasizes the
 distinctiveness of his work from that of the
 Pre-Raphaelites.

551. ———. **William Dyce 1806-1864. A Critical
 Biography.** Oxford: Clarendon Press, 1979.

 A substantial monograph covering this important
 Victorian religious painter's relationship with the
 Ecclesiological Society, with the Nazarenes, and with
 the Pre-Raphaelites, his role in the revival of
 fresco, his stained glass and other church

decorations, and his paintings on religious and
medieval themes.

EASTLAKE, SIR CHARLES LOCKE (1793-1865)

552. Robertson, David. **Sir Charles Eastlake and the
 Victorian Art World.** Princeton: Princeton Univ.
 Press, 1978.

 A comprehensive study of a central Victorian
 figure, painter, Secretary of the Fine Arts
 Commission, and Director of the National Gallery,
 including his advocacy of fresco painting and of early
 Renaissance art.

FLAXMAN, JOHN (1755-1826)

553. Bindman, David. **John Flaxman.** London: Thames and
 Hudson, 1979.

 Catalogue of a major Royal Academy exhibition,
 touching on the artist's Dante illustrations, his
 enthusiasm for the Italian primitives, his friendship
 with William Young Ottley, his medieval subjects and
 Gothicizing decorative designs.

GAMBIER-PARRY, THOMAS (1816-1888)

554. Blunt, Anthony. "The History of Thomas Gambier-
 Parry's Collection." **Burl** 109 (1967): 112-16.

 Starting in the 1850s, Gambier-Parry assembled an
 impressive collection, including Trecento paintings,
 medieval ivories, and enamels; the entire issue of
 Burlington is devoted to its contents. He was also a
 leading exponent of a novel method of fresco painting,
 in which he worked at Ely Cathedral, Highnam, and
 elsewhere (see the "Editorial" to this issue,
 pp. 111-12, and no. 418).

555. ———. "Thomas Gambier-Parry: A Great Collector."
 Apollo 81 (1965): 288-95.

General survey of Gambier-Parry's collections.

GILBERT, ALFRED (1854-1934)

556. Roskill, Mark. "Alfred Gilbert's Monument to the Duke
 of Clarence: A Study in the Sources of Later
 Victorian Sculpture." **Burl** 110 (1968): 699-704.

 Noting the tomb's setting--the Gothic Revival
 Albert Memorial Chapel, Windsor--Roskill traces
 Gilbert's fusion of a Gothic vocabulary with the
 inspiration of sixteenth century Italian sculpture.

GRIGGS, FREDERICK LANDSEER (1876-1938)

557. Comstock, Francis Adams. **A Gothic Vision: F.L. Griggs
 and his Work.** Boston: Boston Public Library, 1966.

 The great English etcher F.L. Griggs specialized in
 accurate and evocative views of Gothic architecture,
 both real and imaginary; Comstock's catalogue is
 provided with illustrations and an introductory essay.

HAIG, AXEL (1835-1921)

558. Crook, J. Mordaunt, and C.A. Lennox Boyd. **Axel Haig
 and the Victorian Vision of the Middle Ages.**
 London: George Allen and Unwin, 1984.

 Haig began his career as an architectural
 illustrator, working in particular for William Burges.
 After 1880, he became a masterful etcher of evocative
 medieval scenes based on castles and abbeys all over
 Europe. This short but well-illustrated monograph
 includes a chronological list of his prints.

HUGHES, ARTHUR (1832-1915)

559. Gibson, Robin. "Arthur Hughes: Arthurian and Related
 Subjects of the Early 1860's." **Burl** 112 (1970):
 451-56.

Publishes Hughes's recently discovered "Knight of the Sun," setting it in the context of his attraction to Malory and his other Arthurian paintings.

HUNT, WILLIAM HOLMAN (1827-1910)

560. Kulterman, Udo. "William Holman Hunt's 'The Lady of Shalott.' Material for an Interpretation." **Pantheon** 38 (1980): 386-92.

History and explication of Hunt's painting; comparison with Tennyson's poem and with other Victorian paintings on the subject.

561. Landow, George P. "Shadows Cast by **The Light of the World**: William Holman Hunt's Religious Paintings." **AB** 65 (1983): 471-84.

A thematic study of Hunt's late religious paintings (1892-1905), relating them to the concerns of Hunt's earlier, Pre-Raphaelite period.

562. ————. **William Holman Hunt and Typological Symbolism.** New Haven and London: Yale Univ. Press, 1979.

Hunt's search for a new pictorial symbolism, blended with a realist style.

563. Liverpool: Walker Art Gallery. **William Holman Hunt.** 1969.

Catalogue of a comprehensive exhibition of the Pre-Raphaelite painter's work.

JAMESON, ANNA (1794-1860)

564. Holcombe, Adele M. "Anna Jameson: The First Professional English Art Historian." **AH** 6 (1983): 171-87.

Against the background of the development of
professional art criticism and of periodical
readership, Holcombe analyzes the content and impact
of Jameson's major works, especially **Memoirs of the
Early Italian Painters** (1845) and **The Poetry of Sacred
and Legendary Art** (1848).

565. Thomas, Clara. **Love and Work Enough: The Life of Anna
 Jameson.** Toronto, 1967.

 Not available to the annotator.

KENT, WILLIAM (?1865-1748)

* Wilson, Michael I. **William Kent, Architect, Designer,
 Painter, Gardener, 1685-1748.** Cited above as
 no. 121.

 Though less accomplished as a painter than as an
 architect, Kent's early paintings on themes from
 Spenser and British history are nonetheless worthy of
 note.

LAYARD, SIR AUSTEN HENRY (1817-1894)

566. Waterfield, Gordon. "Henry Layard: Nineteenth-Century
 Aesthete." **Apollo** 83 (1966): 166-73.

 Discusses Layard's taste for early Italian
 paintings and frescoes and his impact on the National
 Gallery.

LOUTHERBOURG, PHILIPPE JACQUES DE (1740-1812)

567. Joppien, Rudiger. "A Visitor to a Ruined Churchyard –
 a Newly Discovered Painting by P.J. de
 Loutherbourg." **Burl** 118 (1976): 294-301.

 The picture (1790) is partially based on Tintern
 Abbey; the author sets it in the context of Young's
 Night Thoughts, eighteenth century Gothic imagery, and
 English Romanticism.

MACLISE, DANIEL (1806-1870)

568. Arts Council of Great Britain (London). **Daniel Maclise 1806-1870.** 1972.

Maclise painted subject pictures on medieval themes and was involved in the fresco decoration of the Houses of Parliament; this is a major exhibition catalogue of his work.

569. Ormond, Richard. "Daniel Maclise." **Burl** 110 (1968): 685-93.

A general survey of a popular Victorian artist, touching upon his illustrations to Tennyson's **Morte d'Arthur** and his medievalist frescoes in the Houses of Parliament.

MILLAIS, SIR JOHN EVERETT (1829-1896)

570. Boime, Albert. "Sources for Sir John Everett Millais's 'Christ in the House of His Parents.'" **Gazette des Beaux Arts** ser. 6, 86 (1975): 71-84.

Interprets the work and the reactions it provoked; analyzes its debt to Annibale Carracci.

571. Liverpool: Public Libraries, Museums and Art Gallery. **Millais PRB/PRA.** 1967.

Catalogue of a major exhibition (Walker Art Gallery, Liverpool, and Royal Academy, London), tracing Millais's evolution from a member of the Pre-Raphaelite Brotherhood to President of the Royal Academy.

572. Lutyens, Mary. **Millais and the Ruskins.** London: John Murray, 1967.

The personal relationship between the two men.

PLACE, FRANCIS (1647-1728)

573. Tyler, Richard, comp. **Francis Place, 1647-1728. An
 Exhibition Representing All Aspects of His Work.**
 York: York Art Gallery, 1971.

 One of the first English artists to concern himself
 primarily with landscape, Place traveled widely and
 recorded many medieval churches and ruins. His views
 of York were copied for Francis Drake's famous history
 of York, **Eboracum,** in 1736.

PUGIN, AUGUSTUS CHARLES (1769-1832)

* Wedgewood, Alexandra. **The Pugin Family.** In **Catalogue
 of the Drawings Collection of the Royal Institute
 of British Architects,** vol. 16 (no. 25).

RICHMOND, GEORGE (1809-1896)

574. Lister, Raymond. **George Richmond, A Critical
 Biography.** London: Robin Garton, 1981.

 A visionary painter and disciple of Blake,
 Richmond's early art was influenced by early
 Renaissance German and Italian art.

ROBERTS, DAVID (1796-1864)

575. Guiterman, Helen. **David Roberts R.A. 1796-1864.**
 London: Privately published, 1978.

 Not available to the annotator.

576. Howgedgeld, L. **David Roberts and Clarkson Stanfield.**
 London: Guildhall Art Gallery, 1967.

 Not available to the annotator.

577. Scottish Arts Council (Edinburgh). **Artist Adventurer.
 David Roberts.** 1978.

Not available to the annotator.

578. Sim, Katharine. **David Roberts R.A. 1796–1864. A
 Biography**. London: Quartet Books, 1984.

 Roberts was among the most adventurous and well-
 traveled of early nineteenth century topographical
 artists. This biography chronicles his career in
 detail.

ROOKER, MICHAEL ANGELO (1746–1801)

579. Conner, Patrick. **Michael Angelo Rooker 1746–1801**.
 London: B.T. Batsford in association with the
 Victoria and Albert Museum, 1984.

 Chapter II of this general monograph compares
 Rooker's topographical watercolors with those of other
 late eighteenth century artists and places the
 depiction of Gothic ruins in a longer perspective of
 topography and antiquarian interests.

ROSSETTI, DANTE GABRIEL (1828–1882)

580. Ainsworth, Maryan Wynn. **Dante Gabriel Rossetti and
 the Double Work of Art**. New Haven: Yale University
 Art Gallery, 1976.

 Catalogue of an important exhibition, with essays
 by Ainsworth, Susan P. Casteras, and Susan Ball
 Bandelin, focusing on the interaction of Rossetti's
 work as poet and painter.

581. Fleming, G.H. **Rossetti and the Pre-Raphaelite
 Brotherhood**. London: Rupert Hart-David, 1967.

 Concentrates on the artist's early years, his
 relations with Hunt, Brown, Millais, and Ruskin.

582. Grieve, Alastair. "The Applied Art of Dante Gabriel
 Rossetti - 1. His Picture-Frames." **Burl** 115
 (1973): 16–24.

Discusses Rossetti's innovative picture frames of
the 1850s-60s, their relation to the pictures within
them, and their critical reception.

583. ———. **The Art of Dante Gabriel Rossetti: 1. Found.
2. The Pre-Raphaelite Modern-Life Subject.**
Norwich, 1976.

Not available to the annotator.

584. ———. **The Art of Dante Gabriel Rossetti. The
Pre-Raphaelite Period 1848-50.** Hingham, Norfolk:
Real World Pubs., 1973.

A short monograph focusing on the "Girlhood of Mary
Virgin" and "Ecce Ancilla Domini" and analyzing
Rossetti's place in the Pre-Raphaelite Brotherhood.

585. Johnson, Ronald W. "Dante Rossetti's **Beata Beatrix**
and the **New Life**." **AB** 57 (1975): 548-58.

Explores Dante's significance for Rossetti's art.

* Mander, Rosalie. "Rossetti and the Oxford Murals."
In **Pre-Raphaelite Papers** (no. 507), pp. 170-83.

586. Surtees, Virginia. **The Paintings and Drawings of
Dante Gabriel Rossetti (1828-1882). A Catalogue
Raisonné.** 2 vols. Oxford: Oxford Univ. Press,
1971.

An exhaustive and well-illustrated catalogue.

RUNCIMAN, ALEXANDER (1736-1785)

587. Macmillan, J. Duncan. "'Truly National Designs':
Runciman's Scottish Themes at Penicuik." **AH** 1
(1978): 90-98.

Situates Runciman's shift from a Homeric to an
Ossianic scheme for the great painting cycle at

Penicuik House (1772) in the context of enthusiasm for
Ossian among Runciman's antiquarian associates in
Scotland and elucidates Runciman's attempt to develop
an identifiably national type of landscape setting in
paintings based upon Ossian and Milton.

SOUTHALL, JOSEPH (1861-1944)

588. **Joseph Southall 1861-1944, Artist-Craftsman.**
Birmingham: Birmingham Museums and Art Gallery,
1980.

Southall, who began his career as an articled clerk
in a Birmingham architectural office, imbibed the
Gothic Revival dedication to a fusion of design and
craftsmanship, coming under the influence of Burne-
Jones, Ruskin, and Italian art of the fourteenth and
fifteenth centuries. A member of the Birmingham Group
of Artist-Craftsmen around 1900, he not only painted
but also made picture frames and furniture.
Particularly interesting in this catalogue is a short
essay (by Jill Dunkerton) on the nineteenth century
rediscovery of tempera and its early exploitation by
Southall.

TURNER, JOSEPH MALLORD WILLIAM (1775-1851)

589. Finley, Gerald. "J.M.W. Turner and Sir Walter Scott:
Iconography of a Tour." **Warb** 35 (1972): 359-85.

Focuses on Turner's Scottish tour of 1831, his
relations with Scott, and his paintings and
illustrations of Scott themes and sites.

590. ————. "Kindred Spirits in Scotland: Turner and
Scott." **Connoisseur** 183 (1973): 238-47.

Turner's works for **Provincial Antiquities and
Poetical Works,** and his relationship with the author.

591. ————. **Landscapes of Memory. Turner as Illustrator
to Scott.** Berkeley and Los Angeles: Univ. of
California Press, 1980.

A substantial monograph, covering every aspect of
Turner's involvement with Sir Walter Scott; includes a
good account of the competition for the Scott Monument
in Edinburgh (for which Turner favored an obelisk; see
also no. 119).

592. Holcombe, Adele M. "Turner and Scott." **Warb** 34
 (1971): 368-97.

 Describes Turner's contributions to Scott's
 Poetical Works (1832-34), his relations with author
 and publisher.

593. **Paintings and Drawings of Salisbury Subjects by Turner
 and Constable.** Salisbury: The Old Deanery, 1967.

 Not available to the annotator.

594. Whittingham, S. "Turner, Ruskin, and Constable at
 Salisbury." **Burl** 113 (1971): 272-73.

 Turner's watercolor of Salisbury Cathedral (ca.
 1830), bought by Ruskin, is set in the context of
 Turner's rivalry with Constable and of Ruskin's views
 on the two artists.

C. Monographs: Authors Illustrated

BLAKE

 See nos. 517-23.

DANTE ALIGHIERI (1265-1321)

595. Chan, Victor. "Blake, Goya, Flaxman, Romney, and
 Fuseli: Transcriptions and Transformations of a
 Dantesque Image." **Arts Magazine** 55 (March 1981):
 80-84.

Illustrations of Caiaphas and the Hypocrites, from the **Divine Comedy**, starting with Flaxman's of 1792; the influence of medieval and early Renaissance art.

HARDY, THOMAS (1840-1928)

See nos. 305-6.

KINGSLEY, CHARLES (1819-1875)

See no. 491.

MACPHERSON, JAMES (1736-1796)

For Alexander Runciman's great Ossianic sequence at Penicuik, see no. 587.

596. Hamburger Kunsthalle (Hamburg). **Ossian und die Kunst um 1800.** 1974.

Not available to the annotator.

597. Hohl, Hanna, and Helene Toussaint. **Ossian.** Paris: Ministère des Affaires Culturelles. Edition des Musées Nationaux, 1974.

Catalogue of an exhibition at the Grand Palais, covering Ossianic art from Great Britain, Germany, Denmark, and France.

598. Okun, James. Ossian in Painting." **Warb** 30 (1967): 327-56.

Recounts the reception of the Ossianic forgeries, published in 1760, and artistic responses to them in Great Britain, Denmark, Germany, France, Italy, and Russia.

OSSIAN

 See JAMES MACPHERSON

SCOTT, SIR WALTER (1771-1832)

 For Scott's country house, Abbotsford, and his
activity as a collector, see nos. 57, 77-78; for his
relationship with Turner, nos. 589-92.

599. Buxton. Buxton Museum and Art Gallery. **The Lamp of
 Memory. Scott and the Artist.** 1979.

 A small exhibition catalogue containing about 30
nineteenth century English paintings on Scott themes
(Bonington, Wilkie, Landseer, Frith, Danby,
Orchardson, and others), plus some engravings and
related objects.

600. Gordon, Catherine. "The Illustrations of Sir Walter
 Scott: Nineteenth-Century Enthusiasm and
 Adaptation." **Warb** 34 (1971): 297-317.

 Emphasizes the broad popularity of Scott's poems
and novels as pictorial subjects in nineteenth century
English art, discusses painters' responses to them, as
well as his own involvement in the illustration of his
books.

601. Wright, Beth Segal. "Scott's Historical Novels and
 French Historical Painting 1815-1855." **AB** 63
 (1981): 268-87.

 Charts the course of Scott's popularity with French
painters and explores the tension in their work
between literary and visual demands.

WALPOLE, HORACE (1717-1797)

 See nos. 153-56.

PART FOUR: ARCHITECTURE IN NORTH AMERICA

A. General Works--Canada

602. Brosseau, Mathilde. **The Gothic Revival in Canadian Architecture**. Canadian Historic Sites: Occasional Papers in Archeology and History, No. 25. Ottawa: Parks Canada, 1980.

A useful beginning in identifying major and minor works across Canada with an attempt to define stylistic variations--Romantic, Rationalistic and Ecclesiological, High Victorian, and Beaux-Arts. The text is separate from the photographs and there are no plans or interiors.

603. Gowans, Alan. "The Canadian National Style." In **The Shield of Achilles**, edited by W.L. Morton, pp. 208-17. Toronto: McClelland and Stewart, 1968.

University College in Toronto (William Frederick Cumberland, 1856) and the Parliament Buildings in Ottawa (Thomas Fuller, 1861-67) are used as a focus to speculate on the growth of High Victorian Gothic as a national style.

* Hitchcock, Henry-Russell. **Architecture: Nineteenth and Twentieth Centuries**. Cited above as no. 14.

604. Hubbard, Robert Hamilton. **The Development of Canadian Art**. Ottawa: Queen's Printer, 1963.

The chief architectural style in the mid-nineteenth century in Canada was Gothic Revival, of which Hubbard provides a number of examples of all types. Toward the end of the century, styles became specific to certain buildings types.

605. ———. "The European Backgrounds of Early Canadian Art." **Art Quarterly** 27 (1964): 297-323.

While focused on classic revivals, the article discusses the influence of A.J. Downing and A.J. Davis on vernacular Gothic. William Frederick Cumberland's Norman Revival University College anticipated H.H. Richardson's Romanesque Revival Trinity Church by nearly twenty years.

606. ———. "Modern Gothic in Canada." **Bulletin of the National Gallery of Canada** No. 25 (1975): 3-18.

Modern Gothic was largely the preserve of English-speaking Canada, and examples include works by Cram, Sir G.G. Scott, and Henry Sproatt.

607. Kalman, Harold D. **The Railway Hotels and the Development of the Chateau Style in Canada.** Victoria, B.C.: Univ. of Victoria, 1968.

Points to the revival of the medieval French chateaux and how the style became institutionalized for the nation between 1893 and 1939.

608. Rogatnick, Abraham. "Canadian Castles: Phenomenon of the Railway Hotel." **AR** 141 (1967): 364-72.

A descriptive treatment of Canadian hotels, most of which are in the French Chateau style.

609. Weir, Jean B. **The Lost Craft of Ornamented Architecture: Canadian Architectural Drawings, 1850-1930.** Halifax, Nova Scotia: Dalhousie Univ., 1983.

Discusses Gothic Revival buildings by architects as
well as Carpenter Gothic structures influenced by
pattern books. The catalogue reproduces rarely seen
drawings, including those for the University of
Toronto and Gothic Revival churches by William
Critchlow Harris and Hutton and Souter.

610. Wright, Janet. **Architecture of the Picturesque in
 Canada.** Ottawa: Parks Canada, 1984.

Illustrates both charming vernacular houses and
architect-designed villas that can be characterized as
Gothic Revival. The author concludes: "In general
Canadian domestic architecture was dominated by the
more conservative products of the Picturesque...."
For example, houses in Canada might be symmetrical and
yet display modest Gothic ornament. Architect-
designed structures were never as flamboyant as
their English counterparts.

B. Monographs: Places in Canada

BRITISH COLUMBIA

611. Downs, Barry. **Sacred Places: British Columbia's Early
 Churches.** Seattle: Douglas and McIntyre and Univ.
 of Washington Press, 1980.

Discusses the modest, wooden Gothic Revival
churches erected by and for the Anglican pioneers and
offers a glossary, a bibliography and maps; the text
is accompanied by exquisite photographs.

NEW BRUNSWICK

612. Ward, E. **The Story of Stone Church, 1825-1975: St.
 John's (Stone) Church, St. John's, New Brunswick.**
 St. John's, N.B., 1975.

Not seen by the annotator. The Gothic Revival
church of 1824 was designed by the Scottish architect
John C. Cunningham.

ONTARIO

613. Arthur, Eric. **Toronto: No Mean City.** Toronto: Univ.
of Toronto Press, 1964.

Toronto has some landmark medieval revival
buildings and chapters on "Eclecticism" and
"Romanesque and Cast Iron" discuss and illustrate
these. While the text is brief, the captions for the
black and white illustrations are substantial.

614. Dendy, William. **Lost Toronto.** Toronto: Oxford Univ.
Press, 1978.

Descriptive entries are organized by location and
include many buildings in medieval revival styles.

615. MacRae, Marion, and Anthony Adamson. **The Ancestral
Roof: Domestic Architecture of Upper Canada,
1783-1867.** Toronto: Clarke Irwin and Co., 1963.

After 1867 Upper Canada became Ontario; this book
offers examples of chateaux and cottages in the
region.

QUEBEC

616. Lessard, Michel, and Gilles Vilandre. **La Maison
Traditionelle au Québec.** Montréal: Les Editions de
l'Homme, 1974.

In French-Canadian vernacular architecture one
finds survivals of medieval construction techniques
such as colombage pierroté (half-timber) and pièce-
sur-pièce. The authors devote individual chapters to
houses built with these techniques. There is no index.

617. Marsan, Jean-Claude. "Architecture in Quebec 1880 1914." **Canadian Collector** 13 (January/February 1978): 72-76.

Surveys the importance of railroads to the rise of towns. Religious buildings were either in neo-Baroque or neo-Gothic with St. Jacques in Montreal serving as a model for the latter. Marsan discusses Bruce Price's designs for Romanesque Revival railroad stations and Chateauesque hotels.

618. ─────. **Montreal in Evolution: Historical Analysis of the Development of Montreal's Architecture and Urban Environment.** Montreal: McGill-Queen's Univ. Press, 1981.

Suggests Montreal's initial plan evolved from a medieval bastide, but was changed by the Renaissance tradition of France. The neo-Gothic won the favor of the religious orders and was often chosen for churches. French editions of this book were published by Editions Fides in 1974 and 1976.

619. Noppen, Luc. **Les églises du Québec (1600-1850).** Québec: Editions Fides, 1977.

Gothic Revival churches were not prevalent in Quebec, but Noppen includes several in this book with O'Donnell's Notre Dame in Montreal being the most important. Individual entries for each building have photographs and bibliography.

620. Richardson, A.J.H., Geneviève Bastien, Doris Dubé, and Marthe Lacombe. **Quebec City: Architects, Artisans, and Builders.** Ottawa: National Museums of Canada, 1984.

A thoroughly researched volume that documents individuals who worked in Quebec during the first three centuries of the town's existence. Individual biographies discuss medieval survivals of building techniques along with stylistic revivals of the nineteenth century. Written in both French and English. No index.

C. General Works: United States

621. Andrews, Wayne. "American Gothic." **American Heritage**
 22 (October 1971): 26-47, 97.

 With excellent illustrations, Andrews praises the
 vernacular Gothic and criticizes the seriousness of
 Cram.

622. ————. **American Gothic: Its Origins, Its Trials, Its
 Triumphs**. New York: Random House, 1975.

 Attractively laid out and readable, with good and
 unusual photographs, this book discusses the English
 background, the types of structures for which Gothic
 was used, and assesses the assimilation of the style
 by the generation of Louis Sullivan.

623. ————. "Gothic Menace: Forerunner of Contemporary
 Architecture." **Historic Preservation** 22 (January
 1970): 4-9.

 Credits P.B. Wight and Silsbee with bringing Gothic
 West and training the next generation: "Modern
 architecture would be unthinkable without the fanatics
 who preached the Gothic gospel."

624. Cavalier, Julian. **American Castles**. South Brunswick
 and New York: A.S. Barnes and Co., 1973.

 An anecdotal account of thirty-three castellated
 buildings, the text includes outstanding examples such
 as Lyndhurst (by A.J. Davis) and Staunton Hill (by
 J.E. Johnson) but is accompanied by poor
 illustrations.

625. Clark, Clifford E., Jr. "Domestic Architecture as an
 Index to Social History: The Romantic Revival and
 the Cult of Domesticity in America, 1840-1870."
 Journal of Interdisciplinary History 7 (Summer
 1976): 33-56.

An intelligent discussion of a shift in housing
styles from classic revivals to Gothic and Italianate
styles as a result of a crusade that equated Gothic
with Christian living. Clark uses house pattern books
and built structures to make his argument about the
importance of this change in house styles.

626. Clark, Robert Judson, ed. **The Arts and Crafts
 Movement in America, 1876–1916.** Princeton:
 Princeton Univ. Press, 1972.

A series of essays examines English influences on
American efforts to revive quality work in book
design, ceramics, and furniture.

627. DeLong, David G. **Historic American Buildings: A
 Series of Volumes Reproducing all of the Drawings
 of the HABS and Including Photographs of Many of
 the Buildings.** New York: Garland Publishing,
 1979–80.

Subtitle tells all except the regions: eight
volumes for New York State, three volumes for
California, and two volumes for Texas.

628. Downs, Arthur Channing, Jr. "America's First
 'Medieval' Churches." **Historical Magazine of the
 Protestant Episcopal Church** 45 (June 1976): 166–76.

Analyzes the influence of the Camden Society's
plans of thirteenth century English churches on the
parish church revival in the United States.

629. ———. "Stained Glass in American Architecture."
 Nineteenth Century 3 (Winter 1977): 54–60.

Examines the interest in stained glass prompted by
the Gothic Revival and draws illustrations from both
domestic and ecclesiatical structures.

630. Early, James. **Romanticism and American Architecture.**
 New York: A.S. Barnes and Co., 1965.

Traces the influences of romantic ideas on taste, with emphasis on the picturesque as publicized by Downing and Davis. This book also highlights the importance of the Gothic Revival as a source of functionalist theory.

631. Gleason, Philip. "Guilds and Craftsmen: Echoes of the Middle Ages in American Social Thought." **Studies in Medievalism** 1 (1982): 51-72.

Traces the idea of guild socialism in late nineteenth century communities, comparing the schemes of Elbert Hubbard and Edward Pressey, among others, to those of John Ruskin.

632. Guggisberg, Hans Rudolf. **Das europäische Mittelalter im amerikanischen Geschichtsdenken des 19. und des frühen 20. Jahrhunderts.** Basel und Stuttgart: Verlag von Helbring und Lichtenhahn, 1964.

Primarily concerned with literature and history, but there is a brief section on the Gothic Revival, which discusses Godefroy's St. Mary's Chapel of 1806 and the Episcopal Bishop of Vermont, John Henry Hopkins, and his writing on Gothic architecture. The author also suggests that Upjohn and A.J. Davis reinforced trends already occurring in literature and art. An entire chapter is devoted to Brooks and Henry Adams and another to Charles Eliot Norton. The latter chapter mentions Charles Herbert Moore and Russell Sturgis.

633. Harmon, Robert B. **Carpenter Gothic and Nineteenth Century Ornamented Houses in America: A Selected Bibliography.** A-120. Monticello, Ill.: Vance Bibliographies, 1979.

The one-page introduction calls Carpenter Gothic "a uniquely American amalgam." The entries are annotated; some of the citations are nonsensical.

634. ———. **The Chateau or Chateausque** [sic] **Style in American Domestic Architecture: A Brief Style Guide.** A-908. Monticello, Ill.: Vance Bibliographies, 1983.

One of a series of poorly done bibliographies, this short list contains only six references of any substance.

635. ———. **The Richardsonian Romanesque Style in American Architecture: A Brief Style Guide.** A-886. Monticello, Ill.: Vance Bibliographies, 1983.

This brief list includes a guide to other reference works, some of which are of dubious value. The literature of the Romanesque Revival is large and this bibliography is deplorably short. Watch out for the frequent typographic errors.

636. ———. **The Victorian Gothic Style in American Architecture: A Brief Style Guide.** A-907. Monticello, Ill.: Vance Bibliographies, 1983.

Another in Harmon's series of stylistic guides, the introduction here is inaccurate and the references are spotty and often irrelevant. The list duplicates that of **The Victorian Romanesque Style.**

637. ———. **The Victorian Romanesque Style in American Architecture: A Brief Style Guide.** A-887. Monticello, Ill.: Vance Bibliographies, 1983.

The introduction is different, but the references given here are exactly those listed in **The Victorian Gothic Style.**

638. **Historic America: Buildings, Structures and Sites.** Washington, D.C.: Library of Congress, 1983.

Alone, this volume is not particularly useful for medievalism, but the checklist by Alicia Stamm includes 16,738 entries for fifty states and three territories, helping the researcher to find drawings,

photographs, and written data on American buildings
compiled by HABS and the Historic American Engineering
Record. Margot Gayles's "America's Cast Iron
Heritage" in the collected essays illustrates several
Gothic Revival structures.

639. Hitchcock, Henry-Russell. **American Architectural
 Books: A List of Books, Portfolios and Pamphlets** on
 **Architecture and Related Subjects Published in
 America before 1895.** Minneapolis: Univ. of
 Minnesota Press, 1962.

 Nearly fifteen hundred entries include pattern
 books for Gothic Revival houses, books about Henry
 Hobson Richardson and John Root, and many other
 topics. This invaluable list is indexed by style,
 architect, and building type.

* ————. **Architecture: Nineteenth and Twentieth
 Centuries.** Cited above as no. 14.

640. ————. "Ruskin and American Architecture, or
 Regeneration Long Delayed." In **Concerning
 Architecture** (no. 26), pp. 166-208.

 Offers a record of the publication history of
 Ruskin in America and assesses Ruskinian trends in the
 architecture of Mould, Eidlitz, Wight, Sturgis, the
 Potters, and Ware and Van Brunt.

641. Howe, Katherine Susman. "Product of an Age: The
 Gothic Revival in the U.S." **Nineteenth Century** 3
 (Spring 1977): 62-71.

 Emphasizes the social climate that gave rise to the
 Gothic Revival, ennumerating surviving European
 prototypes and speedier access to them, literary
 movements and the social structure of the South as
 contributing to the Revival's fluorescence.

642. ————. "The Gothic Revival Style in America, 1830
 1870." **Antiques** 109 (May 1976): 1014-23.

Traces Gothic Revival from its seventeenth century
beginnings in America through to the modifications
introduced by Charles Eastlake in the 1870s. Explains
its rise in popularity and offers examples in
textiles, pressed glass, lamps, silver, earthenware,
painting, and architecture.

643. Howe, Katherine Susman, and David B. Warren. **The
Gothic Revival Style in America, 1830-70.** Houston:
The Museum of Fine Arts, 1976.

An admirably composed exhibit catalogue documents
the Gothic Revival in the decorative arts.

644. Kenney, Alice P., and Leslie J. Workman. "Ruins,
Romance, and Reality: Medievalism in Anglo-American
Imagination and Taste, 1750-1840." **Winterthur
Portfolio** 10 (1975): 131-63.

Defines medievalism and notes the loose usage of
the term "Gothic" in the period. Discusses the
creative source that the idea of the Middle Ages
provided in painting, literature, and architecture.

645. Kervick, Francis W. **Architects in America of Catholic
Tradition.** Rutland, Vt: Charles E. Tuttle, 1962.

Provides an alphabetical list of over three hundred
architects, many of whom worked in medieval revival
styles. Brief biographies and black and white
photographs are included.

646. Kidney, Walter C. "Another Look at Eclecticism." **PA**
48 (September 1967): 118-27.

Puts the Gothic Revival of Cram and the Romanesque
Revival of Richardson into the broader context of
eclecticism.

647. ———. **The Architecture of Choice: Eclecticism in
America, 1880-1930.** New York: Braziller, 1974.

Makes the point that Romanesque was generally
cheaper to produce than Gothic. The author also
examines major practitioners of both modes.

648. Kniffen, Fred, and Henry Glassie. "Building in Wood
in the Eastern United States: A Time-Place
Perspective." **Geographical Review** 56 (January
1966): 40-66.

From the literature of the geography of settlement,
this carefully-written article assesses structures of
wood built in the folk tradition between 1790 and
1850. The authors discuss a number of construction
techniques that survived from at least medieval times:
wattle and daub on upright posts (puncheoning), half-
timbering and pièce-sur-pièce, for example.

649. Loth, Calder, and Julius Trousdale Sadler, Jr. **The
Only Proper Style: Gothic Architecture in America.**
Boston: New York Graphic Society, 1975.

Valuable for the photographs, this volume also
discusses early Gothic Revival examples not readily
found elsewhere.

650. McArdle, Alma de C. and Diedre Bartlett McArdle.
**Carpenter Gothic: Nineteenth Century Ornamented
Houses of New England.** New York: Whitney Library
of Design, 1978.

Photographic catalogue of wood-framed Gothic
houses.

651. Noble, Allen G., and Margaret Geib. "The Gothic
Revival Cottage." **Places** 1 (1974): 7.

A "graphic and word" sketch of the Gothic Revival
cottage which attributes the success of this building
type in part to the revivalist religious sentiment in
the nineteenth century. These houses often determine
"the character of a place."

652. Park, Helen. **A List of Architectural Books Available in America Before the Revolution.** New enl. ed. Los Angeles: Hennessey & Ingalls, 1973.

 Traces primarily English publications--including those by William and John Halfpenny and Batty Langley--to American institutional and personal libraries. Both William Buckland and Peter Harrison owned books concerned with medieval revivals.

653. Pierson, William H., Jr. **American Buildings and Their Architects: Technology and the Picturesque, the Corporate and Early Gothic Styles.** Garden City, N.Y.: Doubleday and Co., 1978.

 A stylistic development of the Gothic Revival and a typology of the villa. Fully two-thirds of the book is devoted to major figures like Upjohn, Renwick, and Davis and Downing.

654. Sadler, Julius Trousdale, Jr. "A Gothic Sampling." **Nineteenth Century** 2 (Spring 1976): 19-25.

 Remarks on the interest in things Gothic illustrated with pattern book details, rural churches, and major monuments.

655. Schuyler, Montgomery. **American Architecture and Other Writings.** 2 vols. Edited by William H. Jordy and Ralph Coe. Cambridge: Belknap Press, 1961.

 Important essays that discuss works by architects who often revived medieval forms: Francis Kimball; Cady, Berg, and See; Barney and Chapman, and Leopold Eidlitz. Originally written in the late nineteenth and early twentieth centuries, these articles also include discussions of Richardson, R.M. Hunt, Cram, and Cass Gilbert.

656. Scully, Vincent J., Jr. **The Shingle Style and the Stick Style: Architectural Theory and Design from Downing to the Origins of Wright.** (1955) rev. ed. New Haven and London: Yale Univ. Press, 1971.

Invaluable and pioneering study of domestic wooden
structures in which mid-century styles often
overlapped. Gothic Revival and Stick Styles are
related, just as medieval survivals influenced the
development of the Shingle Style.

657. Sherrill, S.B. "Living with Antiques: Lee B.
Anderson's Collection of American Gothic Revival
Furniture and Paintings, New York City." **Antiques**
109 (May 1976): 1032-41.

Discussing furniture makers and other owners of
Gothic Revival furniture, Sherrill also describes the
Anderson collection.

658. Sky, Alison, and Michelle Stone. **Unbuilt America:
Forgotten Architecture in the United States from
Thomas Jefferson to the Space Age.** New York:
McGraw Hill, 1976.

Collection of architectural proposals organized by
architect with some examples of medievalism: J.J.B.
Benedict's 1915 proposal for a summer Presidential
Capitol in Colorado in the form of a castle; entries
to the Cathedral of St. John the Divine competition;
Julia Morgan's Wyntoon Castle; and others. Each entry
has annotation.

659. Stanton, Phoebe. **The Gothic Revival and American
Church Architecture: An Episode in Taste.**
Baltimore: Johns Hopkins Univ. Press, 1968.

Definitive study of the Ecclesiological movement in
the United States. Analyzes the work of an array of
major figures between 1840 and 1856.

660. Stein, Roger B. **John Ruskin and Aesthetic Thought in
America, 1840-1900.** Cambridge: Harvard Univ.
Press, 1967.

Carefully evaluates the impact of Ruskin's writings
on artists in America.

661. Stern, Robert A.M., ed. "The Anglo-American Suburb."
 AD 51, Nos. 10-11 (1981).

 This special profile issue features brief
 illustrated discussions of nineteenth and twentieth
 century English and American suburbs, ranging from
 Llewellyn Park, N.J. (1853, A.J. Davis), to
 Bronxville, N.Y. (1892), to Van Doren Shaw's work at
 Lake Forest, Ill. (1916-17): most communities
 contain superb examples of medieval revival homes.

662. Turner, Paul V. **Campus: An American Planning
 Tradition.** Cambridge and London: MIT Press and New
 York: Architectural History Foundation, 1984.

 Turner's chapter, "The Monastic Quadrangle and
 Collegiate Ideals," focuses on the influence of the
 English system of colleges on American education and
 collegiate architecture. Ralph Adams Cram was a
 prominent spokesman for the revival of the medieval
 English quadrangle on American campuses and Turner
 details the background of quadrangular plans, with
 the University of Chicago being a notable example.
 Other sections analyze the work of Cope and
 Stewardson, the scheme of Princeton, Charles Klauder's
 designs and residential units.

663. Warren, David B., and Katherine Susman Howe. "Gothic
 Revival Furniture in the United States, 1830-70."
 Connoisseur 194 (January 1977): 56-61.

 Stresses how the Gothic Revival began quite timidly
 in details and never became the only reigning style.
 Adopted by major architects, the style then faded by
 1870.

664. Weisman, Winston. "A New View of Skyscraper History."
 In **The Rise of an American Architecture**, edited by
 Edgar Kaufman, Jr., pp. 115-60. New York: Praeger,
 1970.

 Asserts that Gothic was the only historical formula
 that successfully solved design problems of the

skyscraper and offers Cass Gilbert's West Street
Building and Woolworth Tower as examples.

665. Williams, Peter W. "The Varieties of American
 Medievalism." **Studies in Medievalism** 1 (Spring
 1982): 7-20.

 Assesses literary influences on the revival of
 medieval forms in the arts and discusses the writings
 of Charles Eliot Norton and Henry Adams, the buildings
 of Ralph Adams Cram and James Gamble Rogers, and the
 collection of James Jackson Jarves. The cartoon
 "Prince Valiant" even receives mention.

666. Wodehouse, Lawrence. **"The New Path and the American
 Pre-Raphaelite Brotherhood."** AJ 25 (Summer 1966):
 351-54.

 Gives an account of the Ruskin-inspired, short-
 lived Society for the Advancement of the Cause of
 Truth in Art and their journal **The New Path**. This
 group was dominated by the architect-critics, Peter B.
 Wight and Russell Sturgis.

667. Zukowsky, John R. "Cathedrals of Commerce: America's
 Gothic Skyscrapers." **American Art and Antiques** 2
 (January/February 1979): 106-13.

 Examines the background and image of the cathedral
 of commerce for skyscrapers in the 1920s.

668. ————. "The English Chapter House and Some American
 Gothic Spaces." **Studies in Medievalism** 1, ii
 (1982): 39-49.

 Background on the meaning of chapter houses with
 concentration on the use of the form in America, often
 for libraries and assembly spaces, and for parlors.

D. Monographs: Places in the United States

CALIFORNIA

669. Aidala, Thomas R. **Hearst Castle/San Simeon.**
New York: Hudson Hills Press, 1981.

Color photographs by Curtis Bruce complement the
text in this monograph. Chapters on the architecture
and the collection at San Simeon highlight Hearst's
passion for things medieval, as in his third floor
Gothic suite and in the Refectory.

670. Anderson, Timothy J., et al. **California Design 1910.**
Pasadena: California Design Publications, 1974.

Robert Winter's essay, "The Arroyo Culture,"
discusses Ernest Batchelder's career. Pages 126-27
outline Ernest Coxhead's contributions to domestic and
ecclesiatical architecture in the San Francisco area.

* DeLong, David G. **Historic American Buildings: A
Series of Volumes** Cited above as no. 627.

671. Jacobs, Stephen W. "California Contemporaries of
Wright." In **Studies in Western Art: Acts of the
XX. International Congress of the History of Art,
4, Problems of the Nineteenth and Twentieth
Centuries,** pp. 34-63. Princeton: Princeton Univ.
Press, 1963.

Jacobs discusses the picturesque, Jacobean Revival
works of Coxhead, and analyzes the work of other
contemporaries like Maybeck.

672. Longstreth, Richard W. **On the Edge of the World: Four
Architects in San Francisco at the Turn of the
Century.** Cambridge and New York: MIT Press and the
Architectural History Foundation, 1983.

Analyzes a "seminal period of creative endeavor" in the 1890s by focusing on four architects, Polk, Schweinfurth, Maybeck and Coxhead. The latter two are of interest here; Longstreth describes Maybeck's eclecticism as free-wheeling while Coxhead's was tradition-bound. The book discusses academic eclecticism at length and quotes Cram about using forms "from the past not IN the past."

COLORADO

673. Brettell, Richard R. **Historic Denver: The Architects and the Architecture, 1858–1893.** Denver: Historic Denver, 1973.

Devotes an entire section to "Richardsonianism," and illustrates the work of its major practitioners.

674. Stoehr, C. Eric. **Bonanza Victorian: Architecture and Society in Colorado Mining Towns.** Albuquerque: Univ. of New Mexico Press, 1975.

After an introduction on mining history, Stoehr discusses different building types stylistically, including Gothic and Romanesque Revivals. No plans; black and white photographs.

CONNECTICUT

675. Holden, Reuben A. **Yale: A Pictorial History.** New Haven: Yale Univ. Press, 1967.

This volume is valuable for the photographs of Gothic and Romanesque Revival buildings and includes a chronological list of campus structures to 1966.

DELAWARE

676. Hoffecker, Carol E. "Church Gothic: A Case Study of Revival Architecture in Wilmington, Delaware." **Winterthur Portfolio** 8 (1973): 215–31.

Analyzes the cluster of meanings attached to the Gothic Revival that began with specific theology, then became an expression of the pious urbanity of the upper middle class, and then became generalized to a variety of needs. Hoffecker uses a church rebuilt in 1886 in the Gothic mode to stress that the first post-Emancipation generation of Blacks used the Gothic to prove their assimilation.

DISTRICT OF COLUMBIA

677. Goode, James M. **Capital Losses: A Cultural History of Washington's Destroyed Buildings.** Washington, D.C.: Smithsonian Institution Press, 1979.

The chapter on churches has most of the examples of medieval revival buildings, although several early government buildings were castellated. Information on the 252 structures here is substantive.

678. Maddex, Diane. **Historic Buildings of Washington, D.C.** Pittsburgh: Ober Park Associates, 1973.

These selections from HABS provide plentiful examples of Romanesque and Gothic Revival buildings and eclectic works like the Smithsonian Institution.

ILLINOIS

679. Audrain, Calvert W., William B. Cannon, and Harold T. Wolff. **A Review of Planning at the University of Chicago, 1891-1978.** Chicago: Univ. of Chicago Press, 1978.

Of particular interest are the early schemes for the quadrangles by Henry Ives Cobb, Cobb's fifteen Gothic Revival buildings for the University and the early twentieth century variations on Gothic by Charles Coolidge, James Gamble Rogers and Bertram Goodhue.

680. Block, Jean F. **The Uses of the Gothic: Planning and Building the Campus of the University of Chicago, 1892-1932.** Chicago: Univ. of Chicago Library, 1983.

A readable history of the development of the University of Chicago from its initial phase under Henry Ives Cobb to the more archeological Gothic of Shepley Rutan and Coolidge after 1900 and, finally, to the modern Gothic of Bertram Grosvenor Goodhue and Coolidge and Hodgdon.

681. Bruckner, Donald J.R. **Dreams in Stone: The University of Chicago.** Chicago: Univ. of Chicago Press, 1976.

The black and white photographs by Patrice Grimbert and Lopez-Medina are accompanied by captions that give the architect and dates of construction for the buildings on this Gothic Revival campus.

682. Frueh, Erne R., and Florence Frueh. "Stained Glass Windows at the Second Presbyterian Church." **Chicago History** 6 (Winter 1977-78): 210-17.

An in-depth discussion of the patronage and subject matter of windows by Tiffany, LaFarge, Louis J. Millet, McCully and Miles, and Burne-Jones; all the photographs are black and white.

683. Historic American Building Survey. **Chicago and Nearby Illinois Areas.** Park Forest, Ill.: The Prairie School Press, 1966.

Compiled by J. William Rudd, this list of measured drawings, photographs, and written documentation by HABS includes medieval revival buildings by Burnham, Goodhue, Renwick, and Richardson, among others.

684. Lane, George. **Chicago Churches and Synagogues: An Architectural Pilgrimage.** Chicago: Loyola Univ. Press, 1981.

Includes an appendix by style (sixty-six churches
in medieval revival styles), a brief history of each
church, a glossary, and an essay on stained glass by
the Fruehs.

685. Lowe, David. **Lost Chicago**. Boston: Houghton Mifflin,
1975.

Many photographs and brief historical comments
describe Romanesque Revival works by Boyington and
Root and a castellated mansion by Cobb, for example.

686. Tigerman, Stanley. **Chicago Tribune Tower Competition
and Late Entries**. 2nd rev. ed. New York: Rizzoli,
1981.

Essays by contemporary architects and critics
accompany the original program for the 1922
competition; both original and late entries are
illustrated.

687. Vinci, John. "Better Never Than Late: The Late
Entries to the **Chicago Tribune** Competition."
Artforum 19 (September 1980): 56-62.

A summary of the original 1922 competition and an
analysis of a number of late entries, including a few
that take off from the original Hood and Howells
modern Gothic skyscraper.

INDIANA

688. Peat, Wilbur D. **Indiana Houses of the Nineteenth
Century**. Indianapolis, Ind.: Indiana Historical
Society, 1962.

Arranges the buildings stylistically and offers a
short chapter each on Gothic Revival, neo-Jacobean,
and French Romanesque Revival. A chapter on Indiana
architects details the backgrounds of various
designers.

IOWA

689. Horton, Loren N. "The Architectural Background of
 Trinity Episcopal Church." **Annals of Iowa** 43
 (Winter 1977): 539-48.

 Trinity Episcopal Church of 1872 in Iowa City
 probably was constructed according to the published
 schemes in **Upjohn's Rural Architecture.** The Carpenter
 Gothic church uses vertical board and batten
 construction. This article provides a history of the
 church and black and white illustrations.

KENTUCKY

690. Lancaster, Clay. **Antebellum Houses of the Bluegrass:
 The Development of Residential Architecture in
 Fayette County, Kentucky.** Lexington: Univ. of
 Kentucky Press, 1961.

 The author of a monograph on the nineteenth century
 eclectic architect John McMurtry (**Back Streets and
 Pine Trees: The Work of John McMurtry, Nineteenth
 Century Architect and Builder of Kentucky,** Lexington:
 Bur Press, 1956), Lancaster treats McMurtry's Gothic
 Revival structures in this overview of Lexington
 architecture. A.J. Davis also designed in the area.
 The book includes a map, plans, and old and new
 photographs.

LOUISIANA

691. Oszuscik, Philippe. **Louisiana's Gothic Revival
 Architecture.** Baton Rouge: Claitor, 1973.

 Focuses on Dakin's 1847-49 State House, the
 Louisiana Institute for the Deaf, Dumb and Blind,
 St. Patrick's Church, and Afton Villa.

MASSACHUSETTS

692. Banks, William Nathaniel. "The Wesleyan Grove
 Campground on Martha's Vineyard." **Antiques** 124
 (July 1983): 104-16.

From 1835 a Methodist "summer watering place,"
Wesleyan Grove, Massachusetts, became secularized by
the Civil War. Tents were replaced by cottages in
many styles in the 1860s and 1870s: cottage designs
were often derived from pattern books. The color
photos amply document the festive Gothic Revival
structures. The author also discusses the large but
delicate iron tabernacle built over the preacher's
stand in 1879 that features wrought iron columns
supporting open trusswork.

693. Bunting, Bainbridge. **Houses of Boston's Back Bay: An
Architectural History,** 1840-1917. Cambridge:
Belknap Press of Harvard Univ., 1967.

Bunting's typological study contains one chapter
particularly relevant to medievalism, that on "The
Decades of Individualism." Here he considers
Brownstone Gothic, Ruskin Gothic and the Romanesque,
clearly distinguishing among the various revivals and
providing illustrations. Another chapter on
"Authentic Revivals" discusses Romanesque, Gothic, and
Jacobean Revivals at the very end of the nineteenth
century up to 1917.

694. Cambridge Historical Commission. **Survey of
Architectural History in Cambridge.** 5 vols.
Cambridge: Cambridge Historical Commission,
1965-77.

Survey directed by Bainbridge Bunting with
Elizabeth MacDougall, Robert Rettig, Eleanor Pearson,
and Arthur Krimm includes East Cambridge, mid-
Cambridge, Cambridgeport, Old Cambridge and Northwest
Cambridge. Volume Five has index by architectural
style and influences with a quantity of medieval
revival examples. There is ample material on
H.H. Richardson.

695. Forman, Henry Chandlee. **Early Nantucket and Its Whale
Houses.** New York: Hastings House, 1966.

"By 'medieval' we ... mean ... a manner of building
which lagged in both Old and New England down to about

the year 1700, and which therefore had ample time to
flourish on Nantucket." More than half of this book
considers humble seventeenth century structures and
medieval village planning, with an emphasis on the
village of Siasconset.

696. Kay, Jane Holtz. **Lost Boston.** Boston: Houghton
 Mifflin, 1980.

 Though style is not the primary emphasis of this
 book, Kay presents Romanesque Revival buildings now
 gone and some castellated and Gothic Revival
 structures.

697. Tucci, Douglass Shand. **Built in Boston, City and
 Suburb, 1800–1950.** Boston: Little Brown, 1978.

 Two chapters are of special relevance, that on
 Richardson's Boston and on Cram.

698. ———. **Church Building in Boston, 1720–1970: With
 an Introduction to the Work of Ralph Adams Cram and
 the Boston Gothicists.** Concord, Mass.: Rumford
 Press, 1974.

 The subtitle here tells all, although some earlier
 churches by Upjohn, Ware and Van Brunt, Sturgis, and
 Richardson are illustrated.

699. ———. **The Gothic Churches of Dorchester: Readings
 in Modern Boston History.** Boston: Tribune
 Publishing Co., 1972.

 A collection of Tucci's newspaper articles on
 Gothic Revival churches.

700. Weiss, Ellen. "The Wesleyan Grove Campground."
 Architecture Plus 1 (November 1973): 44–49.

 The Methodist camp meeting site at Wesleyan Grove,
 Massachusetts, is notable for the Gothic Revival
 "campground" cottages of the 1870s; their designs were

often drawn from pattern books. Some of the
photographs Weiss uses are late nineteenth century
views.

MICHIGAN

701. Andrews, Wayne. **Architecture in Michigan.** Rev. and
 enl. ed. Detroit: Wayne State Univ. Press, 1982.

 Offers chapters on Romantic Michigan, Richardsonian
 Michigan and Discreet Michigan in which numerous
 examples of medieval revival structures are
 illustrated. Albert Kahn's Tudor Revival domestic
 work is illustrated in the chapter devoted to him.

702. Clark, Robert Judson, et al. **Design in America: The
 Cranbrook Vision, 1925-1950.** New York: Harry N.
 Abrams, in association with the Detroit Institute
 of Arts and the Metropolitan Museum of Art, 1983.

 George Booth, Cranbrook's patron, founded the
 Cranbrook Press in 1900 and modeled it after William
 Morris's Kelmscott Press. In 1907, Albert Kahn
 designed Booth's house in a Tudor Revival style,
 bearing witness to Booth's Arts and Crafts
 affiliations. The 1925 plan of Cranbrook Academy, by
 Eliel Saarinen, recalled Gothic Revival quadrangles.
 Essays in this catalogue by R.J. Clark, Davira
 Taragin, and David DeLong expand on these medievalist
 connections. J. David Farmer's article on metalwork
 and book binding touches on the Arts and Crafts
 links to modern Gothic.

703. Ferry, W. Hawkins. **The Buildings of Detroit: A
 History.** Detroit: Wayne State Univ. Press, 1968.

 Includes sections on the Gothic and Romanesque
 Revivals, the influence of Ruskin, and a whole chapter
 on "The Lure of the Middle Ages." Albert Kahn's
 medieval proclivities receive attention here.
 Numerous black and white photographs illustrate the
 intelligent text.

MISSOURI

704. Van Ravensway, Charles. **The Arts and Architecture of German Settlements in Missouri: A Survey of a Vanishing Culture.** Columbia, Mo.: Univ. of Missouri Press, 1977.

One chapter on half-timbered buildings analyzes the sources and techniques of the medieval framing method. Chapters on stone and brick construction feature several medieval revival churches; there is a brief mention of Gothic Revival furniture.

NEW JERSEY

705. Greiff, Constance, Mary W. Gibbons, and Elizabeth G.C. Menzies. **Princeton Architecture: A Pictorial History of Town and Campus.** Princeton: Princeton Univ. Press, 1967.

A chapter on Romanticism and Revivals illustrates Gothic Revival churches and houses as well as Richardsonian structures. The chapter on Academicism offers a discussion of Cope and Stewardson's Blair Tower (1897), and works by Day and Klauder and Ralph Adams Cram.

706. Wilson, Richard Guy. "Idealism and the Origin of the First American Suburb: Llewellyn Park, New Jersey." **American Art Journal** 11 (October 1979): 79-90.

Wilson provides unusual photographs and discusses the philosophical foundations of this first planned garden suburb that included domestic structures in medieval revival styles.

NEW YORK

707. Conover, Jewel Helen. **Nineteenth Century Houses in Western New York.** Albany: Research Foundation of SUNY, 1966.

Vernacular buildings are the prime focus here. Glossy black and white photographs provide a good

accompaniment to the brief text, which the author
organized chronologically. The medieval revivals are
discussed under "The Romantic Era" and "The Era of
Variety."

* DeLong, David G. **Historic American Buildings: A
Series of Volumes** Cited above as no. 627.

708. Gill, Brendan. **A Fair Land to Build In: The
Architecture of the Empire State.** Albany:
Preservation League of New York State, 1984.

The brief text is accompanied by many small black
and white photographs of medieval revival buildings
not often illustrated elsewhere: for example,
Atterbury's Station Square in Forest Hills or Charles
Haight's Westbrook in Great River. There are also
numerous vernacular examples.

709. Kramer, Ellen W. "Contemporary Descriptions of
New York City and Its Public Architecture,
ca. 1850." **JSAH** 27 (December 1968): 264-80.

Tells of attitudes toward landmarks and relatively
obscure structures at the time of their completion.
The article includes a number of buildings in medieval
revival styles and the reactions to them. One omitted
illustration is published in the October 1969 issue,
p. 225.

710. Landau, Sarah Bradford. "Greek and Gothic Side by
Side: Architecture Around the Square." In **Around
the Square 1830-1890: Essays on Life, Letters and
Architecture in Greenwich Village,** edited by Mindy
Cantor. New York: New York Univ., 1982.

Most buildings built around the Square in the 1830s
and 1840s were related in patronage or style to the
founding of New York University (1831) and its Gothic
Revival building. New York University's building, by
Town, Davis and Dakin, was the "first important
example of English collegiate Gothic in America."
This article describes the building's evolution. In

the immediate vicinity were several Gothic Revival
Presbyterian churches by James Dakin, Richard Upjohn
and James Renwick; Landau compares these churches to
others in the city. A Minard Lafever church receives
some attention too.

711. Parsons, Kermit C. "The Quadrangle on the Hill: An
 Account of the First Buildings at Cornell." JSAH
 22 (December 1963): 199-216.

 President Andrew Dickson White wanted a Gothic
 Revival campus but was unable to prevail over the
 board in the 1860s. The houses of White and of Ezra
 Cornell are used as evidence of their taste for
 Ruskinian Gothic.

712. Reynolds, Donald Martin. **The Architecture of New York
 City: Histories and Views of Important Structures,
 Sites and Symbols.** New York: Macmillan, 1984.

 Major structures examined here include the
 Woolworth Tower, Fonthill Castle, the Brooklyn Bridge
 and St. Thomas Church.

713. Reynolds, Donald Martin, Mary David Barry, and Jane
 Nobes Brennan. **Fonthill Castle: Paradigm of
 Hudson-River Gothic.** Riverdale, N.Y.: College of
 Mount Saint Vincent on-Hudson, 1976.

 Not seen by this annotator.

714. Zukowsky, John R. "Castles on the Hudson."
 Winterthur Portfolio 14 (Spring 1979): 73-92.

 The setting of the Hudson River recalls the Rhine.
 The wealthy clients who built along the corridor
 between upper Manhattan and North Tarrytown occupied
 chateaux, Tudor Revival manor houses and castellated
 mansions with medieval associations.

NORTH CAROLINA

715. Wrenn, Tony P. **Wilmington, North Carolina: An
 Architectural and Historical Portrait.**
 Charlottesville: Univ. of Virginia Press, 1984.

 Most of the medieval revival buildings discussed
 here are churches, including one by T.U. Walter and
 another by Hobart Upjohn.

OHIO

716. Campen, Richard N. **The Architecture of the Western
 Reserve.** Cleveland: The Press of Case Western
 Reserve Univ., 1971.

 This photographic survey highlights fine Tudor,
 Romanesque, and Gothic Revival structures in
 northeastern Ohio. Vernacular and architect-designed
 buildings are included; of special interest are works
 by Burnham and Root, Charles F. Schweinfurth, and
 George Keller.

717. Historic American Building Survey, and The Western
 Reserve Historical Society. **The Architecture of
 Cleveland: Twelve Buildings, 1836–1912.**
 Washington, D.C.: HABS, 1973.

 Photographs and survey data are presented here for
 buildings in medieval revival styles by Hezekiah
 Eldredge, Heard and Porter, John Root, George Keller,
 and Charles Schweinfurth, among others.

718. Wilhelm, Hubert G.H., and Michael Miller. "Half
 Timber Construction: A Relic Building Method in
 Ohio." **Pioneer America** 6 (July 1974): 43–51.

 Concentrates on Holmes County and the Amish
 settlements there. Half-timber construction was a
 vernacular building method associated with the
 medieval period and brought by European immigrants.
 Surveys structures built with this technique and
 describes their features in detail.

PENNSYLVANIA

719. Hanks, David. "Gothic Revival Furniture in
 Philadelphia." **Antiques** 109 (May 1976): 1024-31.

 Furniture from the late eighteenth century to the
 early twentieth century is illustrated and discussed
 in relation to its owners, designers, and makers.
 Gothic was thought to be most appropriate for the
 "quiet, domestic feeling of the library and family
 circle" (A.J. Downing).

720. Kraft, John L. "Ephrata Cloister, an Eighteenth
 Century Religious Commune." **Antiques** 118
 (October 1980): 724-37.

 Highlights Ephrata's buildings and their interiors.
 In addition to illuminating manuscript hymnals, the
 society's members built several half-timbered
 buildings, more a survival from their German heritage
 than a revival. An article about the construction
 techniques used at Ephrata can be found in **Antiques**
 for July 1944, pages 18-20.

721. Lay, K. Edward. "European Antecedents of Seventeenth
 and Eighteenth Century Germanic and Scots-Irish
 Architecture in America." **Pennsylvania Folklife** 32
 (Autumn 1982): 2-43.

 Medieval styles and building techniques survived
 among the early settlers of Pennsylvania. The
 illustrations and text feature combination dwelling
 barns, Fachwerk houses, and community buildings like
 those at Ephrata, and give details of their
 construction and stylistic sources.

722. Poppeliers, John C. "The 1867 Philadelphia Masonic
 Temple Competition." JSAH 26 (December 1967):
 278-84.

 Many of the entries were in Gothic Revival styles
 to recall the first two Temples, an English Gothic
 version by Strickland (1808) and an exuberant
 building by Sloan (1853-55).

723. Stevens, Bryan J. "The Swiss Bank House Revisited:
The Messerschmidt-Dietz House." **Pennsylvania
Folklife** 32 (Winter 1980/81): 78-86.

Discusses the building construction of this 1730s
house and its medieval antecedents, comparing it with
contemporary structures.

724. Tatum, George B. **Penn's Great Town.** Philadelphia:
Univ. of Pennsylvania Press, 1961.

Three chapters on eclecticism (1810-1920) include
Latrobe's Gothic Revival Sedgeley, and Cope and
Stewardson's Jacobean Revival work at the University
of Pennsylvania.

725. Van Trump, James D. **Life and Architecture in
Pittsburgh.** Pittsburgh: Pittsburgh History and
Landmarks Foundation, 1983.

This collection of essays includes Van Trump's
ruminations on nineteenth century Gothic Revival and
modern Gothic buildings in Pittsburgh and the impact
of Richardson on the city.

726. ————. "Revived Romanesque in Pittsburgh." **Carnegie
Magazine** 48 (March 1974): 108-13.

Not available to the annotator.

RHODE ISLAND

727. Jordy, William H., and Christopher P. Monkhouse,
et al. **Buildings on Paper: Rhode Island
Architectural Drawings, 1825-1945.** Providence:
Brown University/Rhode Island Historical
Society/Rhode Island Institute of Design, 1982.

This ambitious catalogue, with introductory essays
by Jordy and Monkhouse on the use of architectural
drawings, has individual entries by a variety of
experts: Jane B. Davies, Margaret Henderson Floyd,
Sarah B. Landau, and Douglass Shand Tucci, for

example. The catalogue includes drawings of medieval
revival buildings by the famous and not-so-famous,
including Ralph Adams Cram, Alexander Jackson Davis,
and E.T. Potter. Architect biographies are in an
appendix.

TEXAS

* DeLong, David G. **Historic American Buildings: A
 Series of Volumes** Cited above as 627.

728. Eickenroht, Marvin. "The Kaffee-Kirche at
 Fredericksburg, Texas, 1846." **JSAH** 25
 (March 1966): 60-63.

 Describes the half-timbered octagon built by German
 immigrants who supposedly were inspired by the late
 eighth-century palace chapel of Charlemagne at Aachen.

729. Herrmann, Maria. "The Restoration of Historical
 Fredericksburg." **Rice University Studies** 63
 (Summer 1977): 119-39.

 Account of the restoration of the German-founded
 Texas town with a history of the settlement from 1846
 as well as a discussion of eight buildings there: the
 reconstructed octagon of the Vereinskirche, a
 Romanesque Revival church and a Gothic Revival church
 and three houses built using Fachwerk (half-timber
 construction), among others.

730. Robinson, Willard B. **Gone from Texas: Our Lost
 Architectural Heritage.** College Station, Tex.:
 Texas A & M Univ. Press, 1981.

 Medieval revival styles came late to Texas but
 Chapter Four considers all types of structures with
 medieval forms; the photographs are valuable.
 Awkwardly written text attempts to synthesize
 buildings with cultural history.

731. Wilhelm, Hubert G.H. "German Settlement and Folk
 Building Practices in the Hill Country of Texas."
 Pioneer America 3 (1971): 15-24.

 Considers the adaptation of the German half-timber
 house to Texas conditions, especially around
 Fredericksburg and New Braunfels, among other topics.

VERMONT

732. Bruhn, Paul A. **A Celebration of Vermont's Historic
 Architecture.** Windsor, Vt: Preservation Trust
 of Vermont, 1983.

 Photographs by Sanders H. Milens present fine
 examples of Gothic and Romanesque Revival structures,
 including Upjohn's Immanuel Episcopal Church in
 Bellows Falls.

WASHINGTON

733. Neil, J. Meredith. "Administrators, Architects, and
 Campus Development: Washington State University,
 1890-1905." **JSAH** 29 (May 1970): 144-55.

 Describes the planning and building of W.S.U. that
 resulted in several Romanesque Revival and turreted
 buildings.

WISCONSIN

734. Landscape Research. **Built in Milwaukee: An
 Architectural View of the City.** (1980) Milwaukee:
 City, 1983.

 A thorough survey of buildings prior to 1930, this
 volume includes examples of medieval revival
 structures of all types. The German immigrants often
 built Gothic Revival churches; many commercial
 structures were designed in the Romanesque Revival
 style.

735. Perrin, Richard W.E. **The Architecture of Wisconsin.**
 Madison, Wis.: State Historical Society of
 Wisconsin, 1967.

 Discusses in a scholarly way building survivals of
 medieval half-timbering, Upjohn's Gothic Revival
 church at Delafield, and Gothic Revival churches by
 E.T. Mix, as well as examples of collegiate Gothic,
 Richardsonian Romanesque and medieval revivals in
 domestic structures.

736. ————. "German Timber Farmhouses in Wisconsin:
 Terminal Examples of a Thousand-Year Building
 Tradition." **Wisconsin Magazine of History** 44
 (Spring 1961): 199-202.

 Connects half-timber construction of western
 Germany to structures in Wisconsin. Gives the
 background of the open frame technique in Europe using
 archeological evidence.

737. ————. **Historic Wisconsin Buildings: A Survey in
 Pioneer Architecture, 1835-1870.** (1962) Milwaukee:
 Milwaukee Public Museum, 1981.

 Both editions include a chapter on half-timber work
 and illustrate some examples of timber and stone
 Gothic Revival churches.

E. Monographs: Architects, Designers, Critics, Patrons

ADAMS, HENRY (1838-1918)

738. Mane, Robert. **Henry Adams on the Road to Chartres.**
 Cambridge, Mass.: Harvard Univ. Press, 1971.

 Of direct relevance here is Mane's discussion of
 Adams's relationships with Henry Hobson Richardson and
 John LaFarge. The main focus, of course, is on
 Adams's publications on Mont Saint-Michel and
 Chartres.

ARNOLDI, KING (Dates not available)

739. Hubbard, Robert Hamilton. **Cathedral in the Capital: A
 Short History of Christ Church Cathedral Ottawa.**
 Ottawa: Cathedral Centenary Committee, 1972.

 A history of the church buildings on the site from
 the early nineteenth century on: Old Christ Church was
 in stone with "gothick" windows and a square
 castellated tower. The 1873 replacement by King
 Arnoldi was modeled after fourteenth century English
 Gothic prototypes.

BAIRD, HENRY CAREY (Dates not available)

740. Baird, Henry Carey. **Victorian Gothic and Renaissance
 Revival Furniture: Two Victorian Pattern Books.**
 With a New Introduction by David Hanks.
 Philadelphia: Athenaeum Library of Nineteenth
 Century America, 1977.

 Includes the 1868 edition of **The Gothic Album for
 Cabinet Makers** that illustrates twenty-three designs;
 Baird apparently took the designs from the Frenchman,
 Désiré Guilmard.

BICKNELL, AMOS JACKSON (Dates not available)

741. Bicknell, Amos Jackson. **Bicknell's Village Builder
 and Supplement: A Victorian Architectural
 Guidebook.** Introduction by Paul Goeldner.
 Watkins Glen, N.Y.: American Life Foundation, 1976.

 Introduction explains that Bicknell compiled
 designs for houses, schools and churches by various
 minor architects. The book includes several Gothic
 Revival cottages and many churches, with plans and
 building specifications. This same volume was issued
 under the title **Bicknell's Victorian Buildings** by
 Dover (New York, 1979).

742. Bicknell, Amos Jackson, and William Thompkins
 Comstock. **Victorian Architecture: Two Pattern**

Books. Introduction by John Maass. Watkins Glen, N.Y.: American Life Foundation, 1976.

Maass compares both Bicknell's **Detail, Cottage and Constructive Architecture** (1873) and Comstock's **Modern Architectural Designs and Details** (1881) to other pattern books. These volumes were aimed at architects and builders and included designs by Frederick Withers and H.H. Holly. Some of the Gothic cottages were built. For Comstock, Gothic simply meant a picturesque house with a steep roof.

BILLINGS, HAMMATT (1818-1874) and JOSEPH E. (Dates not available)

743. O'Gorman, James F. "H. and J.E. Billings of Boston: From Classicism to the Picturesque." JSAH 42 (March 1983): 54-73.

The brothers Hammatt and Joseph Billings worked in Boston in the mid-nineteenth century and designed several Gothic Revival churches influenced by Upjohn. This account summarizes the architectural careers of these two men and explains some of their design sources.

744. Stoddard, Richard. "Hammatt Billings, Artist and Architect." **Old-Time New England** 62 (January-March 1972): 57-65, 76-79.

Biographical sketch of this eclectic architect and versatile artist assesses two Gothic Revival church designs of 1846 and 1862, among others. Asserts that these picturesque churches resulted from influence of friend Arthur Gilman.

BOLTON, WILLIAM JAY (1816-1884)

745. Clark, Willene B. "America's First Stained Glass: William Jay Bolton's Windows at the Church of the Holy Trinity, Brooklyn, New York." **American Art Journal** 11 (1979): 32-53.

Bolton's designs (1843) are Late Gothic in spirit and represent an attempt to fuse stained glass techniques with the growing Gothic Revival in architecture.

746. ———. "Gothic Revival Stained Glass of William Jay Bolton: A Preservation Project and Census." **Nineteenth Century** 7 (Summer 1981): 30-34.

Bolton was familiar with medieval stained glass techniques and color and adapted them for use in American churches. Article includes color photographs and an iconographical analysis.

BRIGGS, LUTHER (1822-?)

747. Zimmer, Edward F. "Luther Briggs and the Picturesque Pattern Books." **Old-Time New England** 67 (Winter/Spring 1977): 36-55.

This Boston architect picked up new styles from pattern books in the 1840s and 1850s, but eventually individualized the designs. He produced buildings in Gothic and Tudor Revivals, among others.

BRIGHAM, CHARLES

See: STURGIS and BRIGHAM

BULFINCH, CHARLES (1763-1844)

748. Kirker, Harold. **The Architecture of Charles Bulfinch.** Cambridge: Harvard Univ. Press, 1969.

Discusses the three known experiments in Gothic Revival design by Bulfinch, foremost among them the Federal Street Church (1809) in Boston.

COBB, HENRY IVES (1859-1931)

749. Lewis, Julius. "Henry Ives Cobb: The Grand Design."
 University of Chicago Magazine 69 (Spring 1977):
 6-15.

 A useful account, adapted from the author's 1954
 M.A. thesis, of Cobb's Gothic designs at the
 University of Chicago.

COMSTOCK, WILLIAM THOMPKINS (Dates not available)

* Bicknell, Amos Jackson, and William Thompkins
 Comstock. **Victorian Architecture: Two Pattern
 Books.** Cited above as no. 742.

CONNICK, CHARLES J. (1875-?)

750. Raguin, Virginia. "Worcester's Tradition of Stained
 Glass Windows." **Worcester Art Museum Journal** 6
 (1982-83): 41-51.

 In addition to opalescent glass "picture" windows,
 Raguin discusses works by Cram's protégé Charles J.
 Connick, particularly those in Wesley United Methodist
 Church. Connick's competitors, like Wilbur H.
 Burnham, Sr., for example, also receive some
 attention.

COOLIDGE, CHARLES A. (1858-1936)

751. Allen, Peter C. "Stanford University: An Academic
 'Inner City.'" **Historic Preservation** 30 (April-
 June 1978): 30-36.

 A popular account of the Richardsonian-inspired
 work of Charles Coolidge (of Shepley, Rutan and
 Coolidge) at the quadrangles of Stanford between 1886
 and 1904. The sandstone buildings recall both Moorish
 Spain and Romanesque France.

752. Turner, Paul V., Marcia E. Vetrocq, and Karen Weitze.
 **The Founders and the Architects: The Design of
 Stanford University.** Palo Alto: Stanford Univ.
 Press, 1976.

 Turner et al., detail the interchanges between the
 client, planner and architect Coolidge and assess the
 rusticated masonry buildings in the quadrangles.

COPE, WALTER (1860-1902) and JOHN STEWARDSON (1858-1896)

753. Horowitz, Helen Lefkowitz. **Alma Mater: Design and
 Experience in the Women's Colleges from their
 Nineteenth Century Origins to the 1930s.** New York:
 Alfred A. Knopf, 1984.

 Places the architecture of the Seven Sisters
 colleges in the collegiate Gothic tradition. Of the
 Jacobean Gothic by Cope and Stewardson at Bryn Mawr
 the author notes: "M. Carey Thomas created at Bryn
 Mawr a campus that linked women to the Anglo-Saxon
 academic tradition, formerly a male preserve. This
 allowed the women's colleges to appropriate Gothic
 forms...."

754. Pickens, Buford, and Margaretta J. Darnall.
 **Washington University in St. Louis: Its Design and
 Architecture.** St. Louis: Washington Univ., 1978.

 The three essays in this catalogue compare the
 "Oxbridge" scheme of this campus to other
 universities. Cope and Stewardson's winning entry of
 1899 is compared to those of the other competitors.

COPELAND, ROBERT MORRIS (1830-1874)

755. Weiss, Ellen. "Robert Morris Copeland's Plans for Oak
 Bluffs." **JSAH** 34 (March 1975): 60-66.

 The four schemes for this development on Martha's
 Vineyard included some designs for Gothic cottages.

CRAM, RALPH ADAMS (1863-1942)

 Includes work by: CRAM and WENTWORTH, CRAM,
 WENTWORTH and GOODHUE, CRAM and FERGUSON

* For another reference to New York's St. John the
 Divine Cathedral, see p. xlii.

756. Allen, Gerald. "The Fourth St. Thomas Church: Some
 Practical Lessons for Building in Today's Cities
 from Ralph Adams Cram and Bertram Grosvenor
 Goodhue." **ARec** 155 (April 1974): 113-18.

 Describes the church and then discusses how Gothic
 was modified to fit the program of this particular
 urban church. The siting and plan work successfully
 in today's New York City.

757. Doumato, Lamia. **Ralph Adams Cram.** A-672.
 Monticello, Ill.: Vance Bibliographies, 1982.

 Twenty-one page bibliography useful for the
 thorough list of Cram's articles and books, including
 reprints and co-authored works.

758. Fitch, James Marston. **Architecture and the Esthetics
 of Plenty.** New York and London: Columbia Univ.
 Press, 1961.

 The chapter, "At Peace with the Past: The
 Unfinished Church," chronicles the Cathedral Church of
 St. John the Divine in New York, begun in 1892 and
 incomplete in 1961. Fitch wonders how such a church
 should be finished in modern times.

759. Fox, Stephen. **The General Plan of the William M. Rice
 Institute and Its Architectural Development.**
 Houston: School of Architecture, 1980.

 Cram, Goodhue and Ferguson attempted to mesh
 medieval and Southwestern forms in this campus design
 (1909-12) and drew on Carolingian and Byzantine

prototypes; the result has some resemblance to
medieval structures of the Mediterranean region.

760. Glenn, E. Bruce. **Bryn Athyn Cathedral: The Building
of a Church.** Bryn Athyn, 1971.

Commissioned by Raymond Pitcairn, this book details
the design, construction, and decoration of a Cram
church of 1913-29. The Swedenborgian cathedral, with
early Gothic as its model, is illustrated in many
color photographs by Michael Pitcairn. A plan and
readable text accompany the photos.

761. [Grove, Harold E.] **St. Thomas Church.** New York:
St. Thomas, 1965.

Monograph on the New York church by Cram, Goodhue
and Ferguson (1911-16) gives the history of the parish
and the building, with a special discussion of the
exterior sculpture and the interior decoration.

762. Hall, Edward H. **A Guide to the Cathedral Church of
St. John the Divine in the City of New York.**
New York: The Dean and Chapter of the Cathedral
Church, 1965.

Most of the book discusses the iconography of the
Cathedral decoration, but some attention is given to
the three chapels by Henry Vaughan. Ample
illustrations are provided.

763. Lynes, Russell. "A Major Resurgence of the Gothic
Style." **Architectural Digest** 36 (May 1979): 44+.

A chatty account of the building campaign of St.
John the Divine as part of what Lynes calls the third
Gothic Revival.

764. Muccigrosso, Robert. **American Gothic: The Mind and
Art of Ralph Adams Cram.** Washington, D.C.: The
Univ. Press of America, 1980.

Biography of the "medievalist in a modern setting" which covers Cram's role in Gothic Revival architecture and documents the New Medievalism promoted by the architect. The photographs are terrible, but the bibliography is useful.

765. ———. "American Gothic: Ralph Adams Cram." **Thought** 47 (Spring 1972): 102-18.

Chronicles Cram's efforts to recreate the spirit of the Middle Ages, which Cram felt de-emphasized nationalism, featured good workmanship, and promoted decentralization due to the agrarian society.

766. ———. "Ralph Adams Cram and the Modernity of Medievalism." **Studies in Medievalism** 1,ii (1982): 21-38.

Assesses Cram as a social critic and discusses Cram's view that the Middle Ages could serve as a paradigm for the modern world.

767. Stillwell, Richard. **The Chapel of Princeton University.** Princeton: Princeton Univ. Press, 1971.

This booklet relies heavily on correspondence between Cram and A.M. Friend and describes the iconography of the sculpture and windows in this chapel (1925-28). Stillwell also discusses the chapel's Romanesque predecessor by R.M. Hunt.

768. Tucci, Douglass Shand. **All Saints' Ashmont, Dorchester, Boston: A Centennial History.** Boston: All Saints Church, 1975.

Points out that the rector of All Saints' Ashmont, designed by Cram, was an advocate of the principles of the Oxford Movement.

* ———. **Church Building in Boston, 1720-1970** Cited as no. 698 above.

769. ————. **Ralph Adams Cram: American Medievalist.**
 Boston: Boston Public Library, 1975.

 This essay accompanied an exhibit and discusses the
 revival of Catholic art, Cram's writings and lectures,
 his partnerships and his explorations beyond Gothic.

770. ————. "Ralph Adams Cram: America's Foremost Gothic
 Scholar-Architect." **American Art Review** 3
 (May-June 1976): 125-36.

 Cram influenced his followers (and detractors) by
 writing and lecturing as well as designing. This
 article provides a useful overview of this many-
 faceted man and is accompanied by a number of color
 photographs. The essay concentrates on a few Gothic
 Revival buildings in New York and New England.

771. Wickersham, George, II. **The Cathedral Church of St.**
 John the Divine. New York: C.H. Conroy, 1977.

 A history of the church from 1892-1911 and 1916
 1941. With many color photographs, one also learns
 about the details of the building and its decoration.

CROPSEY, JASPER F.

 See PAINTING AND SCULPTURE IN NORTH AMERICA,
 Monographs: Artists and Their Associates, nos. 964-66.

CUMBERLAND, WILLIAM FREDERICK (1821-1861)

772. Morriss, Shirley G. "The Nine-Year Odyssey of a High
 Victorian Goth: Three Churches by Fred Cumberland."
 Journal of Canadian Art History 2 (Summer 1975):
 42-53.

 Cumberland, an English emigré architect, built
 three churches in the 1850s for the Ecclesiologists
 that were at the forefront of church design of this
 period. His assymmetrical designs were in contrast
 with the usual symmetrical Georgian forms known in

Ontario. The picturesque churches influenced other
Canadian designers like William Hay.

DAKIN, JAMES (1806-1852)

See also: A. J. DAVIS.

773. Laughlin, Clarence John. "Louisiana Fantasy." **AR** 141
(May 1967): 383-86.

A popular look at the castellated Gothic Old
Louisiana State Capitol (1847-49) at Baton Rouge with
illustrations of the interior and exterior. Structure
was rebuilt in 1880-82 by William A. Freret.

774. Scully, Arthur, Jr. **James Dakin, Architect: His
Career in New York and the South.** Baton Rouge:
Louisiana State Univ. Press, 1973.

Dakin worked with Town and Davis before moving
south, where he designed the Gothic Revival Capitol
(1847-49) and St. Patrick's in New Orleans (1838).
This volume has good color plates and extensive black
and white illustrations.

A.H. DAVENPORT and COMPANY

775. Farnam, Anne. "A.H. Davenport and Company, Boston
Furniture Makers." **Antiques** 109 (May 1976):
1048-55.

Former Richardson employee Francis Bacon was a
designer and vice-president of this firm that revived
many furniture styles. After A.H. Davenport and
Company merged in 1916 with Irving and Casson, the
firm executed commissions for Gothic Revival church
interiors designed by Cram, Goodhue and Ferguson and
for St. Patrick's in New York City.

DAVIS, ALEXANDER JACKSON (1803-1892)

 Includes work by: TOWN, DAVIS and DAKIN

776. Davies, Jane B. "Gothic Revival Furniture Designs of
 Alexander Jackson Davis." **Antiques** 111 (May 1977):
 1014-27.

 Davis never traveled abroad and relied on
 publications by Loudon and Pugin for many of his
 furniture designs. This article illustrates his
 strongly architectural forms, executed primarily by
 Richard Byrne and Ambrose Wright.

777. ————. "Llewellyn Park." **Antiques** 107 (January
 1975): 142-58.

 Solidly documented article discusses Davis's role
 in designing several picturesque houses in the
 development in West Orange, New Jersey.

778. Davis, Alexander Jackson. **Rural Residences, etc.,**
 Consisting of Designs, Original and Selected, for
 Cottages, Farmhouses, Villas, and Village Churches
 New Introduction by Jane B. Davies.
 (New York: New York Univ. Press, 1838) New York:
 DaCapo Press, 1980.

 Reprint makes available a rare publication by one
 of America's leading Gothic Revival architects of the
 mid-nineteenth century. Addressed primarily to the
 client, this pattern book shows Tudor and Gothic
 Revival houses in picturesque settings.

779. Doumato, Lamia. **Alexander Jackson Davis, 1803-1892.**
 A-353. Monticello, Ill.: Vance Bibliographies,
 1980.

 This bibliography is thorough but not annotated.

780. Historic American Building Survey. **Measured Drawings of National Trust Historic Properties.** Washington, D.C.: National Trust, 1974.

 Measured drawings of Lyndhurst include all elevations, plans, site plan, sections and window details.

781. McClinton, Katharine M. "Furniture and Interiors Designed by A.J. Davis." **Connoisseur** 170 (January 1969): 45-61.

 Davis's diaries provide insights into his domestic and church designs. Illustrations are taken mainly from Lyndhurst.

782. National Trust for Historic Preservation. **Lyndhurst on the Hudson River, Tarrytown, New York.** Washington, D.C.: Preservation Press, 1970.

 First published as an issue of **Historic Preservation** (17 [April May 1965]), this booklet includes essays by Alan Burnham on the Gothic Revival, Jane B. Davies on A.J. Davis, John Pearce on furnishings, Helen Duprey Bullock on the Paulding era, Terry Brust Morton on the Merritts and Henry Hope Reed, Jr. on the Goulds. The pamphlet is well-illustrated and succinctly places Lyndhurst, by A.J. Davis, in historical context.

783. "Notes [Herrick House]." **Metropolitan Museum of Art Bulletin** 25 (January 1967): 216.

 Note on the Met's collection of A.J. Davis material is illustrated by a watercolor sketch of the Herrick House.

784. Page, Marian. "Historic Restoration: The Three Eras of Lyndhurst." **Interiors** 125 (September 1965): 104-11, 218-19.

 A general account of the occupants of A.J. Davis's building.

785. Patton, Glenn. "Chapel in the Sky: Origins and
 Edifices of the University of the City of New
 York." **AR** 145 (March 1969): 177-80.

 A history of the school and its first chancellor's
 (James Mathews) importance to the English Gothic
 design of NYU's building by Town, Davis and Dakin.
 There is a useful bibliography.

786. Pearce, John. "Translatlantic Neo-Gothic: A.J.
 Davis's Designs for Lyndhurst, 1838-47, 1864-67."
 Connoisseur 170 (March 1969): 179-87.

 Davis provided a furnished Neo-Gothic house for the
 Pauldings; by the second phase of the building, the
 furniture was less vivacious, partly due to the
 cabinet-makers.

* Reynolds, Donald Martin, Mary David Barry, and
 Jane Nobes Brennan. **Fonthill Castle**
 Cited as no. 713 above.

787. Zukowsky, John R. "The Picturesque and Utopian: A
 Contrast in Spaces." **Nineteenth Century** 2 (1976):
 17-22.

 The author compares the spaces at Lyndhurst by A.J.
 Davis and the Octagon.

DOWNING, ANDREW JACKSON (1815-1852)

788. Downing, Andrew Jackson. **Cottage Residences, Rural
 Architecture, and Landscape Gardening.** New
 Introduction by Michael Hugo-Brunt. (1842)
 Watkins Glen, N.Y.: Library of Victorian Culture,
 1967.

 Although not reprinted from the original edition,
 this version provides a new index and a complete
 bibliography of Downing's publications, prepared by
 John and Judy Freeman.

789. Downs, Arthur Channing, Jr. "Downing's Newburgh
 Villa." **Bulletin of the Association for
 Preservation Technology** 4 (3/4 1972): 1-113.

 Well-researched article describes the history of
 Andrew Jackson Downing's own home on the Hudson as
 well as discussing the interiors, the site and changes
 made by A.J. Davis after Downing's death. Downs links
 the house and grounds to Downing's published theories
 on architecture and landscaping and demonstrates how
 Newburgh Villa served to showcase his ideas.

790. Vance, Mary. **Andrew Jackson Downing, 1815-1852.**
 A-199. Monticello, Ill.: Vance Bibliographies,
 1980.

 Nine-page unannotated bibliography lists works by
 and about A.J. Downing.

EARLE, STEPHEN C. (1839-1913)

791. Dahl, Curtis. "Architecture for a Growing Worcester:
 Stephen C. Earle (1839-1913)." **Worcester Art
 Museum Journal** 6 (1982-83): 3-18.

 Earle, a former employee of Calvert Vaux, designed
 Gothic Revival houses and schools and Romanesque
 Revival churches around Worcester, Massachusetts.

ELDREDGE, HEZEKIAH (1795-1845)

792. Rusk, Sarah E. "Hezekiah Eldredge, Architect-Builder
 of St. John's Church, Cleveland, Ohio." **JSAH** 25
 (March 1966): 50-58.

 This Gothic Revival Episcopal Church (1836-38) has
 been remodeled; the author explains its original
 design and possible sources.

EMERSON, WILLIAM RALPH (1833-1917)

793. Zaitzevsky, Cynthia, and Myron Miller. **The Architecture of William Ralph Emerson, 1833-1917.** Cambridge: Fogg Art Museum, 1969.

Concentrates on Emerson's work between 1870 and 1893, some of which reveals influences of Ruskin, Richardson, and seventeenth century New England houses.

FRERET, WILLIAM A. (1833-?)

See JAMES DAKIN (no. 773).

FROHMAN, PHILIP HUBERT (1887-?)

See also: HENRY VAUGHAN.

794. Kernan, Michael. "Philip Hubert Frohman: A Lifetime Spent in Profound Revision." **Cathedral Age** 45 (Winter 1970): 9-10.

Architect of Washington's National Cathedral since 1920, Frohman revised Bodley and Vaughan's original designs. This article describes the man, his training, and his revisions to "purify the Gothic spirit."

FURNESS, FRANK (1839-1912)

795. Doumato, Lamia. **Frank Furness.** A-366. Monticello, Ill.: Vance Bibliographies, 1980.

Six-page bibliography on the Philadelphia architect whose work is often labeled High Victorian Gothic.

796. "Fearless Frank Furness." **Architectural Forum** 112 (June 1960): 108-15.

Brief article valuable for the photographs of buildings now gone (Provident Trust, Philadelphia, for

example) and also shows the development in Furness's
career from a robust, almost brutal, High Victorian
Gothic to a gentle interpretation of medieval forms
(1886 switching towers for the P & R RR.)

797. Hanks, David. "Reform in Philadelphia." **Art News** 74
 (October 1975): 52, 54.

 Concentrates on the architect, Frank Furness, the
 cabinet maker, Daniel Pabst, and the "modern Gothic"
 furniture associated with Charles Eastlake.

798. Massey, James C. "Frank Furness: The Declining Years
 1890-1912." **Charette** 46 (February 1966): 8-13.

 Not seen by this annotator.

799. ————. "Frank Furness in the 1870s: Some Lesser
 Known Buildings." **Charette** 43 (January 1963):
 13-16.

 Descriptive discussion of the Guarantee Trust and
 Safe Deposit Co. (1875); the Pennsylvania Academy of
 Fine Arts (1876); and the Provident Life and Trust Co.
 Bank (1879). Massey assesses the influence of
 Venetian Gothic on Furness's early work.

800. ————. "Frank Furness in the 1880s: The Successful
 Architect." **Charette** 43 (October 1963): 25-29.

 Discusses Furness's ornament and furniture for
 private residences and railroad stations.

801. Morton, David. "Pennsylvania Academy Restoration:
 Furness Unfettered." **PA** 57 (November 1976): 50-53.

 Good color reproductions of the restored stairwell
 and the galleries of Furness's 1876 Academy.

802. Myers, Hyman. "The Three Buildings of the
 Pennsylvania Academy." **Antiques** 121 (March 1982):
 679-89.

 Focuses on Furness's building for the Academy and
 offers a thorough description of the building's
 fabric.

803. O'Gorman, James F. **The Architecture of Frank Furness.**
 Philadelphia: The Philadelphia Museum of Art, 1973.

 A catalogue of selected buildings is featured along
 with a complete checklist by George Thomas and Hyman
 Myers. O'Gorman's biographical essay is filled with
 stimulating ideas. There is no bibliography but the
 illustrations are good.

804. Robinson, Cervin. "Furness in '73." **Architecture
 Plus** 1 (August 1973): 26-33.

 Robinson's photographs accompany his brief essay
 about Furness's reputation since 1952. Robinson also
 discusses the influence of William Butterfield, John
 Ruskin and Viollet-le-Duc on Furness.

GILBERT, CASS (1859-1934)

805. Jones, Robert Allen. "Mr. Woolworth's Tower: The
 Skyscraper as Popular Icon." **Journal of Popular
 Culture** 7 (Fall 1973): 408-24.

 Discusses Cass Gilbert's Gothic terra cotta
 skyscraper as an image that captured the public
 imagination.

806. Klaw, Spencer. "The World's Tallest Building."
 American Heritage 28 (February 1977): 87-99.

 Considers Gilbert's Woolworth Tower as a "Cathedral
 of Commerce" and mentions its antecedents in the
 British Houses of Parliament as well as in Gilbert's
 own work.

807. Reynolds, Donald Martin. "The Tallest Building in the
 World, 1913-1930." **Immovable Objects.** New York:
 Cooper Hewitt Museum, 1975.

 This exhibit-catalog essay on Cass Gilbert's
 neo-Gothic Woolworth Tower was not available to
 review.

GODEFROY, MAXIMILIAN (1765-1840?)

808. Alexander, Robert. **The Architecture of Maximilian
 Godefroy.** Baltimore and London: Johns Hopkins
 Univ. Press, 1975.

 Of particular interest is the discussion of
 St. Mary's Chapel, the design of which drew on French
 and English medieval sources while the built version
 deviated from the original scheme.

809. Stanton, Phoebe. "St. Mary's Chapel, Baltimore, by
 Godefroy: The History and Restoration of an Early
 Gothick Building." **JSAH** 28 (October 1969): 223-24.

 Godefroy's chapel (1806-07) employed an imaginative
 Gothic in the original designs; the restoration is
 important as evidence of the changing attitudes toward
 the Gothic in the nineteenth and twentieth centuries.

GOODHUE, BERTRAM GROSVENOR (1869-1924)

 See also: R.A. CRAM.

810. Doumato, Lamia. **Bertram Grosvenor Goodhue 1869-1924.**
 A-452. Monticello, Ill.: Vance Bibliographies,
 1981.

 Eight-page bibliography for the most part cites
 references contemporary to Goodhue. The entries are
 not annotated.

811.	Oliver, Richard.	**Bertram Grosvenor Goodhue.**
	New York: Architectural History Foundation and
	Cambridge: MIT Press, 1983.

	Oliver's readable and well-researched monograph
	follows architect Goodhue from his first job with
	James Renwick, Jr., through his partnership with Ralph
	Adams Cram to his own firm for the last decade of his
	life. In association with Cram and alone, Goodhue
	designed and built a large number of buildings with
	medieval inspirations--Gothic, Romanesque and
	Byzantine.

812.	————. "Voyages of the Imagination: Four Post-Modern
	Buildings of Bertram Goodhue." **AR** 164 (September
	1978): 101-8.

	Traces Goodhue's career between 1903 and 1924 and
	discusses two free Gothic buildings: the chapel at
	West Point and the Church of the Heavenly Rest.
	Goodhue's West Point chapel is keyed to earlier
	imaginary drawings that the architect executed in the
	late nineteenth century.

GUASTAVINO Y MORENO, RAFAEL (1842-1908)

813.	Collins, George R. "The Transfer of Thin Masonry
	Vaulting from Spain to America." **JSAH** 27 (October
	1968): 176-201.

	About a traditional Catalan vaulting technique
	common in medieval times brought to America by Rafael
	Guastavino and adopted extensively in building between
	1890 and 1940. Two appendices list Guastavino's
	publications and those on Spanish tile vault
	construction.

HANSON, HALFDAN M. (1884-1952)

814.	Hollister, Paul. "The Building of Beauport, 1907-24."
	American Art Journal 13 (Winter 1981): 69-89.

	This complex in Massachusetts was a combined effort
	of Hanson and the landowner Henry Davis Sleeper. The

result was a vaguely Tudor and Norman English manor
house, comparable to Indian Hill Farm nearby.

HARRIS, WILLIAM CRITCHLOW (1854-1913)

815. Tuck, Robert C. **Gothic Dreams: The Life and Times of
 a Canadian Architect, William Critchlow Harris,
 1854-1913.** Toronto: Dundurn Press, 1978.

 Includes a complete checklist of works, most of
 which are ecclesiastical or residential.

HARTWELL, HENRY WALKER (1833-1919) and WILLIAM CUMMINGS
 RICHARDSON (1854-1935)

816. Vogel, Susan Maycock. "Hartwell and Richardson: An
 Introduction to Their Work." JSAH 32 (May 1973):
 132-46.

 Hartwell and Richardson did their best work in the
 1880s and 1890s; their churches and commercial
 buildings follow the example set by Henry Hobson
 Richardson.

HASKELL, JOHN G. (1832-1907)

817. Peterson, John M. **John G. Haskell: Pioneer Kansas
 Architect.** Lawrence, Kan.: Douglas Historical
 Society, 1984.

 A thorough biography of this nineteenth century
 eclectic architect who designed all types of buildings
 in Gothic and Romanesque Revivals.

HOLLY, HENRY HUDSON (?-1892)

818. Holly, Henry Hudson. **Country Seats and Modern
 Dwellings: Two Victorian Domestic Architectural
 Stylebooks.** Introduction and Index by Michael A.
 Tomlan. Watkins Glen, N.Y.: Library of Victorian
 Culture, 1977.

The 1863 **Country Seats** features picturesque villas
while **Modern Dwellings** (1878) highlights the Queen
Anne; both books show the influence of Holly's mentor,
Gervase Wheeler. Holly's publications do include
Gothic Revival church designs, schemes for castellated
mansions and medieval revival interiors.

819. Madigan, Mary Jean Smith. **Eastlake-Influenced
American Furniture** 1870-1890. Yonkers, N.Y.: The
Hudson River Museum, 1974.

Eastlake, an admirer of medieval architecture and
author of **Hints on Household Taste** (1868), was
influential in the United States in the 1870s.
Authors H.H. Holly and Harriet Spofford promoted
Eastlake's ideas as they understood them. His
simplified "art furniture" was adapted by craftsmen
like C.W. Elliot, A.P. Spofford, and Clarence Cooke.

820. ———. "The Influence of Charles Locke Eastlake on
American Furniture Manufacturing, 1870-90."
Winterthur Portfolio 10 (1975): 1-22.

Henry Hudson Holly and Harriet Spofford were
popularizers in print of Eastlake's ideas, which were
thought to be inspired by medieval prototypes. As
furniture was increasingly mass-produced, Eastlake's
designs became distorted.

HOOD, RAYMOND M. (1881-1934)

821. Doumato, Lamia. **Raymond M. Hood.** A-992. Monticello,
Ill.: Vance Bibliographies, 1983.

Sixteen-page bibliography is reasonably thorough
but not annotated.

822. Kilham, Walter H. **Raymond Hood, Architect: Form
through Function in the American Skyscraper.**
New York: Architectural Book Publishers, 1973.

Standard biography of Raymond Hood with sections on
Hood's work with Ralph Adams Cram, the Chicago Tribune

Tower competition, and the American Radiator Building in New York.

823. Stern, Robert A.M. **Raymond Hood.** New York: Institute for Architecture and Urban Studies, 1982.

Stern's essay to this catalogue places Hood as the last great architect of the era from 1876 to 1929 with an overview of Hood's career. Hood's work for Cram, Goodhue and Ferguson prepared him for his eventual triumph in the Chicago Tribune Tower competition. Hood preferred and was skilled with Gothic forms as also can be seen with his later American Radiator Building in New York.

HOPKINS, JOHN HENRY (Dates not available)

824. Wodehouse, Lawrence. "John Henry Hopkins and the Gothic Revival." **Antiques** 103 (April 1973): 176-83.

This amateur architect and Episcopal bishop of Vermont authored the first book in America on Gothic Revival architecture (1836). The churches that Hopkins designed are catalogued and illustrated here.

HUBBARD, ELBERT (1856-1915)

825. Cathers, David M. **Furniture of the American Arts and Crafts Movement: Stickley and Roycroft Mission Oak.** New York: New American Library, 1981.

A brief section on Elbert Hubbard discusses his guild and Roycroft furniture.

826. Hamilton, Charles F. **Roycroft Collectibles.** New York: A.S. Barnes, 1980.

Concentrates on the artifacts of the Roycroft workshops, founded by Elbert Hubbard. William Morris was a major inspiration to Hubbard whose workshops created hand-illuminated books as well as magazines and furniture.

827. Koch, Robert. "Elbert Hubbard's Roycrofters as
 Artist-Craftsmen." **Winterthur Portfolio** 3 (1967):
 67-82.

 Hubbard was a key promoter of William Morris in
 America. Roycroft industries reprinted "The Ancient
 Mariner" as Horace Walpole had patterned it in 1761.

HUNT, RICHARD MORRIS (1827-1895)

828. Allen, Gerald, and Mark Hewitt. "Biltmore." **Via** 6
 (1983): 130-41.

 Floor and site plans here of this Richard Morris
 Hunt design and a photograph of an early study model.
 The article analyzes the style of the Vanderbilt
 mansion which presents the "image" of French chateaux.

829. Baker, Paul R. **Richard Morris Hunt.** Cambridge: MIT
 Press, 1980.

 Thoroughly documented monograph with ample
 illustrations includes a photograph of the architect
 posing as Cimabue. Baker provides separate chapters
 on Hunt's Biltmore and urban chateaux, and gives full
 treatment to the castellated buildings at West Point
 as well as the masonry and half-timbered houses by
 this versatile architect.

830. Brendel-Pandich, Susanne. "Biltmore in Asheville,
 North Carolina." **Antiques** 117 (April 1980):
 855-67.

 Biltmore by Richard Morris Hunt (1889-95) parallels
 the castles of the Loire valley, displaying gargoyles
 and pinnacles. The Biltmore archives house nine
 hundred architectural drawings, some of which are
 illustrated here.

831. Coles, William A. "Richard Morris Hunt and His
 Library as Revealed in the Sketchbooks of Henry Van
 Brunt." **Art Quarterly** 30 (Fall/Winter 1967):
 224-38.

A speculative article indicating that Hunt probably owned works by Thomas Rickman, Victor Petit, and John Britton.

832. Landau, Sarah Bradford. "Richard Morris Hunt, the Continental Picturesque, and the 'Stick Style.'" **JSAH** 42 (October 1983): 272-89.

Richard Morris Hunt's houses of the 1860s reveal the influence of the European revival of half-timber and vernacular rustic architecture, especially in France. The Griswold House (1861-63) is the central building in this intelligent discussion of Hunt's sources in the French Picturesque movement.

HUTTON, ADDISON (1834-1916)

833. Yarnall, Elizabeth Biddle. **Addison Hutton: Quaker Architect, 1834-1916.** Introduction by George B. Tatum. Philadelphia: Art Alliance Press, 1974.

A former employee of Samuel Sloan, Hutton executed some Gothic Revival buildings on his own, most notably the Arch Street Methodist Church, 1869-70.

IRVING and CASSON

See A.H. DAVENPORT and COMPANY

JOHNSON, JOHN EVANS (1815-1870)

834. Lewis, Henry W. **More Taste than Prudence: A Study of John Evans Johnson, 1815-70.** Chapel Hill: The Borderer Press, 1983.

Of importance here is the chapter on the Gothic Revival Staunton Hill in Virginia (1848-50), with plans, interiors and correspondence reproduced that tell of the development of this plantation.

KAHN, ALBERT (1869-1942)

835. The Detroit Institute of Arts. **The Legacy of Albert Kahn.** Detroit: Detroit Institute of Arts, 1970.

Profusely illustrated exhibition catalogue provides an excellent overview of Kahn's career. The concise introductory essay by W. Hawkins Ferry discusses the early commission for the Scripps Library and Art Gallery (1898) with its reconstruction of Westminster Abbey's chapter house and Kahn's Tudor Revival dwellings. Kahn's 1920s skyscrapers were thought to have been inspired by the verticality of Gothic cathedrals, as already developed by Cass Gilbert in New York.

836. Robinson, Lydia. "Albert Kahn." **AR** 157 (June 1975): 348-57.

Survey of Kahn's work discusses his revivalist domestic designs and his streamlined Gothic Fisher Building in Detroit.

KAPP, W.E. (Dates not available)

837. Cameron, John B. **Meadow Brook Hall: Tudor Revival Architecture and Decoration.** Rochester, Mich.: Meadow Book Art Gallery, Oakland Univ., 1979.

Illustrates architecture and furniture designs of the early twentieth century architect, W.E. Kapp.

KELLER, GEORGE (1842-1935)

838. Ransom, David F. **George Keller, Architect.** Hartford: The Stowe-Day Foundation, 1978.

A lengthy analysis of buildings by type, a list of Keller's work from 1863 to 1931, and a brief biography. Keller often chose Gothic and Romanesque forms.

KIMBEL and CABUS COMPANY

839. Hanks, David. "Kimbel and Cabus: Nineteenth Century
 New York Cabinetmakers." **Art and Antiques** 3
 (September/October 1980): 44-53.

 This New York firm produced "modern Gothic"
 furniture inspired by the tenets of Charles Eastlake
 and Bruce J. Talbert: simplicity, obviousness of
 construction, and sympathetic use of materials.

LAFEVER, MINARD (1798-1854)

840. Landy, Jacob. **The Architecture of Minard Lafever.**
 New York: Columbia Univ. Press, 1970.

 Landy redresses the imbalance in Lafever's career
 for those who perceive him as a Greek Revival
 architect. Lafever's major Gothic Revival churches
 (Church of the Saviour and Holy Trinity) have a
 chapter apiece and there are two other chapters on
 early and mature Gothic Revival in New York.

LYBROCK, ALBERT (Dates not available)

841. Gayle, Margot. "Cast-iron Masterpiece: Gothic Revival
 Tomb of President James Monroe." **Nineteenth
 Century** 7 (Summer 1981): 62-64.

 Story of the tomb's design (in Richmond, Virginia)
 by German architect Albert Lybrock; Monroe's tomb
 resembles iron canopies placed over graves in the late
 Middle Ages.

MACLURE, SAMUEL (1860-1920)

842. Eaton, Leonard K. **The Architecture of Samuel Maclure.**
 Victoria: The Art Gallery of Greater Victoria,
 1971.

 Documents the large homes by Maclure (1860-1929),
 many of which are in a Tudor Revival style.

MAYBECK, BERNARD (1862-1957)

843. Cardwell, Kenneth H. **Bernard Maybeck: Artisan,
 Architect, Artist.** Salt Lake City and Santa
 Barbara: Peregrine Smith, 1977.

 By the curator of the Maybeck drawings at the
 University of California, Berkeley, this book
 includes a chronological list of works and projects by
 this architect who adapted Gothic forms particularly
 in the Christian Science Church (Berkeley, 1910) and
 in his late work at Principia College (Elsah, Ill.).
 A photograph of Maybeck and his family dressed in
 medieval clothes for a pageant accompanies the
 biographical section.

844. Craig, Robert M. "Bernard Ralph Maybeck and the
 Principia: Architecture as Philosophical
 Expression." **JSAH** 31 (October 1972): 234.

 Maybeck looked to an English Cotswold village as
 the model for his design of this Illinois school in
 the 1920s and 1930s, as explained in this abstract.

845. Jordy, William H. **American Buildings and Their
 Architects: Progressive and Academic Ideals at the
 Turn of the Century.** Garden City, N.Y.: Doubleday,
 1972.

 Chapter Six is devoted to Bernard Maybeck and
 discusses the medieval and vernacular sources in his
 First Church of Christ, Scientist, "a redwood San
 Marco, with Ca' d'Oro tracery."

* Longstreth, Richard W. **On the Edge of the World: Four
 Architects in San Francisco at the Turn of the
 Century.** Cited as no. 672 above.

846. Reinhardt, Richard. "Bernard Maybeck." **American
 Heritage** 32 (August/September 1981): 36-47.

Journalistic account of some of Maybeck's "Gothic
houses" and his application of Viollet-le-Duc's
"cloister-and-hearth medievalism" in other works.

MCNALLY, CORNELIUS (ca. 1858-1938)

847. Nelson, Lee H. "White, Furness, McNally and the
 Capital National Bank of Salem, Oregon." JSAH 19
 (May 1960): 57-61.

 This sandstone and granite bank (1892), once
 attributed to Stanford White, is an attempt to copy a
 Furness and Evans bank of 1884. Cornelius McNally, a
 Canadian, was the actual designer of the Salem façade,
 which features rusticated stone, a tourelle, and
 foliate details.

MEDLEY, EDWARD (1838-1910)

848. Richardson, Douglas Scott. "Hyperborean Gothic; or,
 Wilderness Ecclesiology and the Wood Churches of
 Edward Medley." **Architectura** (1972): 48-71.

 The amateur architect Edward Medley drew
 inspiration from medieval timber edifices of Britain;
 his churches in New Brunswick provide a rare parallel
 to wooden villas and cottages.

MOORE, CHARLES HERBERT (1840-1930)

849. Ferriday, Peter. "Professor Moore (1840-1930)." **AR**
 127 (April 1960): 271-72.

 This witty biographical sketch analyzes Charles
 Herbert Moore's theories and their critical reception
 in the United States and England. Moore, who authored
 The Development and Character of Gothic Architecture
 (1890), believed English Gothic architecture to be
 false. The French Gothic had evolved a new structural
 system out of the Romanesque according to Moore; his
 interpretations of historical forms influenced W.R.
 Lethaby.

MORGAN, JULIA (1872-1957)

850. Longstreth, Richard W. **Julia Morgan: Architect.**
 Berkeley: Berkeley Architectural Heritage
 Association, 1977.

 Surveys Morgan's career and offers black and white
 illustrations of her work. Longstreth discusses
 Morgan's affinity with the Arts and Crafts movement,
 saying that the architect adhered to the then popular
 notion of the medieval master builder, in which the
 architect was a semi-anonymous contributor to a team.
 While many of Morgan's works are not related to
 medievalism, several of her houses recall vernacular
 medieval dwellings. Longstreth does not discuss
 the Gothic suite at Hearst's "Castle" since it
 primarily was the product of Hearst himself.

MORRILL, JUSTIN (1810-1898)

851. Wodehouse, Lawrence. "Senator [Justin] Morrill's
 Gothic Cottage at Strafford, Vermont." **Antiques** 98
 (August 1970): 237-41.

 Remarkable inside and out, this Gothic cottage was
 built in 1848 by Morrill, an admirer of Ruskin and an
 avid reader of Scott.

MOULD, JACOB WREY (1825-1886)

852. Van Zanten, David T. "Jacob Wrey Mould: Echoes of
 Owen Jones and the High Victorian Styles in New
 York, 1853-65." **JSAH** 28 (1969): 41-57.

 The English architect Mould used bold polychromy
 for his Victorian Gothic works in New York and South
 America between 1853 and 1875. This article discusses
 his entire career and his importance to architects
 like Furness, Eidlitz and Wight.

NEWSOM, JOSEPH CATHER (1858-1930) and SAMUEL (1854-1908)

853. Gebhard, David, Harriette Von Breton, and Robert W.
 Winter. **Samuel and Joseph Cather Newsom: Victorian**

Architectural Imagery in California, 1878–1908.
Santa Barbara, Calif.: Univ. of California at Santa
Barbara Art Museum, 1979.

Includes essays by the three authors, a selected
list of buildings, major projects and writings by
these architect brothers, and photographs of their
eclectic work in Richardsonian Romanesque, Gothic
Revival, and Chateauesque, among other styles.

NOTMAN, JOHN (1810–1865)

854. Greiff, Constance M. **John Notman, Architect, 1810–65.**
 Philadelphia: Philadelphia Athenaeum, 1979.

 Biographical essay and a catalog of works note
 Notman's Gothic Revival churches of the 1840s.

O'DONNELL, JAMES (1774–1830)

855. Toker, Franklin K.B.S. **The Church of Notre–Dame in**
 Montreal: An Architectural History. Montreal:
 McGill-Queens Univ. Press, 1970.

 Analyzes this important Gothic Revival church
 (1823–29) by James O'Donnell. Toker points out that
 the American Catholic Gothic Revival preceded the
 Anglican adoption of the Gothic.

856. ————. "James O'Donnell: An Irish Georgian in
 America." **JSAH** 29 (May 1970): 132–43.

 Chronicles O'Donnell's career and how the architect
 struggled to free his Gothic forms from his Georgian
 background.

OSTERLING, F.J. (Dates not available)

857. Van Trump, James. **Legend in Modern Gothic: The Union**
 Trust Building. Pittsburgh, 1966.

 Analyzes the massive 1917 office building in late
 Northern French and Flemish Gothic inspired by Cass

Gilbert's Woolworth Tower. F.J. Osterling with Pierre A. Liesch designed this arcade building for Henry Clay Frick.

OUELLET, JOSEPH-PIERRE (1872-1959)

858. Noppen, Luc, Claude Thibault, and Pierre Filtreau. **La fin d'une époque: Joseph-Pierre Ouellet, Architecte.** Québec: Ministère des Affaires Culturelles, 1973.

Ouellet was known for his neo-classical churches but he built several neo-Gothic churches that retained classic proportions.

PEABODY, ROBERT SWAIN (1845-1917) and JOHN GODDARD STEARNS, JR. (1843-1917)

859. Holden, Wheaton A. "The Peabody Touch: Peabody and Stearns of Boston, 1870-1917." JSAH 32 (May 1973): 114-31.

Robert Peabody is the central figure in this article that surveys the firm's houses and commercial buildings. The author argues that Richardson was influenced by their neo-Romanesque designs.

POST, GEORGE BROWNE (1837-1913)

860. Weisman, Winston. "The Commercial Architecture of George B. Post." JSAH 31 (October 1972): 176-203.

Post adopted Richardsonian Romanesque in the late 1880s for the design of tall buildings, such as the outstanding Union Trust Building in New York (1889-90). He also used a chateauesque mode for the Vanderbilt House (1879-82).

POTTER, EDWARD T. (1831-1904)

861. Landau, Sarah Bradford. "The Colt Industrial Empire in Hartford." **Antiques** 109 (March 1976): 568-79.

E.T. Potter worked for Samuel Colt between 1867-72
and again in the 1890s designing an Episcopalian
church, parish house and library. These buildings by
this High Victorian Gothic architect are discussed and
well-illustrated here.

862. ————. **Edward T. and William A. Potter: American
 Victorian Architects.** New York: Garland
 Publishing, 1979.

Landau studied the careers of the Potter brothers,
"the two most important American practitioners of the
High Victorian Gothic," and in doing so she
illuminated much of the architecture between Richard
Upjohn's career and that of the mature Henry Hobson
Richardson. The Potters designed primarily churches
and institutional or public buildings; a complete list
of their works, arranged chronologically, is in an
appendix.

863. ————. "Mark Twain's House in Connecticut." **AR** 169
 (March 1981): 162-69.

The story of the "house that Mark built," designed
by High Victorian Gothic architect E.T. Potter. The
author compares the house with earlier residential
work by Potter and with Richard Morris Hunt's designs.

POTTER, WILLIAM APPLETON (1842-1909)

See also EDWARD T. POTTER

864. Wodehouse, Lawrence. "William Appleton Potter,
 Principal Pasticheur of Henry Hobson Richardson."
 JSAH 32 (May 1973): 175-92.

Potter's well-crafted buildings were High Victorian
Gothic when he began designing; he then followed
Richardson's inspiration in the 1880s. At the end of
his career his designs tended to be historically
correct Gothic.

PRICE, BRUCE (1843-1903)

865. Pitcher, Rosemary. **Chateau Frontenac.** Toronto and
 Montreal: McGraw-Hill Ryerson, 1971.

 Monograph on Price's hotel (1892-1924) in Quebec
 that was not available to annotator.

RATTENBURY, FRANCIS (1867-1935)

866. Barrett, Anthony A., and Rhodri Windsor Liscombe.
 Francis Rattenbury and British Columbia:
 Architecture and Challenge in the Imperial Age.
 Vancouver: Univ. of British Columbia Press, 1983.

 The British architect Rattenbury came to British
 Columbia in 1892 and left in 1930. In the interim he
 designed government and commercial structures, some of
 which were in the chateauesque mode. Like his friend
 Samuel Maclure, he evolved a Tudor Revival style for
 domestic commissions. This monograph provides lists
 of Rattenbury's projects and executed works, and of
 his drawings in the Provincial Archives of British
 Columbia.

867. Segger, Martin. **The British Columbia Parliament**
 Buildings. Vancouver: Arcon, 1979.

 Well-illustrated monograph on the vaguely-
 Romanesque Parliament by Francis Rattenbury also
 discusses other competition designs and Rattenbury's
 chateauesque buildings in Canada.

RENWICK, JAMES (1818-1895)

868. Cook, Leland. **St. Patrick's Cathedral: A Centennial**
 History. Introduction by Brendan Gill. New York:
 Quick Fox, 1979.

 Chapter Four of this popular account concentrates
 on James Renwick and the Gothic Revival; the book
 features lavish color photographs.

869. Doumato, Lamia. **James Renwick.** A-633. Monticello,
 Ill.: Vance Bibliographies, 1981.

 The five pages here have many contemporary
 citations, but otherwise exclude more recent
 scholarship.

870. Frueh, Erne R., and Florence Frueh. **The Second
 Presbyterian Church of Chicago: Art and
 Architecture.** Chicago: Second Presbyterian Church,
 1978.

 The Fruehs tell of Renwick's 1872 design for the
 polychromed Gothic Revival church and the 1900
 reconstruction of the interior in an Arts and Crafts
 manner. The murals by Frederic Clay Bartlett and the
 stained glass by Louis Tiffany, John LaFarge, and Sir
 Edward Burne-Jones are analyzed and illustrated; some
 medieval stained glass methods were used for the
 windows.

871. Hafertepe, Kenneth. **America's Castle: The Evolution
 of the Smithsonian Building and Its Institution,
 1840-1878.** Washington, D.C.: Smithsonian
 Institution Press, 1984.

 An account of the intrigues, politics and scandals
 surrounding the Norman Revival museum by James
 Renwick. We learn about the design competition, the
 building, the additions and restorations as well as
 about Renwick's other work and the influence of
 Senator Robert Dale Owen and Secretary Joseph Henry on
 the architect.

872. Rattner, Selma. "Renwick's Church for Blacks."
 Historic Preservation 24 (July 1972): 32-35.

 A history of the design for St. Mary's Episcopal
 Church in Washington, D.C., with photographs.

RICHARDSON, HENRY HOBSON (1838-1886)

873. Adams, Ann Jensen. "Birth of a Style: Henry Hobson
 Richardson and the Competition Drawings for Trinity
 Church, Boston." **AB** 62 (September 1980): 409-33.

 Clearly written account of the winning entry for
 Trinity Church tells how it was subsequently
 developed: the drawings reveal French planning, a
 conflation of a French "dome" and an English tall
 tower, and the Romanesque rounded arch.

874. **Around the Station: The Town and the Train/Focus of a
 New England Town's Growth.** Framingham, Mass.:
 Danforth Museum, 1978.

 Not seen by the annotator; it considers one of
 Henry Hobson Richardson's stations.

875. Brown, Robert F. "The Aesthetic Transformation of an
 Industrial Community." **Winterthur Portfolio** 12
 (1977): 35-64.

 Analyzes the integrated efforts of Richardson and
 Olmsted to transform North Easton, Massachusetts, into
 an aesthetically satisfying manufacturing village
 between 1877 and 1884. Both men considered the entire
 site and views from and toward individual buildings.

876. ————. **The Architecture of Henry Hobson Richardson
 in North Easton, Massachusetts.** North Easton: The
 Oakes Ames Memorial Hall Association and the Easton
 Historical Society, 1969.

 Valuable for its reproductions of early photographs
 and engravings of North Easton. Brown's short
 introduction discusses North Easton's buildings and
 landscape; there is also a building chronology.

877. Doumato, Lamia. **Henry Hobson Richardson, Boston
 Architect.** A-40. Monticello, Ill.: Vance
 Bibliographies, 1979.

Quite substantial bibliography includes a
chronology of the architect's life.

878. Fleming, Malcolm. "The Saving of Henry Hobson
 Richardson's Union Station, New London,
 Connecticut." **American Art Review** 2 (July/August
 1975): 29-40.

 The New London station was the largest that
 Richardson ever designed and was done in red brick.
 The author compares it to Sever Hall at Harvard as
 well as to the local Richardsonian Romanesque library.

879. Floyd, Margaret Henderson. "H.H. Richardson,
 Frederick Law Olmsted, and the House for Robert
 Treat Paine." **Winterthur Portfolio** 18 (Winter
 1983): 227-48.

 Article on Paine's house, Stonehurst, concentrates
 on the client-landscape architect-architect
 relationship, but does touch on some stylistic debts.
 Floyd contends that William Burges's towered
 collegiate designs inspired the garden façade of
 Stonehurst.

880. Friedlaender, Marc. "Henry Hobson Richardson, Henry
 Adams and John Jay." **JSAH** 29 (October 1970):
 231-46.

 Focuses on the clients for these houses on
 adjoining lots in Washington, D.C., commissioned in
 1884.

881. Hill, Leroy Draper, Jr. **The Crane Library**.
 Introduction by Walter Muir Whitehill. Quincy,
 Mass.: Trustees of the Thomas Crane Library, 1962.

 Brief but useful book with plans, drawings and
 photographs of Henry Hobson Richardson's library in
 Quincy. Hill tells the story of the clients and the
 design and compares the Crane to other works by
 Richardson.

882. Hitchcock, Henry-Russell. **The Architecture of Henry Hobson Richardson and His Times.** (Revised edition, 1961; Paperback, 1966); Cambridge: MIT Press, 1975.

 Standard reference on Richardson first published in 1936, updated in the revised edition.

883. ———. "French Influence on Nineteenth Century Architecture in the U.S.A." AD 48 (Nos. 11-12, Profile 78): 80-83.

 Sources for Richardson's Trinity Church include Vaudoyer's Marseilles Cathedral and medieval churches of the Auvergne; the front portal (now covered by the porch) was derived from St. Gilles de Provence.

884. ———. "H.H. Richardson's New York Senate Chamber Restored." **Nineteenth Century** 6 (Spring 1980): 44-47.

 Color illustrations of the restoration and historic photos of the 1881 Capitol offer good views of Richardson's interiors.

885. ———. "An Inventory of the Architectural Library of Henry Hobson Richardson." **Nineteenth Century** 1 (January and April 1975): 27,31; 18-19.

 Richardson owned works by Britton, Ruskin, Street, and Viollet-le-Duc, among others. Hitchcock also includes a list of photographs that were in the architect's possession.

886. ———. **Richardson as a Victorian Architect.** Baltimore: Smith College by Barton Gillet Co., 1966.

 Especially prior to 1872, Richardson was a Victorian in that he followed the work of the English High Victorians and borrowed willingly from French Romanesque sources, among others.

887. Homolka, Larry J. "Richardson's North Easton."
 Architectural Forum 125 (May 1966): 72-77.

 Richardson built five Romanesque Revival buildings
 in this factory town and this descriptive article
 illustrates them thoroughly.

888. Kidney, Walter C. **H.H. Richardson's Allegheny County
 Courthouse and Jail.** Pittsburgh: Allegheny County
 Bureau of Cultural Programs, 1981.

 Offers numerous illustrations and discusses the
 development of the design from the competition through
 completion.

889. Klukas, Arnold W. "Henry Hobson Richardson's Designs
 for the Emmanuel Episcopal Church, Pittsburgh."
 American Art Review 2 (July/August 1975): 64-76.

 Discusses this 1883-86 church by Richardson,
 offering the preliminary sketches and the built
 version of common brick for study. The church is
 compared to other work by the architect.

890. Newman, M.W. "Granite Hut: Henry Hobson Richardson's
 Glessner House." **Architectural Forum** 137 (November
 1972): 35-41.

 A journalistic account of the Chicago Architectural
 Foundation's rescue of the Glessner House in Chicago.
 Illustrated by plans, details and interiors.

891. Norton, Bettina A., ed. **Trinity Church.** Boston:
 Wardens and Vestry of Trinity Church, 1978.

 The second Trinity Church (1829) was an early
 Gothic Revival structure. The church then relocated
 to Copley Square, in H.H. Richardson's building. The
 text gives accounts of the construction, decoration
 and furniture of the new building.

892. Ochsner, Jeffrey Karl. **H.H. Richardson: Complete Architectural Works.** Cambridge and London: MIT Press, 1982.

Catalogue raisonné includes a biographical note and 400 pages of photographs and text on Richardson's buildings and projects from 1866. The illustrations include one of the series by G.C. Cox of Richardson in a monk's habit.

893. ————. "H.H. Richardson's Frank William Andrews House." **JSAH** 43 (March 1984): 20-32.

This large country residence in Rhode Island has been Labeled as pivotal in the shift from Stick to Shingle Styles. Ochsner located additional drawings and photographs of this house (destroyed by fire); they help reassess its importance and identify some late medieval and some contemporary sources for its design.

894. O'Gorman, James F. **Henry Hobson Richardson and His Office: Selected Drawings.** Cambridge: Harvard College Library, Department of Printing and Graphic Arts, 1974.

Discusses the organization of Richardson's office and illustrates another in Cox's series of the architect in a monk's habit.

895. ————. "The Marshall Field Wholesale Store: Materials Toward a Monograph." **JSAH** 37 (October 1978): 175-94.

A factual history of this "grim fortress of trade" discusses how it became a symbol of an urban commercial structure.

896. ————. "O.W. Norcross, Richardson's 'Master Builder': A Preliminary Report." **JSAH** 32 (May 1973): 104-13.

At least thirty-three of Richardson's buildings
were constructed by the Norcross Brothers, who
provided an all-inclusive building service and went to
great lengths to make Richardson's vision a reality.

897. ————. "On Vacation with Henry Hobson Richardson:
 Ten Letters from Europe, 1882." **Archives of
 American Art Journal** 19 (1979): 2-14.

 With only a brief introduction, O'Gorman excerpts
 the letters and provides illustrations of the French
 and Spanish medieval monuments that the architect
 reported visiting.

898. Price, Charles. "Henry Hobson Richardson: Some
 Unpublished Drawings." **Perspecta** 9/10 (1965):
 199-210.

 The drawings include some for Trinity Church and
 Glessner House and an entry to the Connecticut Capitol
 competition.

899. Randall, Richard H., Jr. **The Furniture of Henry
 Hobson Richardson.** Boston: Museum of Fine Arts,
 1962.

 This catalogue was not seen by the annotator.

900. Roseberry, Cecil R. **Capitol Story.** Albany: State of
 New York, 1964.

 This book on the state capitol designed by
 Richardson, et al. was not available to the annotator.

901. Rudd, J.W. "Cincinnati Chamber of Commerce Building."
 JSAH 27 (May 1968): 115-23.

 Discusses the competition in 1885, which Richardson
 won, and the subsequent development of its design.
 Part of the granite was reclaimed after a 1911 fire
 for use in the Cincinnati Astronomical Society
 Building.

902. Russell, John. "Henry Hobson Richardson." **American
 Heritage** 32 (October/November 1981): 48-59.
 A photograph of the bulky Richardson in a monk's
 habit pens this article on Richardson's major works
 and his inspiration from eleventh- and twelfth-
 century forms.

903. Stebbins, Theodore. "Richardson and Trinity Church:
 The Evolution of a Building." **JSAH** 27 (December
 1968): 281-98.

 Illustrates and analyzes the competition and
 developmental drawings for Richardson's church and
 discusses the completion of the work by Shepley, Rutan
 and Coolidge.

904. Toker, Franklin K.B.S. "Richardson **en concours**: The
 Pittsburgh Courthouse." **Carnegie Magazine** 51
 (November 1977): 13-29.

 Compared with competition drawings of the
 finalists, Richardson's winning design is analyzed in
 terms of its form and massing.

905. Van Rensselaer, Mariana G. **Henry Hobson Richardson
 and His Works.** (Boston, 1888) With a New
 Introduction by William Morgan. New York: Dover,
 1969.

 A biography and chronology of work by Richardson.
 Appendices include Richardson's own accounts of some
 of his major works; Morgan gives a biography of Van
 Rensselaer.

906. Van Zanten, David T. "H.H. Richardson's Glessner
 House, Chicago, 1886-87." **JSAH** 23 (May 1964):
 106-11.

 The authorship of this imposing, inward-looking
 structure belongs to Richardson's office, not to the
 architect himself. Photographs of interiors,
 preliminary drawings and published studies supplement
 the text.

907. Zaitzevsky, Cynthia. "A New Richardson Building."
 JSAH 32 (May 1973): 164-66.

 Discusses the previously unpublished Hayden
 Building in Boston (1875-76).

RICHARDSON, WILLIAM CUMMINGS

 See: HARTWELL and RICHARDSON

RIDDLE, THEODATE POPE (1868-1946)

908. Paine, Judith. "Avon Old Farms School: The
 Architecture of Theodate Pope Riddle." **Perspecta**
 18 (1982): 42-49.

 Riddle designed both the academic program and
 quadrangles for this boys' school. Completed by 1929,
 the school has the steep roofs, clustered chimneys,
 gargoyles, and recessed casement windows of an English
 village and employs traditional materials of wood and
 brick.

ROEBLING, JOHN A. (1806-1869) and WASHINGTON A. (1837-1926)

909. The Brooklyn Museum. **The Great East River Bridge,
 1883-1983.** New York: Harry Abrams, 1983.

 Beautifully illustrated catalogue with essay by
 Deborah Nevins and Lewis Kachur on the chronology and
 imagery of the Brooklyn Bridge. The authors quote the
 painter Albert Gleizes: "[T]he genius who built the
 Brooklyn Bridge is to be classed alongside the genius
 who built Notre Dame de Paris."

910. Trachtenberg, Alan. **Brooklyn Bridge: Fact and Symbol.**
 Chicago: Univ. of Chicago Press (1965) 1979.

 Chapter Five focuses on the Gothic arches of the
 Bridge and how they help make the structure
 monumental. The styles of other bridges are
 discussed.

ROGERS, JAMES GAMBLE (1867-1947)

911. Ryan, Susan. "The Architecture of James Gamble Rogers
at Yale University." **Perspecta** 18 (1982): 25-41.

Rogers's work at Yale between 1917 and 1934 in the
Gothic idiom came largely from the hand of E. Donald
Robb, an employee of Cram. The sculptor Lee Lawrie
executed gargoyles and allegorical figures. The Yale
architecture is compared to that of other campuses.

912. Van Zanten, David T. "'Twenties Gothic." **New Mexico
Studies in the Fine Arts** 7 (1982): 19-23.

Brief yet stimulating discussion of modern Gothic
in the 1920s in relation to the age of movies and
corporate advertising. Works by James Gamble Rogers
are offered as examples.

ROOT, JOHN WELLBORN (1850-1891)

913. Hoffman, Donald. **The Architecture of John Wellborn
Root.** Baltimore: Johns Hopkins Univ. Press, 1973.

A leading Chicago architect and former employee of
Renwick and Wight, Root designed a number of round
arched, Romanesque Revival structures.

914. Monroe, Harriet. **John Wellborn Root: A Study of His
Life and Work.** (1896) With a New Introduction by
Reyner Banham. Park Forest, Ill.: Prairie School
Press, 1966.

Sister-in-law of Root, Monroe published the first
full length biography of this Chicago architect.
Banham discusses Monroe as a critic.

915. Root, John Wellborn. **The Meanings of Architecture:
Buildings and Writings by John Wellborn Root.**
(1885-1890) Edited by Donald Hoffman. New York:
Horizon, 1967.

These essays were written by the imaginative designer of many of Chicago's late nineteenth century buildings, some of which had medieval inspirations. The new edition is fully illustrated; Hoffman's brief essay discusses the critical reception of Root's work.

RUSSELL, ARCHIMEDES (1840-1915)

916. Hardin, Evamaria, J. Brad Benson, and Mary Ann Smith. **Archimedes Russell: Upstate Architect.** Syracuse: Syracuse Univ. Press, 1980.

This prolific architect's work is organized stylistically and thoroughly illustrated by black and white photographs by Jane Courtney Frisse. A great variety of Russell's work, including churches, mausolea, courthouses, college buildings and houses, was executed in Victorian Gothic and Romanesque Revival.

SHAW, HOWARD VAN DOREN (1869-1926)

917. Dart, Susan. **Market Square, Lake Forest, Illinois.** Lake Forest: Lake Forest-Lake Bluff Historical Society, 1984.

Readable, well-illustrated monograph about the "first planned shopping center in the United States." Discusses the eclecticism of Howard Van Doren Shaw's architectural solution, including the neo-Gothic features of two buildings facing the square.

SHEPLEY, RUTAN and COOLIDGE

See: CHARLES COOLIDGE

SILSBEE, JOSEPH LYMAN (1845-1913)

918. McCormick, Thomas J. "The Early Work of Joseph Lyman Silsbee." In **In Search of Modern Architecture** (no. 309), pp. 172-84.

Assesses Silsbee's work in New York and Chicago and discusses a few Victorian Gothic commerical buildings and a chapel.

919. Sorell, Susan Karr. "Silsbee: The Evolution of a Personal Architectural Style." **Prairie School Review** 7 (1970): 5-13, 17-21.

Silsbee employed the Richardsonian Romanesque extensively between 1887 and 1892. This article includes a checklist of his work.

SLOAN, SAMUEL (1815-1884)

920. Cooledge, Harold N. "A Sloan Checklist, 1849-1884." **JSAH** 19 (March 1960): 34-38.

Samuel Sloan (1815-84) designed structures in a wide variety of styles and published pattern books of villas and cottages. This checklist reproduces plates from Sloan's **The Model Architect**, including one of "Eastwick," a Norman villa, and a view of Sloan and Stewart's Masonic Temple (Philadelphia, 1853-55), done in an extravagant Gothic Revival.

SMITHMEYER, JOHN L. (1832-1908)

921. George, Hardy. "Georgetown University's Healy Building." **JSAH** 31 (October 1972): 208-16.

This massive work by John L. Smithmeyer is linked to Romanesque prototypes in Italy and Germany.

STEARNS, JOHN GODDARD, JR.

See: PEABODY AND STEARNS

STURGIS, JOHN H. (1834-1888) and CHARLES BRIGHAM (1841-1925)

922. Floyd, Margaret Henderson. "A Terracotta Cornerstone for Copley Square: Museum of Fine Arts, Boston,

1870-6, by Sturgis and Brigham." JSAH 32 (May 1973): 83-103.

The Boston Museum was derived from High Victorian Gothic work in England; Floyd also offers a good biography of the anglophile John H. Sturgis.

TOWN, DAVIS and DAKIN

See: A.J. DAVIS and/or J. DAKIN

UPJOHN, RICHARD (1802-1878)

923. Cherol, John A. "Kingscote in Newport, Rhode Island."
 Antiques 118 (September 1980): 476-85.

 Design of 1839-41 is shown in color photographs and drawings, with a discussion of the first and later clients.

924. Doumato, Lamia. **Richard Upjohn, Richard Michell Upjohn and the Gothic Revival in America.** A-1258.
 Monticello, Ill.: Vance Bibliographies, 1984.

 This bibliography's title is more ambitious than the actual list, although there is a section on the Gothic Revival. The entries are not annotated.

925. Patrick, J. "Ecclesiological Gothic in the Antebellum South." **Winterthur Portfolio** 15 (Summer 1980): 117-38.

 Explores in depth the role of the Protestant Episcopal Church in fostering the Gothic Revival in the South. Upjohn's buildings and book influenced a number of architects like Patrick Keely, Edward Brickell White, Frank Wills and Henry Dudley.

UPJOHN, RICHARD MICHELL (1828-1903)

See also: RICHARD UPJOHN

926. Curry, David Park, and Patricia Dawes Pierce.
 Monument: The Connecticut State Capitol. Hartford:
 Old State House Association, 1979.

 A collection of essays on this wild Gothic Revival
 work by Richard M. Upjohn includes pieces by George
 Hersey on the ambitious scale, Robert A.M. Stern on
 contemporary interest in the Capitol, Curry on the
 symbolism of the dome and various details, and Pierce
 on the site.

927. Hersey, George L. "Replication Replicated, or Notes
 on American Bastardy." With photographs of the
 Connecticut State Capitol, Hartford, by J.T. Hill.
 Perspecta Nos. 9-10 (1965): 211-48.

 R.M. Upjohn's High Victorian Gothic capitol (1872)
 has a jarring quality in scale and siting; the
 structure also freely replicates Bulfinch's State
 House (1794-96).

VAN BRUNT, HENRY (1832-1903)

928. Van Brunt, Henry. **Architecture and Society: Selected
 Essays of Henry Van Brunt.** Edited with an
 Introduction by William A. Coles. Cambridge:
 Belknap Press, 1969.

 Van Brunt discusses specific designs for Gothic and
 Romanesque Revival buildings and ponders the work of
 Leopold Eidlitz, Richardson, Root, and Hunt.

VAUGHAN, HENRY (1845-1917)

929. "The Cathedral Church of St. Peter and St. Paul:
 What's Progressive about a Gothic Cathedral?" **PA**
 53 (December 1972): 68-75.

 Originally designed by G.F. Bodley with Henry
 Vaughan after a fourteenth century English Gothic
 model, the recently completed cathedral in Washington,
 D.C., is the "last true Gothic structure."

930. Harrington, Ty. **The Last Cathedral.** Englewood
 Cliffs, N.J.: Prentice-Hall, 1979.

 A popular account of the National Cathedral in
 Washington, D.C., begun in 1907 after the designs of
 G.F. Bodley and Henry Vaughan and continued under
 Philip Hubert Frohman. Construction techniques and
 personnel are discussed.

931. Jordan, Robert Paul. "Washington Cathedral: House of
 Prayer for All People." **National Geographic** 157
 (April 1980): 552-73.

 Marvelous photographs accompany this popular
 account of the building of the Gothic Revival
 Cathedral Church of SS. Peter and Paul in Washington,
 D.C.

932. Morgan, William. "Addenda to Henry Vaughan: St.
 Mary's Church, Penacock." **Historical New Hampshire**
 29 (Fall 1974): 187-89.

 A supplement to Morgan's 1973 article on St. Paul's
 School Chapel, this brief essay analyzes the
 Episcopalian chapel in Penacock, New Hampshire. St.
 Mary's has a half-timbered porch, visible in the one
 illustration provided.

933. ————. **The Almighty Wall: The Architecture of Henry
 Vaughan.** New York: The Architectural History
 Foundation/Cambridge: MIT Press, 1983.

 Vaughan was largely responsible for a resuscitation
 of the Gothic Revival in the United States in the
 1880s and imbued his designs with his own High Church
 spirit. Also, Vaughan popularized half-timbering and
 Elizabethan and Jacobean modes for secular
 architecture. Morgan describes Vaughan's
 contributions to ecclesiastical and educational
 architecture in America and the architect's
 familiarity with appropriate medieval models.

934. ————. "The Architecture of Henry Vaughan and the
 Episcopal Church." **Historical Magazine of the
 Protestant Episcopal Church** 42 (June 1973): 125-36.

 Vaughan provided an alternative to Victorian Gothic
 and revived the collegiate chapel as well as half-
 timber construction. Morgan argues that Vaughan's
 prolific output and high quality design helped
 establish the identity of the Episcopal Church. The
 article lists the known works of Henry Vaughan.

935. ————. "Henry Vaughan: Cathedral Architect."
 Cathedral Age 48 (Fall 1973): 18-19.

 An analysis of Vaughan's contributions to
 Washington Cathedral and how the Cathedral fits into
 the revival of late English Gothic by the Episcopal
 Church in America.

936. ————. "Henry Vaughan: An English Architect in New
 Hampshire." **Historical New Hampshire** 28 (Summer
 1973): 120-40.

 The English Perpendicular style as practiced by
 Vaughan introduced the modern phase of the Gothic
 Revival (as seen in works by Cram and Klauder). This
 article illustrates Vaughan's churches, homes, and
 institutional buildings.

937. ————. "Peyton Place Revisited." **Places** 1 (Fall
 1983): 38-39.

 Henry Vaughan's Stanton-Harcourt, a castle built in
 Windham, New Hampshire, for Edward F. Searles, served
 as the model for Samuel Peyton's castle in Grace
 Metalious's 1956 novel, **Peyton Place.**

VAUX, CALVERT (1824-1895)

938. Sigle, J.D. "Bibliography of the Life and Works of
 Calvert Vaux." **American Association of
 Architectural Bibliographers Papers** 5 (1968):
 69-93.

Brief biography followed by an annotated list of
primary, contemporary and modern writings.

939. Vaux, Calvert. **Villas and Cottages: A Series of
 Designs Prepared for Execution in the United
 States.** (1857) With a New Introduction by Henry
 Hope Reed. New York: DaCapo Press, 1968; New York:
 Dover, 1970.

 Vaux offered a record of his early domestic work in
 this publication. In Hope's biographical sketch for
 the 1968 reprint, he notes that "Vaux's apologia for
 his High Gothic ... has a truly modern ring--he placed
 special emphasis on originality as the architect's
 aim."

VIOLLET-LE-DUC, E.E. (1814-1879)

940. Reiff, Daniel D. "L'influence de Viollet-le-Duc aux
 Etats Unis après la traduction des **Entretiens** par
 Henry Van Brunt en 1875." In **Actes du Colloque
 International Viollet-le-Duc** (no. 248), pp. 38-47.

 Surveys American translations of the French
 theorist Viollet-le-Duc and their influence.

WARD, WILLIAM E. (1821-1900)

941. Kramer, Ellen W., and Aly A. Raafat. "The Ward House:
 A Pioneer Structure in Reinforced Concrete." **JSAH**
 20 (March 1961): 34-37.

 Technically innovative in the use of reinforced
 concrete, the Ward House (Portchester, N.Y., 1873-76)
 is a curious combination of Hudson River Gothic and
 French Second Empire. This article concentrates on
 the technical achievements of Ward.

WELLS, JOSEPH C. (dates not available)

942. Davidson, Ruth. "Roseland: A Gothic Revival Mansion."
 Antiques 81 (May 1962): 510-14.

Describes a large carpenter Gothic board and batten house in Connecticut designed by Joseph C. (?) Wells for Henry Chandler Bowen. The photographs show the site, the exterior and interiors.

WHITEHOUSE, HAROLD C. (1884-1974)

943. Woodbridge, Sally B. **Building Through Time: The Life of Harold C. Whitehouse 1884-1974**. Portola Valley, Calif.: American Lives Endowment, 1981.

Whitehouse moved to Washington State, eager to become a cathedral builder. Essentially a late Gothicist following Cram, he completed the Spokane Cathedral in 1925. This volume lists his works and offers a brief biography.

WIGHT, PETER BONNETT (1838-1925)

944. Jones, Elizabeth F., and Mary Jean Kinsman. "Unknown Wight Designs in Louisville, Kentucky." **Nineteenth Century** 6 (Winter 1980): 57-60.

P.B. Wight designed a house and furniture for Thomas Prather Jacob in 1867-68. Drawings and old photographs illustrate this article.

945. Landau, Sarah Bradford. **P.B. Wight: Architect, Contractor and Critic, 1838-1925**. Chicago: Art Institute of Chicago, 1981.

Features a checklist of the publications, buildings and projects by Wight, and Carter, Drake, and Wight, as well as a checklist of the Art Institute's Wight Collection by John Zukowsky. Wight's National Academy of Design (N.Y.C., 1861-65) helped popularize High Victorian Gothic in America.

WILLS, FRANK (1822-1856)

946. Richardson, Douglas. "[Letter to the Editor about John Medley]." **Journal of Canadian Art History** 1 (1974): 41-46.

Richardson discusses John Medley's interest in
Gothic Revival while he was Anglican Bishop of
Fredericton (New Brunswick) and his use of English-
inspired wooden models for humble country churches,
probably provided by architect Frank Wills.

WILSON, JAMES KEYS (1828-1894)

947. Patton, Glenn. "James Keys Wilson (1828-1894):
 Architect of the Gothic Revival in Cincinnati."
 JSAH 26 (December 1967): 285-93.

 This leading architect was the Gothicist for his
 firm and produced churches, colleges, and castellated
 mansions between 1850 and 1870.

WITHERS, FREDERICK CLARKE (1828-1901)

948. Kowsky, Francis R. "The Architecture of Frederick C.
 Withers (1828-1901)." **JSAH** 35 (May 1976): 83-107.
 Reply with Rejoinder, 36 (March 1977): 61-62.

 Withers was both an adventurous secular architect
 and a discerning ecclesiologist who proselytized for
 High Victorian Gothic modes. This article includes a
 checklist of his works. The reply raises some
 questions about what should be attributed to Calvert
 Vaux as opposed to Withers.

949. ————. **The Architecture of Frederick Clark Withers
 and the Progress of the Gothic Revival in America
 after 1850.** Middletown, Conn.: Wesleyan Univ.
 Press, 1980.

 Assesses the importance of this English emigré
 architect to the High Victorian Gothic in America,
 linking his work to the styles of the cathedrals in
 New York City and Washington, D.C., and noting
 Withers's contribution to secular architecture.

950. ————. "Gallaudet College: A High Victorian Campus."
 **Records of the Columbia Historical Society of
 Washington, D.C.** (1971-1972): 439-67.

Kowsky traces the growth of the campus from its founding in 1856 to Frederick C. Withers's employment from 1867-87 as college architect. Withers's 1871 Chapel Hall, done in High Victorian Gothic, was the "first important example of its stylistic genre" in the Washington, D.C., area. Kowsky gives the background of the High Victorian Gothic and closely analyzes Withers's designs.

951. ————. "A Note on the Church of the Good Shepherd." **Bulletin of the Victorian Society in America** 3 (February 1975): 6.

Withers's unexecuted, conservative design is compared to that of E.T. Potter; the author notes a shift from Pugin's influence to Ruskin's influence at this time.

PART FIVE: PAINTING AND SCULPTURE IN NORTH AMERICA

A. General Works

* Clark, Robert Judson, ed. **The Arts and Crafts Movement in America,** 1876–1916. Cited above as no. 626.

952. Hoving, Thomas. **King of the Confessors.** New York: Simon and Schuster, 1981.

Story of the acquisition of a 12th century English Romanesque ivory cross. Also gives some history of the Cloisters collection of the Metropolitan Museum (in Chapter 3), begun by George Grey Barnard and endowed by John D. Rockefeller, Jr.

953. Huntington, David C. **Art and the Excited Spirit: America in the Romantic Period.** Ann Arbor: Univ. of Michigan Museum of Art, 1972.

Huntington's introductory essay places the Gothic Revival in the larger frame of Romanticism. Included in this exhibit were drawings by A.J. Davis. Thomas Cole's **The Departure** is discussed: Cole "explored an extensive range of delicacy and strength offered by the medieval tradition."

* Kenney, Alice P. and Leslie J. Workman. "Ruins, Romance, and Reality: Medievalism in Anglo-American Imagination and Task." Cited as no. 644 above.

954. Thompson, Susan Otis. **American Book Design and
 William Morris.** New York: R.R. Bowker and Co.,
 1977.

 Focusing on the influence of Morris's Kelmscott
 Press in the U.S., Thompson discusses those printers
 who, like Morris, viewed the Middle Ages as a time of
 fine craftwork and thus adopted models for books that
 resembled fifteenth century manuscripts.

Monographs: Artists and Their Associates

ABBEY, EDWIN AUSTIN (1852-1911)

955. Foster, Kathleen A. "Edwin Austin Abbey." **American
 Art Review** 1 (March/April 1974): 83-95.

 Discusses his medieval subjects done in oil after
 1889. Abbey was influenced by the Pre-Raphaelite
 Brotherhood. His literary and theatrical themes
 gained him popularity here and abroad.

956. Foster, Kathleen A., and Michael Quick. **Edwin Austin
 Abbey, 1852-1911.** New Haven: Yale University Art
 Gallery, 1974.

 Includes essays by Foster and Quick examining
 Abbey's history paintings and literary and allegorical
 scenes in relation to those of his contemporaries.
 The authors include a bibliography.

957. Morris, E. "Edwin Austin Abbey and his American
 Circle in England." **Apollo,** n.s. 104 (September
 1976): 220-21.

 Reviews the show of Abbey's work at Yale and
 mentions George Henry Boughton, an associate of
 Abbey's, who painted Camelot (1898).

958. Whitehill, Walter Muir. "The Making of an
Architectural Masterpiece--The Boston Public
Library." **American Art Journal** 2 (Fall 1970):
13-35.

Assesses Edwin Austin Abbey's decorations of the
Delivery Room of the Library with its subject of the
Quest of the Holy Grail, painted between 1895 and
1902. Whitehill discusses the public response to
Abbey's version of this Arthurian legend.

BARTLETT, FREDERIC CLAY (1873-1953)

959. Frueh, Erne R., and Florence Frueh. "Frederic Clay
Bartlett: Chicago Painter and Patron of the Arts."
Chicago History 8 (Spring 1979): 16-19.

Discusses Bartlett's early medievalized murals in
churches and institutional buildings in Chicago.

COLE, THOMAS (1801-1848)

960. Baigell, Matthew. **Thomas Cole.** New York: Watson
Guptill, 1981.

Concentrates on Cole's landscapes, including those
of the 1830s that are set in medieval times. A brief
text precedes 32 color plates.

961. Noble, Louis Legrand. **The Life and Works of Thomas
Cole,** edited by Elliot S. Vesell. Cambridge:
Harvard Univ. Press, 1964.

Cole's 1837 correspondence related to his "feudal"
paintings is included.

962. Parry, Ellwood C., III. "Gothic Elegies for an
American Audience: Thomas Cole's Repackaging of
Imported Ideas." **American Art Journal** 8 (November
1976): 26-46.

Discusses Cole's four feudal landscapes of 1837 and
1838 and compares them to the work of other painters.

The importance of dioramas to Cole's work is also
explored.

963. Coletti, Joseph. **The Sculpture of Joseph Coletti.**
 Introduction by Allan Priest. New York: MacMillan,
 1968.

 A student of the medievalist Arthur Kingsley Porter
 at Harvard, and an associate of Cram, Coletti executed
 architectural sculpture between 1927 and 1959 that was
 reminiscent of Romanesque and Gothic works. This
 catalogue of his works provides thorough illustrations
 of his many projects.

CROPSEY, JASPER F. (1823-1900)

964. Stebbins, Theodore E., Jr. "American Landscape: Some
 New Acquisitions at Yale." **Yale University Art
 Gallery Bulletin** 33 (Autumn 1971): 7-26.

 Among other subjects in this article, Jasper F.
 Cropsey's study for Warwick Castle on the Avon at Yale
 is illustrated and analyzed. The artist was
 commissioned by Cyrus Field to paint the Castle, a
 subject of many historic legends and poems.

965. Talbot, William S. **Jasper F. Cropsey, 1823-1900.**
 Washington, D.C.: National Collection of Fine Arts,
 Smithsonian Institution Press, 1970.

 Considers the painter's early introduction to the
 Nazarenes in Rome and then Sir Walter Scott's
 influence on him, visible in several canvases set in
 feudal times. Brief attention is given to Cropsey's
 Gothic Revival architectural designs.

966. ————. **Jasper F. Cropsey 1823-1900.** New York:
 Garland Publishing, 1977.

 Talbot's 1972 dissertation reconstructs Cropsey's
 entire career with published and unpublished
 materials. This architect-turned painter was
 influenced by the Nazarenes, John Ruskin and medieval

sites in Britain and Italy. Cropsey chose a feudal
setting for an "epico-allegorical" painting inspired
by the writing of Sir Walter Scott. Talbot includes a
section on Cropsey as an architect and his
"Gothic-flavored mansard" apartments.

FEININGER, LYONEL (1871-1956)

967. Gray, Cleve. "The Architecture of Lyonel Feininger."
 Art in America 54 (March 1966): 88-91.

 Discusses Feininger's development of a single
 theme, the church tower, in his graphic work.

968. Prasse, Leona E. **Lyonel Feininger, a Definitive
 Catalogue of His Graphic Work: Etchings,
 Lithographs, Woodcuts.** Cleveland: Cleveland Museum
 of Art, 1972.

 A painstakingly researched volume that provides
 excerpts from Feininger's letters and discusses his
 career as a printmaker.

969. Ruhmer, Eberhard. **Lyonel Feininger: Zeichnungen,
 Aquarelle, Graphik.** Munich: F. Bruckmann, 1961.

 Brief catalogue essay accompanied by excellent
 reproductions of the artist's work between 1907 and
 1955. The author discusses Feininger's fascination
 with crystalline imagery as seen in his pictures of
 church towers, villages, etc.

970. Tzeutschler, Ann. "Lyonel Feininger: Markwippach."
 Cleveland Museum Bulletin 48 (April 1961): 72-75.

 This painting (1917) of a Thuringian village with
 the Romanesque church tower as a focus also was
 executed as a woodcut. The author discusses
 Feininger's relationship to the Bauhaus, a "medieval
 workshop translated into machine age terms."

GIFFORD, SANFORD ROBINSON (1823-1880)

971. Weiss, Ila Joyce Solomon. **Sanford Robinson Gifford,**
 1823-1880. New York: Garland Publishing, 1977.

 Nineteen sixty-eight Columbia dissertation with a
 1976 preface describes Gifford's interest in
 picturesque medieval secular architecture. Weiss
 analyzes sketches of Scottish ruins on pages 115-16.

KIRCHMAYER, JOHANNES (ca. 1860-1930)

972. Tucci, Douglass Shand. "A Carver of Saints: Johannes
 Kirchmayer, America's Foremost Architectural
 Sculptor in Wood." In **Germans in Boston,**
 pp. 30-36. Boston: Goethe Society of New England,
 1981.

 Kirchmayer worked during the last phase of the
 American Gothic Revival for Irving and Casson in
 Boston and the William F. Ross Co. He executed works
 for buildings by Henry Vaughan and Ralph Adams Cram in
 what he termed his "American Gothic" style.

LAFARGE, JOHN (1835-1910)

973. Weinberg, H. Barbara. **The Decorative Work of John**
 LaFarge. New York: Garland Publishing, 1977.

 Nineteen seventy-two Columbia dissertation
 supplemented by a bibliography from 1972-76. Weinberg
 documents LaFarge's major commissions for religious
 and secular paintings and his stained glass
 contributions. She devotes part of her text to the
 early Christian and medieval inspirations for
 LaFarge's decorative schemes in churches.

974. ———. "John LaFarge and the Decoration of Trinity
 Church, Boston." JSAH 33 (December 1974): 323-53.

 LaFarge assembled a unified church interior with
 the help of ten assistants. Symbols of the
 evangelists are reminiscent of medieval manuscripts,

while other painting in the church imitates Romanesque
stone banding.

RICHARDS, WILLIAM TROST (1833-1905)

975. Ferber, Linda S. **William Trost Richards (1833-1905)**
 American Landscape and Marine Painter. New York:
 Garland Publishing, 1980.

 Nineteen eighty dissertation out of Columbia
 University with a chapter on Richards as an American
 Pre-Raphaelite which explains the history of the
 English Pre-Raphaelite Brotherhood and Ruskin's
 influence both in England and the United States.

STELLA, JOSEPH (1880-1946)

976. Jaffe, Irma B. **Joseph Stella.** Cambridge: Harvard
 Univ. Press, 1970.

 Stella viewed the arches of Brooklyn Bridge as
 "dominating ... with their Gothic majesty sealed in
 the purity of their arches." Jaffe illustrates and
 discusses the Bridge studies that Stella made between
 1918 and 1941.

977. ————. "Joseph Stella and Hart Crane: The Brooklyn
 Bridge." **American Art Journal** 1 (Fall 1969):
 98-107.

 Jaffe discusses the inspiration of the Bridge to
 both artists and the religious meaning that it held
 for them.

WOOD, GRANT (1892-1942)

978. Corn, Wanda M. "The Birth of a National Icon: Grant
 Wood's American Gothic." In **Art: The Ape of**
 Nature; Studies in Honor of H.W. Janson, edited by
 Moshe Barasch and Lucy Freeman Sandler., pp. 749-
 69. New York: Harry N. Abrams, 1981.

Comments on the rich associations with Wood's
picture of 1930 and traces the derivation of its title
and format.

979. ————. "The Painting that Became a Symbol of a
 Nation's Spirit." **Smithsonian** 11 (November 1980):
 84-97.

Contains a wealth of information on Grant Wood's
concept, composition, and models for "American Gothic"
and assesses its importance as a "collective self-
portrait."

980. Dennis, James M. **Grant Wood: A Study in American Art
 and Culture.** New York: Viking, 1975.

Dennis's definitive biography of Wood includes a
chapter on American Gothic that assesses Wood's
interest in stained glass work and in Late Gothic
paintings.

981. Marling, Karal Ann. "Don't Knock Wood." **Art News** 82
 (September 1983): 94-99.

Analyzes the critical reception of Wood's "American
Gothic," among other works.

Note: Items are entry numbers except where specified.